BECOMING
LEONARDO

BECOMING LEONARDO

AN EXPLODED VIEW OF
THE LIFE OF

LEONARDO DA VINCI

MIKE
LANKFORD

MELVILLE HOUSE
BROOKLYN • LONDON

Melville House Publishing 8 Blackstock Mews
 46 John Street and Islington
 Brooklyn, NY 11201 London N4 2BT

mhpbooks.com facebook.com/mhpbooks @melvillehouse

ISBN: 978-1-61219-595-7

Library of Congress Cataloging-in-Publication Data
Names: Lankford, Mike, author.
Title: Becoming Leonardo : an exploded view of the life of
Leonardo da Vinci / Mike Lankford.
Description: Brooklyn : Melville House, 2017. | Includes
bibliographical references and index.
Identifiers: LCCN 2016047737 (print) | LCCN 2016048617
(ebook) | ISBN 9781612195957 (hardback) | ISBN
9781612195964 (ebook)
Subjects: LCSH: Leonardo, da Vinci, 1452–1519. | Leonardo,
da Vinci, 1452–1519—Psychology. | Artists—Italy—Biography.
| BISAC: BIOGRAPHY & AUTOBIOGRAPHY / Artists,
Architects, Photographers. | HISTORY / Renaissance. | ART
/ History / Renaissance.
Classification: LCC N6923.L33 L37 2017 (print) | LCC N6923.L33
(ebook) | DDC 709.2 [B] —dc23
LC record available at https://lccn.loc.gov/2016047737

Printed in the United States of America

1 3 5 7 9 10 8 6 4 2

For Dr. Larry Campbell

There are three classes of people: those who see, those who see when they are shown, those who do not see.

—LEONARDO DA VINCI

READER BEWARE: I recommend you keep a legitimate biography alongside this bastard of my brain so as to remain constantly in tune with the truth as it is generally understood. I will provide such a list of recommended biographies at the end. The intent here is to see Leonardo simply as a man sitting across the table covered in ordinary sunlight, absent the halo. Dirty fingernails and all. To view him as he was viewed by others during his own lifetime, albeit through a twenty-first century knothole. I don't think he would approve. Leonardo did not like halos, and he sure didn't like being spied on.

CONTENTS

BECOMING
LEONARDO

1352	The Black Death kills 60 percent of the population in Italy. The Little Ice Age continues across Europe, causing widespread famine.
1452	Leonardo is born.
1452	The Second Great Fire of Amsterdam destroys three quarters of the city.
1452	Painter and mosaicist David Ghirlandaio born (d. 1525).
1453	Eruption of Kuwae in the Pacific.
1453	Constantinople falls to the Ottoman Turks.
1453	Hundred Years' War ends.
1454	Gutenberg prints his first Bible.
1455	Sculptor Lorenzo Ghiberti dies in Florence (b. 1378).
1455	Sculptor Donatello's *Penitent Magdalene* installed at Florence Cathedral.
1456	Hurricane sweeps Vinci, Tuscany.
1458	Pitti Palace in Florence begun.
1460	Portuguese explorer Pêro de Sintra reaches Sierra Leone.
1461	Sarajevo founded by the Ottomans.
1462	Vlad III, also known as Dracula, attempts to assassinate Mehmed II.
1465	Massive flooding in central and southern China.
1466	Donatello dies in Florence (b. 1386).
1467	The polyalphabetic cipher invented by Leon Battista Alberti.

KING DEATH

Ages 0–15

MOST OF HIM is lost to us, of course. The timbre of the voice, the thoughts visible in his eyes, the physical gestures when happy or sad, the way he walked, his smell, his hands, the habitual grimace his friends knew all too well but no one bothered to record—all that is lost. When he was young there was no reason to write any of it down, and when he was old he became too hard to describe, too strange. What to do with Leonardo?

It's helpful in terms of myth building to have fewer facts rather than more. Were Leonardo born today we'd have hospital records, blood types of both parents, genealogies going back to Charlemagne, not to mention the views of his neighbors there in the tiny tourist town of Vinci. Fortunately, for the sake of romance and myth, we have none of that but for a single scrawled entry in a family ledger by his grandfather Antonio: "1452. There was born to me a grandson, the son of Ser Piero my son, on the 15th day of April, a Saturday, at the 3rd hour of the night. He bears the name Lionardo."

Swaddled and lying there in the straw-stuffed cradle, a couple of early spring flies buzzing his face (one perhaps landing on his lip and beating its wings) that little red baby started life with one large problem: He was, by the rules and customs of the day, illegitimate. Outside the law. His parents were not married. They apparently were not

even properly introduced. Traditionally it was thought his mother was a local girl who let the neighboring notary—Ser Piero—get too close in a dark place. New evidence suggests that Leonardo's mother Caterina may have been a house slave brought to Italy from elsewhere. Which means, it might have been rape.

Because of the plague and such massive death, Florence—the city-state that ruled Vinci, the tiny village beside Mount Albano where Leonardo was born and which gave him his name—had permitted the importation of slaves, provided they were infidels and converted immediately to Christianity and took Christian names, most often young women from Turkey and North Africa. Caterina was a popular name and it so happened that a wealthy client of Ser Piero's named Vanni di Niccolo owned a slave named Caterina. Niccolo died in 1451 and as executor of his estate Ser Piero would've had to deal with his property, including Caterina. The next year a Caterina appeared in Vinci, pregnant by Ser Piero. Nothing is known of her past.

Which would mean little or nothing but for the evidence of Leonardo's fingerprints on a few of his paintings, fingerprints that reveal the same dermatoglyphic structure—that is, the same pattern of loops and whorls—as people of Middle Eastern origin.

If true, it could mean Leonardo grew up not just a bastard son living with a weak claim on family, but of mixed race as well. Not obviously so, as it was not remarked on by Vasari or anyone else, but it would've been part of his own identity and well-known while growing up in the village. It meant he was two things, not one. And perhaps later this was even a part of his "mysteriousness," something ill-defined about him, something he hid.

And if so, then it suggests two more possibilities. One, that if Caterina had a hand in raising him or saw him frequently, and told him stories, both to entertain him and make him proud, then what kind of stories might those be? Fantastic? Heroic? Self-justifying? Stories from her home country? Or perhaps stories she made up? An important question. What kind of cross-cultural tall tales was the little kid

hearing? There was at the time a cult of the Magi which had wisdom coming from the east.

And two, notice that as an adult his sense of fashion seemed rather more Turkish than Italian: the long hair and beard curled, the purple cloak, the rings and such. He rather resembled an Ottoman Pasha out for a stroll. This was a deliberate adult identity that may well have started as youthful fantasy and wishful thinking. Caterina may be the key to understanding Leonardo's unique identity in later years, but in truth we have nothing but a few fingerprints and a couple of indirect references to guide us. Much later, in 1503 when he was fifty-one, he made an effort to move to Constantinople, writing to the Sultan Bayezid II and offering his services, all while praising Allah.

THE ADULT IS formed in childhood, and Leonardo's childhood is a factual blank. What were his shaping forces? It's generally thought that he was raised by his grandparents and uncle Francesco in Vinci, assisted perhaps by Caterina just down the road in Campo Zeppi, while his father built his notary business in Florence, roughly thirty miles away and on the other side of Monte Albano.

Leonardo as an adult certainly seemed a willful person (to say the least) who expected to get his own way, so how might an eighty-year-old grandfather have influenced that? Likewise, an uncle only sixteen years older than Leonardo himself? The suggestion is of a clever boy doted on by his grandparents and uncle while his less-engaged father is away.

One also imagines a childhood free to roam the countryside and eat bugs and drink from the streams. No doubt five-year-olds perished quickly in those days, and no doubt a curious boy would get into trouble rather more often than not. But the rocks Leonardo fell off of and the streams that nearly drown him and the mule that threw him twenty feet into the weeds—none of those hypothetical events seemed to have harmed him much, or left visible scars.

But how could we know? Scarring was common in the age before antiseptics. So common that it would not be remarked on unless it was a defining feature of some kind, or prompted a nickname perhaps. Back then the whole of humanity was covered with scrapes and scars. It was evidence of being alive. Yet Leonardo was described by Vasari and others as attractive and well-coiffed, so the inevitable accidents of childhood left no mark that can be seen from this distance.

The village of Vinci is located on a high hill, above the valley but still beneath Monte Albano. It is pock-marked with hundreds of gullies and low places where, lying down, a boy can see nothing but the sky above. Visually it's a place of contrasts, but what dominates the surrounding area is not even visible from Vinci, and that's the city of Florence on the other side of Monte Albano. It cannot be overstressed what the presence of a city nearby means to a child growing up isolated in the country—especially an important city where amazing things were to be seen and marveled at. It was a place he heard about each time his father returned, and from every passing visitor, and perhaps a place he'd visited as a boy, but he was fifteen or so before he moved there and growing up in the vicinity of such a place magnetized his life. It had to. He had the long view, and in the distance, on the other side of the mountain that blocked him, was something glorious. And because he couldn't see it, mysterious as well. Such things shape the mind and dreams.

Other than his grandfather and mother Caterina, the other large but unaccounted influence in Leonardo's young life was his uncle Francesco. Uncles can be a good thing. When all else fails, sometimes it's the uncle who steps in to save the day. Biographer Serge Bramly describes Francesco as a "gentle and contemplative man of independent character, who surely knew the names and qualities of plants (the region is rich in medicinal herbs), the signs of bad weather, the habits of the wild creatures, and the superstitious legends that govern country people's acts." Leonardo would've acquired in Francesco's company a love for the outdoors and a curiosity about the natural

world. It seems they were always close, even as Leonardo grew older. When Francesco died childless in 1506, it was to Leonardo, and not to his legitimate nephews, that he left his possessions.

The likelihood is that Francesco visited Florence on occasion, and likely took little Leonardo along with him once the boy was old enough to travel. To prime the pump of Leonardo's imagination there had to be examples for him to mull over, experiences to re-inhabit and embellish, and the village of Vinci offered little in the way of cathedrals or libraries or aesthetic thrills beyond those of nature.

Other than Caterina, I think his uncle was the major influence in his young life. What I could never prove but strongly suspect is that Leonardo learned from the personal example of his uncle Francesco to *take your time and get it right*. This craftsman's code is so embedded in Leonardo, so idiomatic of his personality, I think it had to have been learned early and repeated often. There was a "go slow" movement at the time that reflected a very real need of some to live quietly, rejecting the quick pace of the marketplace. Think of Montaigne a hundred years later, or Epicurus seventeen hundred years before. Unlike his brother, Francesco lived in the country, forswearing the city. Why? Might the pace of the country be more congenial to him, and might this in turn have influenced Leonardo in the same quiet and contemplative way?

Leonardo grew in response to what he knew and heard from others. To aspire you first have to see, to take aim, and Leonardo had an imagination that clearly turned toward art. So what did he see that turned him? Francesco likely took Leonardo along with him on business trips to Florence where they stayed with Ser Piero and saw the sights. Thirty miles isn't that far. No doubt he'd seen the occasional icon or statue in a local church near Vinci or Empoli, but that's clumsy devotional art and not likely to set the mind on fire. My guess is Leonardo was already throwing off sparks, and it was his uncle Francesco who saw it first and fanned it into flame.

One item of his childhood rarely remarked on is that the village of Vinci is on top of a rather high hill, meaning little Leonardo would've grown up with a line-of-sight of twenty-two miles or more to the distant horizon. Perhaps only an urban flatlander can appreciate this, but most people's field of vision growing up can be measured in tens of feet, up to a half mile perhaps. An ordinary horizon on flat ground out in the open is three miles. Leonardo grew up with a bird's-eye view of the countryside that was panoramic, a view that surely worked its way into his dreams as childhood landscapes often do. How different would he have been if the family had lived in Venice instead of Vinci?

Hilltops also have considerably more wind, which suggests the flying of kites and the gathering of birds. A flatland Leonardo, like a watery one, would not have been quite the same boy. He was a child of the hill country who grew up with a little thinner air and a longer view than most. This shaped him—especially once he got into the thick atmosphere and narrow streets of Florence.

How did children grow up in the fifteenth century? Mostly, I'd say, thanks to a certain amount of luck. Hilltops attract lightning strikes. Storms are worse. Likewise, a stranger passing through and sneezing could result in you breaking out in pustules. The average lifespan was a bit under forty, but you had to survive childhood first. Leonardo knew people who died young. Everyone did.

Death was everywhere. In 1456, a hurricane ravaged Tuscany. Leonardo was four years old and heard it from inside the house—assuming the roof stayed on. Periodically, as a result of drought, there were severe famines where cannibalism was not unheard of. Between the ages of ten and fifteen there were also outbreaks of plague in his area. And plague appeared again when he was twenty-seven and living in Florence, and again at age thirty-two for three long years in Milan, when nearly a third of the city's population died. For Leonardo, epidemics were a fact of life. Death, everywhere, always. Even the murder rate in Europe then was more than thirty times what it is today. One key to understanding Leonardo is to see the brutal chaos

he came out of, the chaos he tried to separate himself from, the noise on every side. It was not an easy place to think a straight thought.

People could die of a small cut or broken bone, and people he knew surely did during his fifteen years growing up in Vinci. Animals were slaughtered and he watched this closely, as any country kid would. Chickens plucked, necks rung, heads boiled and skinned—any child with imagination and empathy would twitch ten times a day just being out of the house. Either that or turn into a tough guy who was impervious to the pain of others. We see evidence of both later on. Both together: the exterior remove, the interior churn. From his drawings and sensibility we know he loved animals and knew them well. He would later write fables where the animals spoke and gave humans wise advice. He also had a fable where a rock did the same. A talking rock. These were his friends growing up. He talked to them and they talked back. He became a vegetarian after all, and collected interesting rocks all his life. Maybe for companionship.

How much pain and misery did he witness in his early years, and what effect did it have? I would imagine any Renaissance imagination must have been framed by death, and spurred on by it. *Memento mori.* He learned to distrust life early on, I suspect, probably one day at a time. The family dog, the favorite cat, his grandfather, his father, here today and gone tomorrow, catch what you can.

Francesco's advice: *Slow down, breathe deeply, Leonardo. Take your time and think it through.*

Without a doubt his drawing was a source of solace, of tuning out the world, and of capturing it as well. Consider those early lost drawings not for their focus on some particular thing, like a twig or a frog, as would be usual, but for what's blocked out. They are psychological documents as well as artistic. Any drawing is. Most importantly, one senses that the act of drawing became his way to learn about a thing. It was how he contemplated the world.

One of Leonardo's greatest discoveries as a child had to be the power of his own left hand. It must've seemed magical to him at

first—and to everyone else. Not only could it capture reality and put it on paper, but the effort of drawing a thing seemed to inform him as well, as if he knew it better afterwards. As if he owned it afterwards. As if to study something closely enough to draw accurately was to also learn it deeply all over its surface, to absorb the thing through visual touch. For him, drawing was a way of knowing the world, and he learned that as a child. Self-taught, it seems clear.

And knowing the world was a defense against it. Drawing would provide him with his role and his disguise. Drawing was central to his identity all his adult life, until he lost it near the end—but by then he was living with a king and coasting, putting on the occasional pageant, otherwise studying his toes a lot.

The micro events leading up to Leonardo's discovery of what he had at the end of his left arm must be one of the great untold tales of Renaissance art. In a sense, that hand led him through life and was his most valuable possession. It no doubt produced a flood of fantasies by the age of ten or twelve. My guess would be naked angels and devils and dragons. His later dragons, drawn as an adult, are terrific and show his familiarity with the genre. There were surely family stories about the first time the boy picked up a piece of charcoal and drew on a flat rock. Leonardo's life seemed to generate tales like that, but they too are lost.

It's equally likely that Leonardo first saw art in the local pottery industry where his family had a financial interest as property owners. Designs on the sides of piss-pots and jars and their repetitious pattern is something even a child could learn to do—not to mention the joy of shaping the pot itself. It might've been his very first spark, watching that old potter bend over his wheel, scratching his design on the side with a stick, it all blurring together as the pot spun. Early animation.

We know he loved to walk and Leonardo in his childhood rambles would've learned the nuts and vegetables growing around him, like wild asparagus and mushrooms and pears. Learning nature was a huge and complex task which required years of study. He learned

that everything had its uses, and even its secrets. Foraging was part of village life then, as was collecting recipes. Herbs were collected for medicinal and maybe entertainment purposes. Did his grandmother keep a garden? Collect recipes? Caterina? Francesco? Nature was an open book of knowledge, endlessly complex and varied to him who had the eyes to read it. Leonardo learned to *see* by looking ever more closely at those things around him. The discovery process had to do with revisiting a thing over and over until it revealed itself. Any bee or snake was its own little world of complexity and well worth study. Vinci in the 1460s was a very quiet place at times. A lizard crossing the road could draw a crowd.

We know he was curious, we know he was bright, and that he could draw like a demon, and that he lived in the country for about fifteen years, attentive to the clouds and birds around him. His was a long childhood for the time. Was this delay in becoming an apprentice a result of his self-directedness, his willfulness? His reluctance? His apparent *uniqueness* in all things mental, like writing? Leonardo, being left-handed and apparently self-taught, learned to write his native Tuscan from right to left instead of the traditional left to right. Not actually reversed writing so much as mirrored writing: normal writing running the wrong direction—thus readable with a mirror. He may have started writing this way as a child to keep his left hand out of the ink, and because a quill pen requires you to drag it, not push it. And probably, at some level, it just made more sense to him. It was easier. And apparently there was no teacher around to slap his wrist and make him do it right. According to some neuroscientists Leonardo's backward writing shows evidence of a rather severe dyslexia. As a solitary child he'd likely developed the habit before anyone fully noticed, and then found it impossible to change. There were consequences though, all through his life. What *could* he be trained to do?

We also know that a fifteen-year-old without duties in a tiny place like Vinci is trouble waiting to happen, which may be why it was decided he should move to Florence and finally begin the arduous task

of fitting in with the rest of humankind. His father had no doubt already warned him what was in store for him. Warned him and threatened him, probably. A man full of dry facts and grinding ambition would describe a future the teenage Leonardo would fear deeply: *You won't be playing all day in a creek once you have a master. You'll learn the value of real work.*

The consensus view is that Leonardo stayed in Vinci until two deaths about the same time (his grandfather Antonio and young stepmother, Albiera Amadori) required his father Ser Piero to bring him to Florence to be trained in a trade or craft of some sort and made self-supporting. Apparently there was some indecision about him even at that age. What to do with Leonardo? Where to place him? Could he learn to write legibly at all? How difficult was it for him to read? What occupations were open to a child like that?

It would seem Ser Piero's hand was forced. He could no longer ignore the growing problem. Left alone the boy had grown up like some weird weed out in the woods and now he needed to be trained to a discipline, to some purpose, and put to work.

But there are no records of this time, no family journal detailing their decisions. What is known is what likely happened, what happened most usually in such family situations: The boy was too much to handle, he needed to be apprenticed to a craft. The decision was made and that was that, although I'm sure it was welcomed by Leonardo.

To my mind, studying the fire that night, fifteen years old and bursting with dreams and desires, he was ready to get out of Vinci. *What if* grabbed this boy like a fever.

1467 The Onin War commences in Japan.

1468 Baeda Maryam succeeds his father Zara Yaqob as Emperor of Ethiopia.

1468 Sonni Ali, king of the Songhai Empire, takes power over Timbuktu.

1468 Sandro Botticelli paints *Madonna and Child*.

1468 Andrea del Verrocchio paints *Madonna of the Milk*.

EVERYTHING'S BIG AT FIRST

Ages 15–16

WALKING TO FLORENCE from Vinci is a two day trip, up and down hills. Even a fifteen-year-old would feel a bit worn out by two days of walking, but one can guess that his bubbling brain was wide awake as he approached the city late that second day. It was a landscape similar to what he knew but the river leading them to Florence was large and busy with barges and other traffic.

Everything funneled into Florence. At the time, it was the most amazing city in all of Italy. Fifty thousand people lived there, people from all over Europe and the near east. Constantinople had fallen to the Ottomans just fourteen years before, sending Christian scholars and traders and craftsmen westward like ants out of a flooded nest to places like Venice and Florence. The citizens of Florence surely felt it, that cosmopolitan variety on their streets in just the last few years, all the goods and crafts available, all these people speaking Turkish and Greek.

Coming down alongside the river he would have sensed it before he saw it, and seen it before he heard it, and heard it before he could even smell it—stepping finally into that mass of swirling human motion, full of beggars, merchants, princes and pickpockets all pushing past each other. He'd come into town over the Ponte Vecchio, the butcher's bridge, a tunnel of hanging meat and pooling blood dripping into the river. For a sensitive country kid with an eagle eye that missed noth-

ing, the wagons and horses and metal-smiths and shouting tradesmen must've seemed a solid wall of noise and chaos. Prisoners were hauled through the streets screaming and tortured. Executions were in public. People burned alive. This didn't happen constantly of course but was common enough. Walking into town that first day and wandering around the next week or so, what did he see? And what did he think about it? What effect did the city have early on? Did it close him off, or open him up? Or both?

It must've frightened him at first. He walked through streets filled with the homeless. Poverty then meant utter and complete destitution. Like back streets in Calcutta today, human misery was pressed up against both walls, along with the animals and sewage. People died in the streets and laid there. Animals too. A dead horse could bring traffic to a halt for hours and force you to find a way around. If your nose worked at all it was probably plugged shut. Everybody was a mouth-breather back then. Life in Florence would always be like this for Leonardo, a festering sewer of brilliance and despair. The Ponte Vecchio remained the butcher's bridge until 1593 when an offended Medici changed it to gold dealers.

Perhaps he worked for a while as his father's clerk when he first got to town. He *could* write both directions—although his rightward script has a certain kindergarten, pencil-squeezing quality to it. It's possible he worked for his father, but it doesn't sound like a good fit. If he tried, it may have been an early failure, something else that pushed him toward art.

This period, even if short, was probably one of the most confusing of his life. He was the bumpkin. With little education, nothing in the way of family claim or courtly exposure or even an idea of what was expected of him, he was the flat-footed kid with the loose jaw standing to the side and still in the way. I also suspect this didn't last long. We know Leonardo was a great observer, a great looker in his later years, but those first few days in Florence he was *all* eyes.

He ended up apprenticed to an artisan who took in pupils, a man

named Andrea del Verrocchio who, it is generally agreed, was exactly the right man for the job. And one can only assume that the solitary child, finding himself among like-minded others his own age for the first time, felt a huge sense of relief, and perhaps a sense of belonging as well. Of feeling he was in the right place at last.

One of the statistical certainties about Leonardo's youth up to this point was that he was unique in his own experience. He'd not met anyone like himself, until now, and there were likely several others around with names like Botticelli, who were plenty good and knew it. And, they'd studied, so they could say *what* they were doing and *why*, instead of relying on instinct as he was forced to do. He had a great eye and a fabulous hand, but squat for technique. They had a vocabulary and he didn't. They knew perspective and color and light by the rules and didn't have to figure it out each time as he did. And he must've felt this sharply. He had a lot to learn, and I'm pretty sure we can still hear the sucking sound as he inhaled it all five hundred years ago. Lots of, *Oh! I see! I see!* Questions he didn't know enough to ask were being answered daily by his new master Verrocchio, who was showing him how to observe the world all over again, both as an artist and as a young man new to the city.

Clearly Leonardo became fascinated with technique and prized it greatly, most likely because he could appreciate it so well. It had not always been there for him. He acquired this technical knowledge a bit late. And it solved real problems for him. I suspect that, from Leonardo's point of view, he'd already come up against his limits, encountered difficulties he couldn't figure out, and felt he was learning everything too slowly. I think he was perpetually catching up, even when he was ahead of the curve. This sense of lateness is the animating spark of every autodidact. But at this point he knew nothing and everything he saw seemed fresh and wonderful, or nearly so. The strength and optimism of youth at full tide.

That first year in Florence had to be intoxicating. If there was ever a time in history to be a fly on the wall, I might pick that studio for a

few days, or however long a fly lived back then. I'd buzz him just to see his eyes snap-to on my paltry fly-self. Who knows? Leonardo might've been one of those guys who can snatch flies out of the air, left-handed. A valuable Renaissance skill.

What kind of country boy tricks did he employ to win his way that first year? Fly catching? Knife throwing? Animal sounds? How agile was he with those hands? Good with chalk, but what else? Again, impossible to know, but it is generally thought that Verrocchio's statue of David is modeled on a sixteen-year-old Leonardo, which suggests the warmest kind of welcome for the newcomer. Verrocchio was nearly the exact same age as his uncle Francesco.

The highlight of those early years in Florence had to be going to the top of Filippo Brunelleschi's magnificent dome on the Florence Cathedral to help Verrocchio install the large bronze globe atop its lantern. The highest point in all of Florence, the view is still amazing. For the boy who grew up with a bird's-eye view of the world, it must've seemed purely wonderful after the months down on the streets and between the buildings. That view meant a lot to him and he surely returned to it many times, even after Verrocchio's globe was installed and the job over. He knew how to get up there. A good place to launch a toy bird, or even a little kite.

This dome had come out of a man's mind. In Florence the imagination was real. In the country the imagination was an intangible thing, a ghost, blowing through a moment insubstantial as wind. But in Florence a man could think of the most ingenious thing, and build it. Standing on top of that huge dome reaffirmed a causality for Leonardo that would've been impossible at another time or place. He carried into Florence questions about how the world worked and his place in it, and surely one of the great inspirations of his young life was the sight of that dome from anywhere in the city. Brunelleschi's dome hovers over a person not just physically, but imaginatively as well. It's an idea made of bricks—at least if you're a young Turk on the make. The church was a structure Leonardo knew the history of, and that knowledge

changed everything about how he saw it. It had been a multi-stage, one-hundred-and-forty year building project with many engineers which was finally completed only after the right man came along to finish it. All hail Brunelleschi!

He was also able to see Brunelleschi's ingenious machine for lifting and lowering. Brunelleschi had been dead twenty-one years, but his machine was alive and we can be certain that Leonardo saw it, and that he was fascinated with it, because he drew it in such detail. And the general consensus amongst experts is that Brunelleschi's machine was used by Verrocchio to install his globe on top of the dome. People were alive who knew Brunelleschi and told stories about him. Storytelling was one way you passed the time. Leonardo learned to listen as well as learn to see in Verrocchio's workshop. He learned about the "ingenio," the inventor of new things, the engineer/artist. Brunelleschi was one, Leon Battista Alberti was another. Verrocchio himself was a man of many talents. These were Renaissance Men before the term existed. Leonardo had them for models. Amongst certain people it was the spirit of the age.

It was also a reason not to settle too quickly into any one thing. Their examples served as license to be ambitious.

DURING THIS PERIOD Leonardo learned much, not only about drawing and perspective and sculpture and goldsmithing and music and dancing and all of Verrocchio's other various arts, but about people as well. After a few years living in the city, this solitary country boy had absorbed all the warnings and cautions he'd been told about dishonest merchants and thieves of every sort, but during this time he also seemed to be making a huge discovery about society itself. There was the truth he'd been told by those who should know, the authorities (his father most likely), those ancient nuggets passed down through the ages of conventional, received wisdom that sent all heads to nodding ("the early bird gets the worm")—and then there was the truth he was observing for himself

with his own two eyes. And they didn't always match up. For instance, take all the talk he heard from believers about papal infallibility.

Or then again, don't. In Renaissance Italy a critical discussion on the topic was a dangerous discussion to have, despite the fact that papal hypocrisies were not that hard to see, and Leonardo was not the first to see them. That he would question conventional wisdom in all kinds of ways strikes me as quite natural. Conventional folk, rewarded by society (or hoping to be), embrace the values of the dominant class. They accept and approve of things because it benefits them to do so, and for that reason they can believe in them. As much as anything, Leonardo stood outside those values, and apparently distrusted them. He could, of course, have embraced conventional wisdom as a way of being accepted, and many others would've done just that, but my sense is that in the process of learning to think for himself, he was simultaneously learning to distrust the authority of others. It all had to do with seeing clearly, objectively, outside the interpretation of others. To see for himself.

Nevertheless, something started this rupture, this distrust so evident later in his life. Few if any real facts exist about his early years in Florence but my guess is he already considered himself an outsider long before he had the chance to join anything. He grew up like that.

This was a time of great complications for Leonardo. He had moved from a simple life around familiar people to an anthill of confusion where his ability to read others was crucial. How well he was able to do this is unknowable, but given that, later on, he didn't seem to trust a lot of people (if any), then this distrust is grounded in earlier experience of some sort.

For Leonardo, like any teenager, it was a time not only for learning his craft, but of trying things out, of looking into dark places, asking inappropriate questions, doing strange things.

THE PRIMARY SOURCE for much of the Leonardo lore over the last five centuries is one book written by a late Renaissance artistic entrepreneur

named Giorgio Vasari. Vasari seemed to have known everybody and been everywhere and did everything worth doing in Florence during his sixty-two years there. Perhaps his greatest talent was for architecture even though he painted acres of battle scenes and religious visions for his Medici patrons, in addition to decorating and building various palaces. But what Giorgio Vasari is best remembered for is his book, *Lives of the Most Excellent Painters, Sculptors, and Architects.*

In it, he tells the story of how Ser Piero was approached by a sharecropper near Vinci who had made a small, wooden shield—known as a buckler—and wanted it decorated by an artist in Florence. Because he valued this neighbor, Ser Piero agreed to take the crude shield to Florence and have it painted, and he gave it to Leonardo to do so. Vasari tells the story in his usual wide-eyed fashion:

> For this purpose, then, Leonardo carried to a room of his own into which no one entered save himself alone, lizards great and small, crickets, serpents, butterflies, grasshoppers, bats, and other strange kinds of suchlike animals, out of the number of which, variously put together, he formed a great ugly creature, most horrible and terrifying, which emitted a poisonous breath and turned the air to flame; and he made it coming out of a dark and jagged rock, belching forth venom from its open throat, fire from its eyes, and smoke from its nostrils, in so strange a fashion that it appeared altogether a monstrous and horrible thing; and so long did he labor over making it, that the stench of the dead animals in that room was past bearing, but Leonardo did not notice it, so great was the love that he bore towards art.
>
> The work being finished, although it was no longer asked for either by the countryman or by his father, Leonardo told the latter that he might send for the buckler at his convenience, since, for his part, it was finished. Ser Piero having therefore gone one morning to the room for the buckler, and having knocked at the door, Leonardo opened to him, telling him to wait a little; and,

having gone back into the room, he adjusted the buckler in a good light on the easel, and put to the window, in order to make a soft light, and then he bade him come in to see it.

Ser Piero, at the first glance, taken by surprise, gave a sudden start, not thinking that that was the buckler, nor merely painted the form that he saw upon it, and, falling back a step, Leonardo checked him, saying, "This work serves the end for which it was made; take it, then, and carry it away, since this is the effect that it was meant to produce." This thing appeared to Ser Piero nothing short of a miracle, and he praised very greatly the ingenious idea of Leonardo; and then, having privately bought from a peddler another buckler, painted with a heart transfixed by an arrow, he presented it to the countryman, who remained obliged to him for it as long as he lived. Afterwards, Ser Piero sold the buckler of Leonardo secretly to some merchants in Florence, for a hundred ducats; and in a short time it came into the hands of the Duke of Milan, having been sold to him by the said merchants for three hundred ducats.

Perhaps. What does seem useful in the tale are the specifics that come through, details that establish a pattern. Firstly, that Leonardo accepted the shield and then kept it for so long that Ser Piero forgot about it. Had any number of people later in Leonardo's life heard this story they would've surely nodded their head in recognition. The life-long pattern of delay and procrastination is already apparent. Likewise that he took the shield to a private room he allowed no one else to enter. I suspect there was a series of private rooms in Leonardo's life, places where he could think and fiddle and be alone. And thirdly, contrary to the usual view of him as a fastidious gentleman, he had a huge tolerance for stink.

And more than anyone else I can think of, Leonardo seemed a man willing to wait for inspiration and insight. He seemed willing to study a thing until it spoke to him and revealed its secrets. This flies in the face of modern production values, especially in the arts, but Leonardo was

his own guru, and following his uncle's example, seemed content to take his time and get it right.

In part I attribute this to his (apparent) lack of concern for the opinion of others. Time functions largely as a social agreement, and that was even more true back then. Fifteenth-century Florence was pre-industrial and pre-steam; no one punched a time clock. Their sense of duration in general was different than our own, but even among people at the time Leonardo seemed to operate strangely. And I think the key to explaining that odd sense of time was his quest for insight and meaning and respect for the discovery process. Not that he'd call it such a thing. He might've just thought he was "studying how to do it."

My point is, it's not that he didn't value time, but that he valued it so highly. It was life itself and was the currency he paid for knowing, what he exchanged in return for insight. Weeks and months are a long time to paint a shield, but then—he got it *so right*.

The shield story also shows us what a scumbag Leonardo's father was. He not only lied to Leonardo and cheated him, but lied to the sharecropper who trusted him with his shield. And furthermore made money off both of them. Vasari of course heard this story fifth-hand from someone (probably Melzi) but what he didn't report was how Leonardo reacted to his father's dishonesty. This is a sharecropper from Vinci who worked for his father. Was he a stranger or a friend? If Leonardo knew the man and made him a wonderful shield, then later visited Vinci and saw the man and asked about it, his father's treachery would've been instantly apparent.

A notary succeeds according to the trust the public places in him. His reputation is everything. To know that public trust is a fraud and that privately the man is a scrounge, and furthermore, that this man is your father who profits off you with lies, it teaches a lesson, even if everyone *is* smiling.

Likewise, Leonardo shows up in Milan fifteen years later and, while visiting the duke's castle for the first time, what does he see hanging on the wall?

The tale also suffers from the compression of its telling over the years. Much too stagy to sound totally convincing, but something like it probably occurred and points to, as Serge Bramly observed, Leonardo's "morbid imagination." Likewise his desire for effect. Leonardo seems a very deliberate person, controlling the viewer—his father—in every way to achieve his effect. There's a theatricality to the event, a rabbit-out-of-the-hat quality that attempts to box in and control the observer. Probably because he didn't trust his father. One senses Leonardo revealed that shield to himself fifty times before he revealed it to his father once. As much as he loved discovery, I think there was a grinding repetition to his thinking as well. His spontaneity was well rehearsed.

One also senses Leonardo using his art as a weapon, a way of pushing back and refuting his father's low opinion of him. A triumph over his father, even if only aesthetic, was a victory nevertheless. Since the story of the shield was most likely passed on and repeated by Leonardo himself, his intent must've been to show his artistic power in monetary terms his father recognized.

What such staginess really reveals, though, is the extent of his self-observation. He was a close self-observer, and his own audience, and what he valued most of all was the thrill of the new and the act of discovery and revelation. The act of knowing, of seeing, which required solitude and focus. Which required being left alone, to be precise. It was necessary to concentrate, to lose himself therein.

NEXT TO NOTHING more is known about this stage of his life, but a couple of things are suggested. First, at the age of twenty, in roughly five years or less, he had satisfied Verrocchio of his skills as an artist adequately enough to become a member of the painter's guild. This is normally a time when a young artist sets up shop for himself and begins to seek commissions and perhaps even students of his own. Leonardo did not do this but instead seems to have remained at Verrocchio's bottega.

Some writers have suggested that this speaks to a lack of ambition, but that doesn't seem right to me. I think his ambition was plenty strong, but also cautious, not yet fully realized. He wanted to put out work that met his own standards, and those standards were still evolving. Like a writer who refuses to publish his early stories, excellent though they may be, Leonardo surely saw flawed early work done by others he was careful to avoid. He'd already heard artists say, *If only I could get it back for just half an hour so I could fix that damn tree!* Leonardo wasn't going there. Too deliberate, too cautious, fearful of rejection, already second-guessing everything. Then there was his writing problem as well. Opening his own shop would not be easy and he was in no hurry to start. It was easier to work on Verrocchio's projects. It left him more free time.

The problem with this avoidance was that he didn't get the encouragement and connections others got early on, and he became instead a man who increasingly produced more for himself than for others. The principle judge and jury had to be himself. This was a survival skill for him. The only judgment he could rely on was his own.

But the interesting distinction already exists; the artwork is the important thing, not society's schedule for his success, much as it bothered him. The ideal was in front of him, he had only to look and see and catch it. Success for Leonardo would not be in the opinions of others, any more than he could help it, because those could not be trusted, but rather in his own sense of quality. I don't think he held back so much as he wasn't ready to come out yet, he didn't have anything he really wanted to show. He was learning to trust himself. In his first thirty years we have only a few paintings (not all of which are equally good) and several drawings. He's doing other things. Unlike Raphael or Michelangelo, had Leonardo died at thirty, we wouldn't know him now at all. As Kenneth Clark said, "At this age he was primarily engaged with clothes, horses, and learning the lute."

1468 Johannes Gutenberg dies in Mainz, Germany (b. 1398).

1469 Painter Filippo Lippi dies in Spoleto (b. 1406).

1469 Moctezuma I, Aztec ruler of Tenochtitlan, is succeeded by Axayacatl.

1469 Marsilio Ficino completes his translation of the collected works of Plato.

1472 Ultimate Renaissance man Leon Battista Alberti dies in Rome (b. 1404).

1473 Lopo Gonçalves is the first European to cross the equator.

1473 Leonardo draws *Madonna of the Snows*, his first known surviving drawing.

1475 Leonardo paints an angel in Verrocchio's *The Baptism of Christ*.

1475 Leonardo paints *Ginevra de' Benci* and *Madonna of the Carnation*.

1475 Birth of Michelangelo.

1470s The parachute with frame is invented in Italy (inventor is anonymous).

CHAPTER 3

HOT TO TROT

Ages 16–23

ONE OF THE few things we do know of Leonardo's activities during
this time is his contribution to Verrocchio's *Tobias and the Angel*
where he added the curls on Raphael's hair, and the transparent dog
running alongside—perhaps an artistic first.

The other early evidence of Leonardo's growing talent is the fa-
mous angel in Verrocchio's painting, *The Baptism of Christ.* The story,
originally told by Vasari and endlessly repeated since, described how
Verrocchio asked the eighteen-year-old Leonardo to paint the second
angel in the bottom left corner, and that Leonardo painted an angel
so remarkable that Verrocchio threw up his hands in amazement and
then permanently retired from painting because he'd been shown up
by his own student. This is according to Vasari, who is the only source
anyone has.

Vasari's credibility as a narrator of historical fact frequently seems
suspect to me, but whenever his interpretations appear to go beyond
both human nature *and* common sense, it is reasonable to ask what
his motives might be. Biographer Richard Turner makes the strong
point that Vasari was describing not only a great artist in Leonardo,
but arguing for a new kind of artist as well. Depicting Leonardo as a
creator, as a maker of worlds, Vasari was preparing his thesis for the
biography he would later write about Michelangelo, his true hero, and
implicitly arguing for himself as well—the artist as a new kind of man

and Vasari as the apostle Paul, the bringer of good news, the maker of icons and packages.

In any event, the story as Vasari tells it doesn't make sense. Historians have discovered that Verrocchio did paint other things after this and, frankly, Leonardo's angel just isn't that good. Personally I prefer the other angel, the one with the puzzled look. And the notion that others in the workshop walked around dazzled for three days doesn't make sense either. I think there was some disagreement about his angel. It doesn't blend in to the painting. He did it with oils when Verrocchio's work was in tempera. It looks a bit sugar coated. The other angel has a sense of substantiality about it, a competent angel there to do some spiritual work, whereas Leonardo's angel is posing. I'm not at all sure it was seen as a success at the time, but I'm a minority of one and everybody else can go sit with Vasari.

Leonardo's other painting of the period is his *Annunciation*, which shows his early cut-and-paste technique. This is the painting where the angel Gabriel comes to the Virgin Mary to tell her she is carrying the Christ child. As pointed out by Jonathan Jones, the great chronicler of the rivalry between Leonardo and Michelangelo, the setting is not so much about the baby Jesus as it is about painting exquisite drapery.

We see Mary sitting on the patio outside her palace, dressed to the nines, reading a book on a pedestal (which is in two places at once) when the angel shows up. I'm not sure where Leonardo got his details, but I'm with Jones in supposing the painting is mainly an excuse for him to show off his drapery skills, and that required a well-dressed Mary and angel both. Hence the palace. The pedestal upon which her lectern rests is closer to the viewer than the lectern itself, which is further away and seems like it was painted first. This is probably because he'd copied the pedestal from a Verrocchio model a little too literally. The trees in the background are a bit over-stylized as well, a bit too Botticelli-esque, not a mistake he would make again, but the other wonder of the scene is the yard in which Gabriel kneels. Mary

has a dandelion problem. Maybe a dozen different weeds are sprouting wild everywhere. This is Leonardo showing off his knowledge of plants, country boy that he is. One gets the sense that if Leonardo knew something, he'd tell you about it sooner or later, at least as a young man. Like any autodidact, he was proud of his hard-earned knowledge. He could probably be a bore at times and only later in life learned that, in the sorcery business, "less is more."

And, for the first time, in the background of the *Annunciation* we see his version of strange rocks. From the very beginning, the man liked rocks. What he really liked, I think, was the contrast and counter-argument those rocks provided to the fancy humans at the front of the picture. That contrast seems critical to the polarity of his imagination. Everything in twos with Leonardo. A divided point of view.

And his rocks would only get more bizarre at time went on. When we get to *Virgin of the Rocks*, ten years hence, they appear almost as a ruined building arching overhead. Such rocks don't exist in reality, as he well knew. He was messing with the natural order of things, and clearly liked it.

Those rocks in the background also suggest a young boy who learned to draw alone by himself what he saw around him. A German Leonardo at this time would've been drawing interiors of rooms and potted plants, but Leonardo da Vinci was an outdoor child who entertained himself with a pen and the paper his uncle gave him. One senses a purity about that drawing experience he tried to return to at other times in his life, losing himself in solitude and capturing some rare thing on paper for elaboration later on.

Leonardo's background scenery has been interpreted in a variety of ways over the last five hundred years, but it strikes me primarily as a reminder of the temporary existence of this butterfly life in front of you. This sense of temporariness also explains a number of other things about him which have puzzled writers. Leonardo viewed himself as temporary first of all—he would appear to have grown up with an acute sense of mortality and taken it as a theme over his life. He

might live through the coming year, he might not. The abyss was always there. This was a sense that his paintings captured, a moment that gave them a certain heightened reality. *Be here now.* He knew that self-awareness because he lived it. Death was everywhere, always.

WHEN WE COME to *Ginevra de' Benci,* the first of Leonardo's formal portraits, the evolution in his thinking is enormous. He has woken up as a composer and this painting is his first masterpiece of ambiguity and strangeness. *Ginevra's* backstory is best told elsewhere, but it is enough to say it was likely painted as part of a platonic love affair, a particular court fashion of the age, and commissioned by a diplomat named Bernardo Bembo of his young love and fascination, Ginevra, both of them married to someone else. That Leonardo turned in a painting like this (after who knows how many weeks and months working on it) must've been a complete surprise. If anything, the reveal on his dragon buckler was nothing compared to what he cooked up this time. You can expect it was well-managed. *Ginevra* makes an impression and one can only imagine Bembo's reaction. Leonardo is on his way.

The painting ended up at her brother's house. I don't guess Bembo could take it home to Venice, what with the wife and kids and all.

When I saw *Ginevra de Benci* at the National Art Gallery in Washington D.C., I was the same age as Leonardo when he painted it, and naturally was a bit more critical of it than the middle-aged connoisseurs around me. "Pretty good," I conceded. "But she's half-asleep . . . needs more light in the eyes. She's all mask."

But such were the views of the young savage, unschooled in the ways of art or interpretation. I see it now as more of a courtly painting, a woman with all eyes upon her. She's the reflection of some man looking. She may in fact be a reflection of all men looking. She's become an "objet d'art." According to this recent expert.

What it really shows me, however, is Leonardo's emerging sense

of what the Greeks called *enargeia*—an ideal of vivid, hallucinatory representation, the arresting pose, something that *Ginevra* and the earlier buckler dragon have in common. It's the composition that strikes me as remarkable; this is the first evidence of the mastery of arrangement of background and foreground that was everywhere in his later great works, that ideal he sought in his compositions. And what, I think, Michelangelo and Raphael and other younger painters learned from him. But it's hard to say. Ideas were in the air and everyone was breathing deep as they could. Ownership was not anyone's concern, it was discovery, and a big part of that was riffing off what you saw around you. Look at Leonardo's swirling cluster of figures around Mary in his *The Adoration of the Magi*, and Michelangelo's large swirl of faces around God on the Sistine Chapel ceiling. Sparks jump in mysterious ways.

1476 Galeazzo Maria Sforza, Duke of Milan is assassinated (b. 1444).

1477 Volcano Bárðarbunga erupts in Iceland with a volcanic explosivity index of 6 on a scale of 7.

1477 First edition of *The Travels of Marco Polo* is printed.

1477 Charles the Bold, Duke of Burgundy, is again defeated and finally killed.

CHAPTER 4

JAILBIRD

Ages 24–25

IT'S THERE IN the echo.

Out of the many things Leonardo represents, first and foremost to my mind, are the questions of talent and identity and the freedom to grow. He seemed to be a rather neurotic person, which suggests he felt stymied in some way throughout his life. We know freedom of every kind was important to him, and at almost any cost. This quest for artistic and personal liberty seems quite expansive and included freedom from onerous responsibilities, including deadlines and contracts and the expectations of others—all virtues of the notary, by the way.

This freedom was important because losing it meant something vast to him; it went to his identity and ability to function. Later on, his clothes, his attitude, his art—everything speaks to his desire to live as he wants, willfully how he wants, and especially in how he spends his time. This is a reaction to something.

At some point that freedom had been disputed and he feared losing it entirely. Any powerful, life-long reaction requires some precipitating event of equal psychological strength and the suggestion is he lost his freedom at some point, and maybe several times. He'd grown up with slavery and knew that owning oneself was a matter of chance and luck. You don't hold something that tightly unless you feared losing it. Or, if it has already been taken away once before.

You listen for the echo because next to nothing is actually known

of Leonardo's life during his first twenty-six years. We have only a few facts: three tax returns that mention him as a dependent, a guild membership, his arrest by the Florentine police for sodomy, and an early contract for the altarpiece for the Chapel of St. Bernard in 1478. And out of that handful of facts, only one tells us anything significant.

In Florence at that time were public drop-boxes called tamburi, where written accusations could be deposited. Also called "holes of truth," they were a way of notifying the authorities of any criminal behavior while functioning equally well for slander and abuse. They might better have been called "holes of bullshit." Today we have sites on the internet for this purpose.

But the police at the time (known as Officers of the Night) took these accusations seriously enough to arrest people based on nothing but an anonymous charge of misconduct. In early April 1476, Leonardo was arrested on such a charge, along with three others, for allegedly using the services of a seventeen-year-old male prostitute named Jacopo Saltarelli. What this assumes, of course, is some exchange of money, and that's not known. Whether or not he and others hired Saltarelli, or they were just all partying together on Jacopo's night off, we don't know, but they were seen together and the accusation was of sodomy. Most eighteenth- and nineteenth- and twentieth-century writers assumed Leonardo had to be innocent, but that may have been their homophobia; my twenty-first-century assumption is just the opposite, but we don't know.

Attitudes on homosexuality have changed so much in just the past decade (at least in America and Europe) it's worth reminding ourselves what it actually meant to be arrested for sodomy in Renaissance Florence. Charles Nicholl parses the facts. Italics are mine.

Sodomy was nominally a capital crime, punishable (in theory but almost never in practice) by *burning at the stake*. A statistical survey of the Office of the Night prosecutions show that over a 75-year period (1430–1505) more than 10,000 men were

charged with sodomy—a rough average of 130 a year. Of these, about one in five was found guilty. *A few were executed*; others were exiled, *branded*, fined or *publicly humiliated*. Thus the charges leveled against Leonardo in 1476 were by no means uncommon, and by no means trifling. He was almost certainly arrested; he was in danger of savage punishment. Between the philosophical languor of Platonic love and the holding-cells of the Office of the Night is a long drop.

Prosecution, moreover, was the sharp end of a more general disapproval among the God-fearing majority. Homosexuality was routinely denounced from the pulpits, though not all went as far as the preacher Bernardino da Siena, who exhorted the faithful to spit on the floor of Santa Croce and shout "To the fire! Burn all sodomites!"

For years historians covered over this event and pretended it didn't happen. More recently they have decided that while it did happen, there was no jail time or punishment. Or if there was jail time, it was brief to vanishing. A day or two, perhaps. We're told that Leonardo, writing in his notebook years later, *"You put me in prison,"* doesn't really mean what he says, and we shouldn't make too much of it. He escaped punishment, most experts agree. Yet, how do they know?

On April 9, 1476, this anonymous note was deposited in a Tamburo accusing Jacopo Saltarelli of being a male prostitute and provides the names of four of his alleged consorts, or customers.

I notify you, Signori Officiali, of a true fact, namely, that Jacopo Saltarelli . . . has been a party to many wretched affairs and consents to please those persons who request such wickedness of him. And in this way he has had many dealings, that is to say, he has served several dozen people about whom I know quite a lot and here will name a few:

- *Bartolomeo di Pasquino, goldsmith, living on Vacchereccia*
- *Leonardo di Ser Piero da Vinci, living with Andrea del Verrocchio*
- *Baccino the doublet-maker, living near Orsanmichele, in that street with the two large wool-shearer's shops leading down to the loggia of the Cierchi; he has opened a new doublet shop*
- *Leonardo Tornabuoni, alias "Il Teri," dressed in black*

These committed sodomy with said Jacopo: and this I testify before you.

Against these four names is written, "absoluti cum conditione UT retamburentur." This meant they were at liberty pending further inquiries, or complaints, and that they were obliged to attend the court when summoned. They did so two months later, on June 7, when the case against them was formally dropped. What is not marked is the date of their conditional release.

It is simply a note jotted in the recording log. The case against them relied on witnesses coming forward and testifying during the sixty day period, and none came forward so the charges were dropped, but none of this addresses what happened when Leonardo was arrested and likely held in prison. How long he was held is not known. One might well ask, how long were most suspects held until their conditional release? A night? A week? Longer?

I don't know, but I know a few other things. I know that when you're arrested and thrown in the pokey in most advanced nations today, it certainly *seems* a long time before you're let out. We know that people die in temporary detention. And we know that the charge hanging over him was a capital offence and subject to burning at the stake. Whether or not his guard agreed with these sentiments we cannot say, but he might've. Prison guards have rarely been in the vanguard of social change. Who was Leonardo's guard? Did he drink much? Attend the services at Santa Croce? Can't say.

What do we know about prisons in Renaissance Italy? Nothing good, that's for sure. The notion that Leonardo was in for just a quick overnight and then out the next day rather misses the point. It's not known how long he was held there, and we can only guess at the effect it had on him by the echoes it left in his life. There's your measurement.

Trauma can come in packages big or small. Leonardo's arrest was probably not accomplished by a whisper in his ear at a discreet moment, but rather more of a yank and a yell, making it public knowledge from the first instant. I imagine as well that Leonardo could not count on his father to come to his aid or post bail for him. Ser Piero might not even admit to *knowing* his son after this. It might even be what caused a rupture between them. There was a considerable amount of homophobia in Florence and most scholars agree that, as a man of his place and time, Ser Piero would likely have seen Leonardo's homosexuality as sodomy and sinful. What evidence does survive suggests considerable distance between them for the next two decades or more until Ser Piero's death. What kind of bombshell was this in Leonardo's life?

Nor could Verrocchio, as a poor artist and without influence, come to his assistance in any meaningful way. Leonardo was on his own, and on that first night lying on the stone bench with old dirty straw stuffed under his head for a pillow, feeling ridiculous in his bright clothes, poor though they were, with a silly little kerchief tied on the sleeve, facing who knows what kind of punishment the next morning, he was no doubt thinking hard. We know it was a long night indeed. A night, I'd argue, that changed his life.

What were prison cells like back then? Cold, dark, and damp. Rats liked them a lot. Snakes too. Prison reform was at least three hundred years in the future. Power was capricious and you were guilty until you could prove your innocence. An interesting question would be if Leonardo had known anyone arrested and punished before this. Say, any of the twenty-six men records show were punished in just the

previous twelve months? And if so, was their punishment severe? Any of them burned or whipped naked? Is that what he spent the night thinking about? Hadn't Botticelli been arrested earlier on a morals charge?

It's early April in Florence, and he's laying there in his holding cell in the ancient prison Le Stinche, swatting flies, the smell of shit in the air, thinking of a bird over and over. Everything dark as ink. He had to see in the dark, a study in deepest shadow. His vision adjusted, ears wide open, like a bat hanging in the corner, thinking his morbid thoughts. Thinking his life was over before it had even begun. And his own twenty-fourth birthday was in just a few days. Not only that, but his father Ser Piero had a new heir, a legitimate son named Antonio, born just two months earlier in February. It was a bad time to be Leonardo.

What was he doing while lying there? One thing he probably did was study the door closely enough to visualize a way to pull those hinges out of the wood. If only he had paper and pen. It was a long first night.

The consensus view is that the presence of a Tornabuoni on the list was what caused the charges against everyone to be dropped two months later, the Tornabuoni family being the in-laws of Piero de Medici, the son of Florence's ruler Lorenzo de Medici. But if that was the case, why wait the two months? We also assume they were all released at the same time. It's equally likely, if not more so, that the aristocratic Tornabuoni was released quickly enough, maybe even the same night, but that his cohorts had to let some judicial wheels grind fine before they were back out in the sunshine. Their release wouldn't appear as urgent. No money or political pull. No evidence against them, either. They were growing grimy in there, waiting for a decision from someone. We do know that poor people are imprisoned all the time, and universally consider it a bitter experience, not to be repeated. Leonardo's response? Once, in his notebook, he wrote, "The greater the sensibilities, the greater the harm." I rather think his

life was full of harms, and prison, even for a short time, was one of the worst. His personality was a response to his life and the question must be, what caused him to be that way?

We can expect he was interrogated, asked about his role in the events, and asked about the role of the others involved. He would've been asked to rat out his friends. Was that part of his guilt? And what was it like to be interrogated back then, perhaps by your guard, the Christian guy with hairy arms who kept spitting on the floor? And on a morals charge? Was he beaten? Some scholars think so. A lot of other people were. And worse.

One way or another it appears he got out of the situation, either by cooperating with the police, or by the influence of others to have the charges dismissed, or simply from lack of evidence or further testimony against him. Or maybe they just needed the space for a real criminal.

He no doubt came out with a case of fleas, if not crabs or lice or other critters that live in the hair.

His friends saw a difference in him after that, and watched that difference solidify over the next several weeks while Leonardo waited to see if the charges would be dropped—that is, to see if he had a future. It all depended on whether or not someone came forward to witness the charge. Then a second complaint was filed against him, but again no witness came forward. He must've been rattled to his bones. Two months of constant fear is long enough to bake anything into your thinking forever.

And it no doubt changed his relationship with his father, Ser Piero. Who, all historians agree, was a money-grubbing grind of a man who wore out three wives until he finally, at age fifty, had a "legitimate" male descendant to recognize, the aforementioned Antonio, so that he was no longer stuck with just his clever sodomite bastard son.

The worst moment of Leoenardo's life? He was a mongrel outsider with clever hands, and in jail self-deception is impossible. He had no pull and no influence, he was just a poor student, and in a capricious

world, he could be doomed by any idiot looking out a window. So he slowly became a cipher. As a defense, he would give the idiots nothing. Simple emotional camouflage, with a purple cape for distraction.

One of his earliest surviving machine drawings from that period is of a turn-screw and brace and clamp designed to pull the hinges off a door.

AFTER THE SODOMY charge was dismissed in mid-June 1476, Leonardo immediately left Florence to follow Verrocchio to Pistoia for a commission, an enormous marble cenotaph in Pistoia's cathedral to honor Cardinal Niccolò Fortaguerri. Leonardo, whose aunt Violante also lived in Pistoia, was probably glad to get out of town for a while. He stayed gone maybe a year and it is believed that while in Pistoia he was able to pick up a side job making a terracotta angel for a parish church in the nearby village of San Gennaro. This statue is a remarkable piece of work and shows his developing style, with some parts very well done, and others seemingly rather hurried, probably because he was running late and had to finish up, people yelling at him. It appears the angel was originally painted, polychrome being common then for terracotta and wood statuary.

The angel was set in the corner of the church and was no doubt admired and remarked upon for several years, especially for the subtly and shading of the painting. Then people became accustomed to it, and over time the thing started gathering dust and the paint flaked off and the light in that corner faded as a tree grew outside—and people just stopped paying attention. The only record of the statue is from 1773, when a workman knocked it over with a ladder and broke it into pieces, and it had to be repaired by a local artisan. Not until the mid-twentieth century did someone visiting the church notice the dim piece of work in the corner and wonder, *Doesn't that look a little bit like . . . Naww, couldn't be. No way.*

Leonardo likely stayed in Pistoia until Verrocchio finished the cenotaph in the cathedral and returned to Florence with him in early 1477, at which time he apparently separated from Verrocchio and set up his own shop. All we have of the next few years are bits and pieces. Very interesting bits however. It seems in the next year or so a pupil of Leonardo's named Paolo was sent away by Lorenzo de Medici (head of the family and de facto boss of Florence) to Bologna where Paolo was imprisoned for six months for the "wicked life" he'd been leading at Leonardo's bottega. This punishment could have easily been laid on Leonardo himself, but we don't know the particulars. We don't know how reckless the twenty-five-year-old was after his release from jail. We can assume that if Lorenzo was aware of the sexual peccadilloes of an art student, he'd be aware of the master's peccadilloes as well.

Lorenzo and Leonardo would have met through Verrocchio while Leonardo was his student, but it's not clear how well they knew each other at this time. There was no patronage that we know of, but if they ever did know each other, it seems Leonardo was out of favor soon enough, probably for his pronounced homosexuality. For a variety of reasons I'll explore later, it seems Leonardo was easier to dislike than we moderns might want to imagine. Some people grew to despise him, and with reason. Leonardo apparently had a gift for pissing people off.

During these early aimless years in Florence, before he began keeping notebooks, before he became the deliberate investigator of the natural world in all its many manifestations, and long before he really even knew what he was doing at all, it's likely Leonardo was already asking the large questions about how the world worked. By this point he had surely developed his intense attraction for the examples of those like Leon Battista Alberti or Filippo Brunelleschi or Francesco di Giorgio Martini or other *ingenios* who were not stuck in a shop or bent over a work bench (or locked in jail), but were out in the world where they gave full reach to their

talents and curiosity. The artist/inventor/engineer. The complete man. The man of many parts, made one. He didn't yet know how to do it, but becoming such a man became his goal.

Already his fascination with machines had begun to consume him. He drew them, studied them, and was amazed at what could be done with clever gears and wheels. And now, of course, he needed to make a living. He began reading engineering tracts in translation, like Taccola's technological treatises, *De ingeneis* and *De machinis*, which include many annotated drawings of many innovative machines and devices, and some of Taccola's own inventions. It's equally possible Leonardo knew the work of Martini (later published as *Trattato di Architettura, Ingegneria e Arte Militare*), which may have circulated in manuscript during those years. Martini, too, was an inventor and engineer who interspersed illustrations with text, very much like Leonardo would later do. Taccola at least, and perhaps Martini as well as others were huge influences on Leonardo's thinking about engineering and military devices at this stage, as well as the style of his notebooks later on. The major difference, of course, is the beauty of Leonardo's drawings. He was never just an engineer of machines.

He was also fascinated by water and how to control it. He studied canals and how they're made, as well as rapid little creeks and the tiny fish that manage to swim against the current. Since he had been a small boy standing knee-deep in the river, water had seemed an alternative world to him, fascinating but difficult to understand, especially when it became willful and rose up out of its banks. No one, it seemed, understood the nature of water at all, but for the rare engineer who learned how to tame it. He wanted to be such an engineer.

But then, there were so many things he wanted to study, he didn't know where to begin. The life of a fish, the life of a bird, the life of a noble horse, of a rabbit underground—all these things fascinated him. Where to begin? It seems he had nothing but time on

his hands. He probably dabbled in everything. He certainly had no commissions to distract him. Nor money for food, either.

1478 Beginning of the Spanish Inquisition.

1478 Leonardo paints *Benois Madonna* and draws *The Virgin and Christ Child with a Cat*.

1479 Ferdinand II ascends the throne of Aragon and rules together with his wife Isabella I, Queen of Castile.

1480 Mariner's astrolabe used for the first time as Portuguese circumnavigate Africa.

1481 Mehmed II, Sultan of the Ottoman Empire, dies and is succeeded by his son Bayezid II.

1481 Axayacatl, Aztec ruler of Tenochtitlan, dies and is succeeded by his brother Tízoc.

1481 Fire destroys the roof and the spires of the Cathedral of Notre Dame at Rheims.

1481 Last Aztec Stone Calendar is carved.

1481 Leonardo begins *The Adoration of the Magi*.

STRANGE FRUIT HANGING
FROM THE BALCONY RAIL

Ages 26–29

ANYONE WHO HAS watched their life fall apart knows the signs: calls not returned, applications ignored, commissions you're perfectly qualified for being given to others—then the river floods, and once that's over and the mud dries, plague hits. That sort of thing.

Except for the missed calls, Leonardo's last few years in Florence appear to have been a version of this. He doesn't know what to do, his reputation is in the crapper, churches aren't hiring him for their altar pieces, and he's afraid of losing what little he's got—which is that left hand, mostly, and whatever comes out of it next. He's living as a freelancer now, moved out of Verrocchio's and on his own. Verocchio's name does not appear in any of his surviving notebooks. We have no idea why.

The story of the next four years is one of him failing (not least in his own eyes) to achieve anything of merit, and then after failing miserably, moving to Milan to start over again. True freedom meant not being saddled with a history, either.

What we do know is that Florence at that time was a much more violent place than Dodge City at its worst. Even an isolated mining camp has nothing on crude behavior when it comes to the sophisticates of 1478 Florence caught up in a moral spasm. And Leonardo was there for all of it, even sketching one hanging body, drawing his own

conclusions about humanity. Life was cheap back then, but especially so if your name was Pazzi.

The tale's told like this: two families vying for dominance, fueled by pride and arrogance and money lust, reach a crisis point when Family Number 2 can no longer tolerate merely having millions, but must have tens of millions as well. And, this being Florence in 1478, the first idea that occurred to the ringleader of the deprived Family Number 2 was a public assassination of the two adult sons of Family Number 1, known to history as the Medici who, through their far-flung system of banks, had great wealth and used it to control Florentine politics. Family Number 2 was the long-suffering Pazzi, extremely wealthy merchants and bankers in their own right who had their own political connections and were tight with Pope Sixtus IV in Rome, who personally didn't like the Medici much either and seemed to nod his acquiescence to the assassination scheme. Then on April 26, the two Medici sons, Lorenzo and Giuliano, attend the Easter services at Florence cathedral, where Bernardo di Bandino Baroncelli and Francesco de' Pazzi fell on them, stabbing in every direction— a frenzy of blood, the floor slick with it. Giuliano falls and dies while Lorenzo managed to get behind the sacristy's door and was barely saved. A friend who helped him died instead.

Given that the Medici are the biggest deal in town, and one of their heirs is lying dead on the floor with nineteen knife wounds, and the other heir barely survives with a slash on his neck, general panic naturally ensued.

The Pazzi, thinking they'd set off a popular uprising against the Medici, went running through the streets shouting *"Popolo e liberta!"*

But not that day. No such uprising occurred, which left the Pazzi in the doubly awkward position of having assassinated one of the town's leading citizens and badly wounding another, and finding no one happy about it. Instead, church bells were ringing all over the place and the uprising turned against *them*. In the next forty-eight hours, over eighty members of the Pazzi family and their associates

were hunted down and hung from balconies. The story is told that the elder of the Pazzi family, Jacopo, who had opposed the plot at the beginning and only reluctantly went along at the last minute, was hung from a balcony alongside his nephew Francesco, the instigator of it all. As the two men dangled at the ends of their ropes, hands bound behind them, bumping into each other, the old man repeatedly tried to bite his nephew before he died.

We all know the feeling.

Anyway, Leonardo was there. Probably upstairs looking out a window, as being out on the streets during a general riot can get you hurt. No doubt many innocent people died that day. Grudges and debts were paid off in the general confusion. Some of the bodies were left hanging for weeks.

That was in April. Later that year the floods came and caused great damage to the lower parts of the city, followed by the plague and still more death and destruction. Of the four assassins in the cathedral that morning, three were caught and hung by sunset, while the fourth, Bernardo Baroncelli, escaped. When he was hunted down and captured in Constantinople some months later and brought back to Florence to be tortured for a while, then hung, Leonardo sketched the hanging body, a sketch that survives. He's looking closely at how the feet dangle, the arms hang, the drape of the clothes, and then draws the face twice to get the proper angle and strangled expression. He studied it sufficiently to capture it. It's not impossible that he knew the man. Was it his first corpse to draw? Probably not. We don't know. There was a commission for just this sort of memorial propaganda by the Medici, but it was done by Botticelli instead. Leonardo drew the corpse for free. Because he wanted to. How dead bodies hung was of interest to him, and good models not always available. Not to mention that this one was hanging just around the corner from his father Ser Piero's house. An opportunity not to be missed.

In 1481, because he had backed the wrong side and the Medici were still in power, Pope Sixtus began making gestures of reconciliation,

one of which was to ask Lorenzo de Medici to send him the names of the best painters in Florence whom he could employ to decorate his new chapel, the Sistine. Lorenzo sent him a list, all of whom were hired and left for Rome where there was paying work and great prestige. Leonardo's name was not on that list, although Verrocchio's was. In any event, Leonardo stayed behind in Florence and instead took a contract where he was paid in grain and wine and ended up painting a church clock. Another bad time to be Leonardo.

It's during periods like this that many people would fold their tent and return to the conventional path and maybe train to be a notary's clerk and learn to keep their ambitions modest. Maybe he could get a job with the city and just paint on the weekends. He'd have to start near the bottom but in a few years could be in charge of the sewers or some such, drawing a regular wage instead of this pillar-to-post nonsense he was living now. You can bet he got this advice.

But Leonardo didn't fold his tent. He may have never considered it.

What does it mean to be talented and disliked and failing for entirely personal reasons? If Lorenzo doesn't like you, it's probably time to move on. Yet Leonardo doesn't, even though there's plague in the city as well. He eventually manged to find work and started two paintings during this time, *The Adoration of the Magi*, commissioned by the Augustinian Monastery of San Donato at Scopeto, and *Saint Jerome in the Wilderness*, commissioned by Bernardo Rucellai. Both are brilliant compositions, and both point to important directions in his later paintings, but both are only half-finished and seem abandoned. Why, no one knows, but it seems a new disruption had occurred.

The two paintings had very different histories afterward. *The Adoration* was stored in the house of Giovanni de Benci, brother of Ginevra, but *Saint Jerome* mysteriously disappeared and then reappeared three hundred years later in Rome, cut up and used as a table top. The story is that Cardinal Fesch, the uncle of Napoleon Bonaparte, an art collector of some repute, was out shopping one day and discovered the table top for sale in a shop. Suspecting that

it might be Leonardo's, he bought the table and began to search for the rest of the painting. He eventually found it in a shoemaker's shop where it was being used as a wedge in his bench. Cardinal Fesch re-assembled the two parts and it hangs in the Vatican today.

LEONARDO'S FEELINGS ABOUT Florence had changed. He'd ar-rived wide-eyed and wonder-struck and he'd met the great men and seen great work; but he'd also seen the boot-licking necessary to get commissions and he'd seen the prejudices *some* princes have for *some* painters, both pro and con, and he saw that these things could not be overcome. Inside the art community Florence was a very small place and everybody knew everyone's business. Rumors probably rampant. Who's up, who's down, who's in and who's out? Leonardo.

We do know that by this time his father, Ser Piero, having found a fertile wife, is making babies like buns in an oven. Leonardo already had two more half-brothers. In his own life the new addition was a best friend named Fioravante. Leonardo was probably playing his fid-dle a lot. His life these last few months is a mystery. He seems to be waiting.

Happy people don't move to strange cities and start over. A person with many dear friends and close family ties does not abandon them in favor of more strangers in his life. In his eyes, he left Florence be-cause nothing (or not enough) was holding him there. Like anyone rebooting their life at the age of thirty, Leonardo wanted to put the past behind him: the unfinished work, that whole business with the police, his father with his third wife, not to mention Verrocchio off in Rome with every other decent artist he knew. Nothing held him there. But he needed safe passage to whatever was next. He couldn't just up and go on his own.

Then he heard that Lorenzo was putting together a gift package for the new ruler of Milan, Ludovico Sforza, consisting of various ac-tors and poets and artisans and musicians, as well as works of art, and

he found a way to have himself included in the package—apparently by presenting Lorenzo with an astonishing work of realistic metal sculpture which he then proceeded to turn over and rub with a bow, releasing music into the air.

Leonardo, being Leonardo, doesn't just buy a flute at the music store and maybe paint it or something. Instead, he created his own instrument, a cross between a horse's skull and an early violin, made mostly of silver, with the skull being the resonance chamber and the eye holes the sound ports, known as a *lira da braccio*. Strings were tuned down by the snout, perhaps by individual teeth. No image of this thing exists in his notes but I suspect it stood out from the other gifts to Sforza both because of its absolute uniqueness (imagine a horse's skull made of silver, probably life size) and because it was louder than anything else on the bandstand, and certainly louder than any of the wooden instruments. While historians have referred to the instrument as a lute, the *lira* was more like a fiddle; think dobro guitar for the sound it made. The metal body would act as a resonator.

The music he performed on this beast was apparently a combination of bowing and plucking drone strings for the background fill, all while singing a story. Today we have bass players for the drone part, and dancing fools for singers, but back then, for one night only, there was Leonardo and his singing horse skull, charming Lorenzo for all he was worth, one last time. He really wanted to get out of Florence.

And Lorenzo probably thought, *Sure, why not?*

THIS WHOLE BUSINESS of Leonardo as musician receives a gloss from most biographers simply because it seems so unexpected. Vasari especially gets it wrong when he says, "He gave some little attention to music, and quickly resolved to learn to play the lute, as one who had by nature a spirit most lofty and full of refinement: wherefore he sang divinely to that instrument, improvising upon it."

In fact, the evidence of Leonardo's passion for music is clear. He

wrote about it in his notebooks, told musical jokes, and was clearly an experienced musician already when he wowed Lorenzo with his performance on the silver skull. Not to mention the fact that he apparently gave lessons on the *lira* to others as well. This proficiency doesn't happen just because you're smart. Smart people aren't any better musicians than anyone else, and are frequently worse. My guess is Vasari couldn't play at all. Leonardo's abilities on the *lira* speak to years of practice, as well as to performance experience. This wasn't karaoke. Leonardo had been out playing, improvising, exploring music, developing his chops, which may go some way toward explaining what he was doing in Florence those last few years. If he was good enough, he may have earned money as a gigging musician. And playing music for money in Leonardo's time meant passing the cup.

What we do know is that this passion for music continued once he was in Milan. The first portrait he did there was of a fellow musician and friend, Atalante Migliorotti, and he's reputed to have illustrated a book on musical harmony, *Practica Musicae*, by Franchino Gaffurio. One has to wonder, what does harmony look like? If we were talking nothing more than notation on a staff, anyone, Gaffurio himself, could've done that. No, he asked his weird friend Leonardo to *illustrate* it, because Leonardo could. Visual music? Was Leonardo synesthetic? Or rather chromesthetic? We don't know; more than half of his notebooks (ten out of eighteen, probably about six thousand pages) are lost to us. There could be a whole book of musical drawings in there and we wouldn't know it.

1482	Portuguese explorer Diogo Cão reaches the Congo River, where he erects a stone pillar.
1482	The first edition of *Euclid's Elements*, in Latin translation, is printed in Venice.
1482	Sandro Botticelli paints *Primavera*.
1482	Giulio Campagnola, Italian engraver and painter who invented the stipple technique in engraving, is born (d. 1515).
1482	Federico da Montefeltro, the Italian mercenary nicknamed "the Light of Italy," dies in Ferrara (b. 1422).

FROM THE EDGE TO THE CENTER

Age 30

THE TRIP FROM Florence to Milan was a 188-mile journey that took about a week, done on donkeys or horses or carts, or on foot, and done in as large a group as you could join for the safety of numbers. Bandits were everywhere along the road, preying on travelers. The solitary person, pausing to peer under a rock or sketch a flower, would be easy pickings. Trips between cities were not casual things back then but planned expeditions with armed guards. This contingent from Lorenzo would've been well protected and Leonardo was able to bring his luggage with him, his "two virgin Marys," miscellaneous papers and drawings, and whatever he kept in his grip. His entourage would've included two or three others at least, including his friend Tommaso di Giovanni Masini, better known by his nickname Zoroastro, and the musician Atalante Migliorotti.

Time and distance were still matched in 1482. A horse could make it lively but distance didn't change. A place was as far away as it took to walk or ride, one step at a time. It was not a disjointed world like today where there's a whine and a roar and an hour later you're in Omaha.

And not only were space and time united, but also day and night. Living by oil lamp or candle you noticed light all the more, and the degrees of light. Even reflected light had value. The reality of modern intensive lighting is that it not only illuminates but it blinds you at

the same time—brighter light means blacker shadow. Leonardo lived in a world of integrated light. Causality connected everything. Really, such connections lay at the surface if a person would just pause and look for it—his particular gift. This interest in making connections was what drove Leonardo, as well as his friend Zoroastro, riding beside him on the road to Milan. My guess is that Zoroastro's fingerprints are all over Leonardo's work, but there's no way to know. They were together on and off for maybe thirty years. He could well have been Leonardo's model maker. Our ignorance of their working relationship is nearly complete.

A word might be said about a Renaissance truth easily ignored: it was a rude and crude world covered in splinters where you were almost never alone. To live as a gentleman meant having an attendant who fetched your water and emptied your water and cleaned up in between. And, in Leonardo's case, would also grind his colors and sharpen his quills and other workshop duties. Zoroastro may well have started out like this, both a student and attendant. Later on he seems much more a partner or sub-contractor, a jack-of-all-trades.

Imagine being Leonardo's jack-of-all-trades.

"Zoro . . . I've been thinking about a windmill."

When people imagine Leonardo they rarely notice this mysterious figure standing behind him, mostly obscured, wearing a cape and a hood and a thick black beard, rolling astrological dice in his hand, the infamous and mysterious Zoroastro, also known as "Indovino" or the soothsayer. He may have taken the place of Leonardo's student Paolo, whom Lorenzo de Medici had snatched five years earlier and sent to Bologna in order to save his soul. I believe Zoroastro tells us something about Leonardo since he was probably one of his closest and longest companions. Apparently he was there for it all: the early hard times in Florence, the highs and lows of Milan for eighteen years (with a special emphasis on the giant horse), and with Leonardo still when he returned to Florence to paint *The Battle of Anghiari* (and perhaps pilot his flying machine) and then on to Rome together. An

independent artisan in his own right, a metallurgist, Zoroastro was also an astrologer, soothsayer, and alchemist. And a vegetarian, one who wore linen rather than the skins of dead animals, a vegan with a bushy, untamed beard. They were clearly friends who shared an interest in searching out obscure knowledge and other occult truths, and they were both reacting to a lot of the same things. They lived in the same world, ate the same food, and probably shared the same parasites—cousins living in the guts of each other. Zoroastro might've known Leonardo as well as anybody, and had more in common with him. His rounded handwriting is identified in Leonardo's notebooks. If there was one person in Leonardo's life I would love to discover kept secret journals, it would be Zoroastro. His Leonardo, I suspect, would be rather different than ours.

Zoroastro reminds us that Leonardo lived on the cusp between medieval times and the beginning of the modern. Leonardo was not a modern man, but a mixture of old and new. One of his shopping lists shows him paying for an astrological reading. Scholars frequently obscure this part of Leonardo's life in their abundant admiration for him, but I think Leonardo had a lot in common with other sui generis talents (like Isaac Newton, 150 years later) in that there's a tendency to mix the occult in with his science. It was, after all, the world he lived in. He got it with his mother Caterina's milk. He wasn't outside the consensus *all* the time. Leonardo did a lot of the same things other people did; most things, in fact.

But an abiding interest in the arcane such as Zoroastro and Leonardo shared makes sense. Most things, it seemed, were still unexplained. It was an age of small cuts and bad smells and unfortunate puddles in dark streets. Lots of twisted ankles. Bones that don't heal right. People limped and walked sideways and held their arm curled and still considered themselves blessed by good luck. The alternative to everything was death. Welcome to 1482.

Leonardo was thirty years old, headed towards thirty-one. By any reasonable expectations at the time, his life was more than half over

and he would soon be entering his twilight years. He'd produced no remarkable work yet. He had little to show for himself. A lot of potential for sure, but who's hiring potential? If he was well-known at all it was amongst those he'd stiffed over their fees and unfinished work back in Florence.

But something's about to happen. He's about to shed his skin like a snake and become multicolored and shiny, but nobody knows this yet. Not even him. It had been an extremely slow gestation to get to this point. One of Leonardo's greatest gifts was surely his longevity. He's the result of a vast accumulation of skills and knowledge and insight, and that took time. Screw Vasari.

It was a change he had wanted to make but felt unable to in Florence. This suggests to me a sensitivity to the expectations of those around him, especially those in power—a sensitivity he must've considered limiting in some way and wanted to throw off. It may well be that he left Florence because of Lorenzo de Medici and Ser Piero and their rather narrow opinion of him, or others we know nothing about whose expectations and estimation of him had become a straightjacket. In any event, it suggests to me a fear of changing and looking ridiculous. He feared the sneer or the laugh, so in order to try new things, in order to *be* new things, he had to get away from their disapproving gaze. It's in Milan we hear about his stylish clothing. It's in Milan he begins keeping his notebooks. It's in Milan where the possibility exists of getting on good terms with the local prince, not in Florence. It's this internal pressure to grow and change that made the decision for him, all else was just rationalization. Lots of creative people leave home for the exact same reason today.

There's something about this trip north that seems transformative to me. He wanted to spread his wings, but first he'd have to grow them. He felt these impulses, these needs, this desire to know, and Florence had become too difficult. It may be he felt like a failure there and couldn't be reminded of it every single day. To stay there would've been to stagnate, to live in the past. He needed to lay that burden

down and allow himself to reach for something new. It felt so much better. And yet, it was the riskiest thing he could do. He was starting again from scratch. Folks up there didn't know him from Adam.

WHAT, PRECISELY, WAS the trip north like? I tend to think Leonardo was rather quiet at the beginning. He was moving both toward a place, and away from another, so his thoughts were divided. He had the two half-done Marys, several finished drawings and many sketches, and that silver horse skull packed in a box—pretty much everything he owned in the world. It would have been a bad time to fall down and break his left arm or sprain his wrist.

I imagine much of Leonardo's thinking on this trip north was taken up with strategizing about his new life in Milan. He had some contacts he could call on, and perhaps even a connection with the Predis brothers, at whose house he would live for a while. And no doubt a large part of Leonardo's thinking on that trip north was along the lines of how he might appear more polished and diplomatic in the future, more the gentleman he wanted to be. Other than the phrases he used when writing to himself, we have little idea of his personality at this time. I look around at other talented outsiders, misunderstood and perhaps angry about it, and I think he wanted to temper his rashness, his tendency to talk too much perhaps—or his tendency to offer the critical remark. A refined mind is a critical mind, and that leaks out. A sarcastic Leonardo? What were those rough edges he wanted to sand off?

We don't know of course because most of the people Leonardo spent his life around were semi-literate at best and left no records. Most people then didn't even know what year it was, or care; they lived by the seasons. There was perhaps a 10 percent literacy rate. And a world without the written word is a world of rumor, and of shifting meaning, and various versions of everything—a world of subjective chaos riddled with misperception and ignorance. This is what Leo-

nardo was reacting to on a daily basis. It was all he'd ever known. And his abhorrence of that stupidity drove him like a dog on fire.

I believe he fashioned a new persona and dressed the part and started over in Milan as a reinvented man, like Ben Franklin, or Mark Twain, or Isaac Newton, or as so many others have done since. He was a man looking for his groove and having to begin again. His plan, if he had one, was to make a good first impression with his silver horse skull and then improvise whatever came next. And as soon as possible—draw something. That left hand would lead the way.

1482 Tatars plunder Kiev, Ukraine.

1482 The Treaty of Arras concluded between Louis XI of France and Maximilian I of Austria.

1482 Portuguese explorer Diogo Cão sails up the Congo River.

1482 The Torah, or Pentateuch, is first printed as a book in Bologna, Italy.

1482 Sandro Botticelli paints *Madonna of the Book*.

THE MUSICIAN FROM FLORENCE

Age 30

BEFORE ARRIVING IN Milan, Leonardo had written a letter of introduction to Ludovico Sforza listing all the many skills and talents he possessed. Or claimed to. We still have an early draft. Closer analysis reveals it to be a significant piece of bravado masquerading as a well-timed job application. During this period Ludovico Sforza was spending roughly 75 percent of his considerable income on his war with Venice, and Leonardo seemed to know that. He piled it on rather thick. The handwriting, which is from left to right, is not his.

> My most illustrious Lord, I have sufficiently seen and examined the inventions of all those who count themselves makers and masters of instruments of war, and I have found that in design and operation their machines are in no way different from those in common use. I therefore make bold, without ill-will to any, to offer my skills to your Excellency, and to acquaint your Lordship with my secrets, and will be glad to demonstrate effectively all these things, at whatever time may be convenient to you, all the items briefly noted below.
>
> 1. I have methods for making very light and strong bridges, easily portable, and useful whether pursuing or evading

the enemy, and others more solid, which cannot be
destroyed by fire or assault.

2. When a siege is under way I know how to remove water
 from the trenches, and to make all manner of bridges,
 covered ways, scaling ladders, and other devices suitable
 for this sort of operation.

3. If the place under siege cannot be reduced by
 bombardment, because of the height of its banks or the
 strength of its position, I have methods for destroying any
 fortress or redoubt even if it is founded upon solid rock.

4. I have certain types of cannon, extremely easy to
 carry, which fire out small stones, almost as if it were a
 hailstorm, and the smoke from these will cause great
 terror in the enemy, and they will bring great loss and
 confusion.

5. I have ways of silently making underground tunnels and
 secret winding passages to arrive at a desired point, even if
 it is necessary to pass underneath trenches or a river.

6. I will make armored cars, totally unassailable, which will
 penetrate the ranks of the enemy with their artillery,
 and there is no company of soldiers so great that it can
 withstand them. And behind these the infantry can
 follow, quite unharmed and encountering no opposition.

7. In case of need I will make cannon and mortar and light
 artillery, beautifully and usefully constructed, quiet
 different from those in common use.

8. Where bombardment turns out to be impractical I
 will devise catapults, mangonels, caltrops, and other
 wonderfully effective machines not in common use. In
 short, whatever the situation, I can invent an infinite
 variety of machines for both attack and defense.

9. And when the fight is at sea I have many kinds of highly
 efficient machines for attack and defense, and vessels

which will resist the attack of heavy bombardment, and
power and fumes.

10. In time of peace I believe I can give complete satisfaction,
equal to any other man, in architecture, in the design of
buildings both public and private, and in guiding water
from one place to another. I can undertake sculpture in
marble, bronze or clay, and in painting I can do everything
that it is possible to do, as well as any other man whoever
he may be. Moreover, the bronze horse could be made that
will be to the immortal glory and eternal honor of the lord
your father of blessed memory and of the illustrious house
of Sforza."

He concludes with, "And if any of the items mentioned above
appears to anyone impossible or impractical, I am ready to give a
demonstration in your park or in any other place that should please
Your Excellency—to whom I recommend myself in all humility, etc."

A psychological document as much as a sales pitch; he was playing
with and setting up the expectations of Ludovico. The apparent reason
for the letter is to suggest he could make the much-rumored equestrian
statue to honor Ludovico's father Francesco. As a piece of psychol-
ogy it does not persuade us today because we live in such a media-
rich, hyper-retail, hurry-up environment, but at the time it seems
getting to your point too quickly might have been counterproductive.

And besides, he wanted to get it all in, the other stuff, the stuff he
really wanted to do: the innovative machines and bridges and assault
techniques. There's been vast speculation as to the amount of chutzpa
involved here, but clearly Leonardo wanted Ludovico to think he
knew how to do all these things. He had ideas on all this for sure, but
if he'd built any of the items listed in his letter, they were likely mod-
els he made with Zoroaster's help. There's zero evidence otherwise
for real expertise in any of these areas—except for the very last part,
the art stuff.

Notice he doesn't mention music.

The man he was attempting to impress, Ludovico Sforza, the new Duke of Milan, was a hard customer to be sure. From Ludovico's point of view, everybody was hitting on him constantly with one scheme or another, and he had to be careful. This new guy, the musician from Florence, promised a lot, but they all promised a lot and then delivered the usual crap. However, the silver skull was skillfully done, and he did play it well. Perhaps, if he survived the climate, he would be useful in the future.

THAT LUDOVICO WAS even sitting on the ducal throne of Milan is a study in power politics during the Renaissance. Nothing about it was legitimate. It was all a grab.

The family dynasty started with his grandfather, Muzio Attendolo, who had been a hired soldier, a condottiero, who had gained the name Sforza ("strong") in battle. The usual tough guy, he had sixteen children, one of which was named Francesco, and it was with Francesco that the grab began. The boy was raised as a soldier, fighting alongside his dad in an early bonding experience of chopping and hacking and stabbing people. When the old man, fully armored, fell off his horse one day into a river and sank like a stone, young Francesco, moved beyond tears, then and there dedicated his life to being a condottiero, just like dear old dad.

For the next few years he could be found fighting on various sides of various wars, depending on who had the ducats, until he found himself back with the Milanese and Duke Visconti, whose daughter, Bianca Maria, had captured his fancy. Their eventual marriage would be key to the Sforza family fortune, but first he had to win over the duke, who apparently knew him well and trusted him not an inch. More battles followed; him switching sides regularly, a sword for hire, until he was back with the Milanese again and finally able to marry Bianca Maria in 1441.

After Duke Visconti died without a male heir in 1447, his son-in-law Francesco was waiting in the wings. Riots and famine followed and in 1450 the city's senate, in desperation, chose Sforza to replace the dead duke. Surprisingly, Francesco was pretty good at the job and would expand the dukedom and modernize Milan in important ways, not the least of which was a system of taxes which raised enormous revenue for the government. Milan slowly became a city of learning and culture and trade in ways it had not been before and people came to accept and even love Francesco. But Francesco suffered from dropsy and gout and finally, in March 1466, simply dropped dead and was succeeded as duke by his son, Galeazzo Maria Sforza, whom nobody loved. And for several good reasons.

For one, Galeazzo had a bad rape habit. Not an occasional failing, he enjoyed going after the wives and daughters of numerous Milanese nobles, and then passing them on to his courtiers once he was tired of them. The husband of one woman who complained had his hands amputated. Galeazzo also took sadistic pleasure in torturing the men who had offended him, especially pulling apart the limbs of his enemies with his own hands. Sforza once had a poacher executed by forcing him to swallow an entire rabbit, with fur, and had another man nailed alive to his coffin. One can only imagine what Galeazzo found to do in his spare time. Butterflies likely avoided him.

It was also during these years that Galeazzo became close friends with Lorenzo de Medici and visited him in Florence in a grand parade of wealth and luxury. A document in the Milanese court archive gives us an idea of the parade's size: eight hundred horses carrying a retinue of cooks, courtiers, chaplains, butlers, and barbers, not to mention the trumpeters, pipers, falconers, dog handlers, pages, and assorted others. Among the troupe was Galeazzo's younger brother Ludovico, still a teenager, known as Il Moro ("the Moor") because of his ruddy, dark complexion. It's hard to imagine anybody in Florence missing that parade, and no doubt watching from the crowd as they passed by was Leonardo, nineteen years old.

Once back in Milan, Galeazzo returned to his usual pursuits and soon enough virgins and priests (who in his absence had criticized him from the pulpit) were running for their lives. Long story short, Galeazzo's behavior became intolerable to people and after a while assassination became more than just a concern for Galeazzo, it became an abrupt fact.

On the day after Christmas, 1476, just as everyone was getting over their feasting and pageants, Galeazzo visited the church of Santo Stefano for a little sanctimonious praying. Waiting for him in the crowd were three men he knew well, all fairly high-ranking officials at the Milanese court. Each had his own complaint. Gerolamo Olgiati was a Republican idealist, and Carlo Visconti was upset over Galeazzo raping his virgin sister. The third man, Carlo Lampugnani, descended from Milanese nobility and, because of Galeazzo, his family had lost considerable property and faced poverty and ruin.

When Galeazzo finally walked through the door of the church, Lampugnani knelt before him, said something no one else was able to hear, and then stabbed Galeazzo right between his balls, twisting it back and forth, no doubt. He stabbed him again in the chest, this time looking Galeazzo in the eye. Olgiati and Visconti quickly joined in, as did a servant of Lampugnani's. Everybody was stabbing Galeazzo as fast as possible.

In half a minute, Galeazzo was dead—and everyone involved would be too, soon enough. A riot immediately followed and eventually people were hanging and burning all over town. It took weeks for everything to settle down again.

Problem was, the next duke in line was Galeazzo's son Gian, who was only seven years old. Not old enough to have committed any capital crimes yet, he also wasn't old enough to rule Milan with much authority, either, so his uncle Ludovico stepped in as regent to maintain law and order. All for the good of Milan, you see. The boy was exiled to the country to stay with his mother in quiet isolation where

he lived a totally managed life, right up until the moment Ludovico had him poisoned eighteen years later.

Ludovico had been in power about five years when Leonardo first met him. He had not been expected to rule, being the second son of Francesco, but nevertheless his mother Bianca saw to it that his education was not restricted to the classical languages. Under the tutelage of the humanist Francesco Filelfo, Ludovico received instruction in the beauties of painting, sculpture, and letters, and he was also taught the methods of government and warfare. At least enough to get by.

After a few years in office he'd surrounded himself with courtiers and sycophants and toe-suckers, not to mention the women and servants and slaves scraping around, yessing him every which way. Ludovico was king of the world, in Milan anyway, and found life outside the palace tedious and hardly worth living. He had the money and jewels, the girlfriends, the army, the dutiful population that applauded when he came out on the balcony to wave. Life was good, on one hand. On the other, everyone had their fingers in his pocket, robbing him blind, and he knew it.

1482	Tizoc begins his rule of the Aztecs.

1482 Tizoc begins his rule of the Aztecs.

1482 Di Giorgio Martini publishes *Trattato di Architettura, Ingegneria e Arte Militare.*

1483 Richard III is crowned king of England at Westminster Abbey.

1483 The Sistine Chapel opens in the Apostolic Palace in Rome.

1483 Verrocchio goes to Venice and begins the equestrian statue for Bartolomeo Colleoni.

1483 Giovanni Bellini is named official painter of the Republic of Venice.

1483 Leonardo draws a parachute. Paints *Virgin of the Rocks.*

1484 William Caxton prints the first book published in England, *Aesop's Fables.*

1484 Pope Innocent VIII issues papal bull to hunt heretics and witches in Germany.

1484 Pope Innocent VIII bans the practice of smoking cannabis as sacrament, insisting on wine instead.

1484 King John II of Portugal appoints a commission of mathematicians to help seamen find latitude.

1484 Diogo Cão carves his name on another stone pillar deeper up the Congo River.

CHAPTER 8

INGENIO

Ages 30–32

IF ANYTHING CAME of Leonardo's introduction and letter to Ludovico, there is no evidence of it for the next few years. And no evidence at all that Leonardo was spending his time with defense contractors making weapons of war. Instead, his first job at the castle was apparently solving a plumbing problem for the princess. She needed more hot water in her bath.

The first actual commission of any kind he received in Milan was for an altarpiece, later called *Virgin of the Rocks*, at the newly built Chapel of the Immaculate Conception in the church of San Francesco Maggiore, commissioned by the Brothers of the Confraternity. It's a three-piece affair with a large central panel which Leonardo painted, and two side panels done by two of the Predis brothers with whom he was living at the time—little angel musicians on one side, and little angel singers on the other, four of each. The Brothers of the Confraternity were quite clear about what they wanted. The details were written into the contract everyone signed. The central panel was meant to show a manger scene with the Virgin Mary glorious and splendid and surrounded by angels and prophets, and up above God Himself looking down from the majesty of heaven, blessing everyone—but most especially that little baby in the crib at the center of the painting, Jesus the Christ Child. That is what they wanted. The monks tried to make it as clear as possible. Theirs was a newly built

chapel, devoted to the cult of Mary, and this altarpiece was central to their mission. The monks even specified the colors to be used and the amount of gilding. They could not have been more precise without drawing the thing themselves.

What the monks got, of course, was nothing they recognized. The painting is another of those weird-wonderful visions which seem to have come out of pre-time and always existed. A manger scene, of sorts, it shows Mary and baby Jesus and baby John the Baptist and the angel Uriel sitting alongside a stream and everyone seems to be talking with their hands. Tugging at your attention, though, is that alien landscape behind Mary that seems desolate and strange and the wrong place to be. What is it? A world of brutal mountains and spires and forbidding distance (I think it's supposed to be Egypt), all seen from beneath an impossible rock archway that functions, somehow, as the shed in a more conventional manger scene. A hybrid shed/cave. As geology it doesn't make sense, nor as theology, as it references no moment in the Bible (where's the father?), but instead seems to be made up almost entirely out of Leonardo's own psychology, as if it was a dream he remembered. Utterly odd and unique and stunningly beautiful, and not what they asked for at all.

The monks hated it. Completely. The painting was rejected and payment instantly stopped and twenty years of acrimony began. The Brothers would have to find *another* artist now, one they could trust to do their will.

What I don't understand is the narrative always given to the painting. Scholars are unanimous in assigning the baby under Mary's arm and protection as being John, not Jesus, who they place across from Mary down at the front of the painting next to Uriel. Why? Did Leonardo leave notes or something?

On its own merits, as it appears just to me, the painting seems to depict John (who was older) sitting by the creek recognizing and blessing Jesus. And Jesus is sitting next to his mother, thanking John. I mean, isn't the angel Uriel looking right at us, pointing to the baby

under Mary's arm as if to say, *"That's Him"*? But what the experts see instead is Jesus off sitting by the angel at the edge of the creek with that little drop-off right behind him and it's John who is getting all Mary's affection.

Clearly there was some early confusion about it. Years later, when a duplicate *Virgin of the Rocks* was painted, the scene was changed in subtle ways. Uriel is no longer looking at us, or pointing. And someone, as if to insist the baby next to Mary must be John, not Jesus, later painted John's traditional cruciform reed staff in the crook of his arm. They also added the halos.

If I was to hazard a guess, I'd say it's baby Jesus sitting next to Mary in the Louvre version, and baby John sitting next to her in the London version—even though the two babies look otherwise identical. Just shows the confusion Leonardo could create out of a straightforward commission for a manger scene. The original painting was placed in storage and rarely seen for the next few years, until Ludovico apparently came by and liked it enough to buy and send to his father-in-law Maximilian as a gift.

Perhaps as a consequence of this misunderstanding, Leonardo's next few years in Milan don't show a sudden success, and this is interesting for a number of reasons, not the least of which is that his early reputation—according to Vasari, at least—appeared to be much grander. Vasari's version is that Leonardo shows up in Sforza's court and is an instant and huge hit, talk of the town, and welcomed into the fold. But then again, Vasari is guessing, telling the story fifty years later.

What is also interesting is that Vasari is folding time, seeing the famous dead Leonardo in the young Leonardo walking into town with dust still on his boots. While this conflating of time is common today (most biographers seem guilty of it, including me), I find it interesting that it was there at the beginning too. But then, Vasari's source for much of this was Melzi (not met yet) who revered his old master totally and had devoted his life to preserving Leonardo's notebooks

and reputation and spoke as a true devotee, probably in hushed tones. But I don't know. It *was* an old Melzi who Vasari talked to, and what Vasari heard were no doubt the well-polished stories Melzi had been telling for years—stories that have a tendency to morph and distill and flatten over time. And that's *before* Vasari got ahold of them and morphed them some more. Leonardo's early impression on the court in Milan now seems rather different. Instead of designing machines of war, frightening and terrible as he'd promised, he was designing a stage set and costumes for weddings and pageants, fixing the plumbing, painting a portrait of Ludovico's mistress, and amusing people with magic tricks. Hanging out, in other words, making himself useful, doing odd jobs, winning the Duke over bit by bit. He turned thirty-one along in here, then thirty-two.

At some point he did get an appointment at court and was no longer just a freelancer working one job or another, but a part of the engineering staff. It was as the Duke's new engineer and painter that he likely sat at banquets with the rest of the palace staff, and if so, he existed now within a hierarchy of twelve other engineers headed by Bramante. It was an important position, but still paid somewhat less than the court dwarf, leading one to assume that dwarves clever and witty enough to live at court were rare and much harder to find than engineers and painters. One wonders how well Leonardo knew this individual, and if he sketched him in one of those many notebooks we no longer have.

Aside from the occasional task at court, it's his free time that matters. In a sonnet written by Ludovico's court poet, Guidotto Prestinari, Leonardo is accused of spending his days hunting in the woods and hills around Bergamo for "various monsters and a thousand strange worms." He also explored caves and climbed mountains to study the fossils and geology and to glimpse the view up high, making him one of the very first European alpinists. We also know from his later inventories that around this time he began buying more books as well. And he began contemplating the creation of his own books on various

subjects, beginning with painting, which he preferred to treat as a science, while at the same time analyzing and treating machine design and hydraulics more as creative arts.

But then, like his handwriting, everything seems reversed with him. I wonder if that wasn't the experience of knowing him as well. Whatever you expected him to do, he may well do the opposite and surprise you. Orderly personalities with control issues would find that irritating, no doubt.

It's my sense that whenever the historical Leonardo goes quiet, he's off doing something delightfully weird and impossible to guess. He'd be following his nose and I wonder how—in a world where everybody watched everybody else and where the stupid question was *de rigueur*—how he answered them. Thinking for yourself and being a bit ahead of your time must've been a giant pain in the ass. Often enough I suspect Leonardo just ignored questions he didn't want to answer, unless, of course, they were asked by the Duke himself.

Meanwhile, what kind of evolution did Sforza's thinking undergo as he got to know Leonardo better? They began working together more frequently during this period, and Ludovico was no doubt a close observer of other people—and Leonardo was one of those guys, the more you watched him, the more peculiar he becomes. After a while you can imagine their conversation.

"What are you doing, Fiorentino? Why so much time splashing water in my canals? The herdsmen say you spooked their sheep."

My guess is Leonardo avoided this situation whenever possible and gave the Duke only the briefest of answers. One data bit beyond the absolute minimum required could easily provoke ten more questions, which may well require him to recite all of known science on a subject before he was allowed to leave. *"Why? Why? Tell us, Leonardo, why must the water flow as you say it will? Tell us, please."* Those are the times when being a ducal engineer could drive you nuts and require long walks in the country. This relationship with Ludovico will need further exploring but suffice it to say that being an ingenio back then

was not always easy, or even pleasant. It all depended on the prince. Ludovico in a bad mood? Most likely not a good thing. If into his third cup he asks the most ignorant question the court ingenio has ever heard, the ingenio still wrinkles his brow and rubs his chin and treats it as an inquiry well-asked, and will endeavor to answer it in terms the Duke will understand, without making it seem so.

But whenever possible, Leonardo would likely draw a picture. It was so much easier, and so much more persuasive, and left no questions because it would appear self-evident and explain itself. And if some part was still vague or not worked out in Leonardo's mind it didn't matter, a picture could still be drawn with a sharp pen and appear quite precise. As he well knew, the illusion of a working device was different from the device itself, built and ready to go.

What mattered most with Leonardo was seeing with his own eyes. And while this was the highest standard he held for himself, the eyes of others could be easily deceived by drawings and paintings done well, and he certainly knew this too. Leonardo used his talent both as a way to articulate his ideas to make things clear, and as a way to deceive and convince others when need be. The philosopher knows the beguiling nature of beauty and how convincing it can be, regardless of the underlying facts. The seeker of truth must beware of beauty in all things as the ultimate deceiver. Ludovico, I'm guessing, didn't know this.

Or maybe he did, and they played this game of deception both ways. Hard to say.

Pictures had a different and much more powerful effect on people then. They didn't live in a world of images or reflections. They didn't have that sense of "otherness" about themselves. There was no photography, no outside context—the very thing Venetian flat mirrors brought one hundred years later—but instead only integral moments not fractured by aberrant points of view. People lived their entire lives without ever once seeing the back of their own head. Art was still rare, and excellent art very rare (and usually locked up), so people didn't see

a lot of it and their response to beauty was much more immediate and intense and even passionate. In our image-rich culture, it is difficult to imagine living in an entirely handmade world, where beauty of *any* sort would be unusual and a single picture could completely take over your mind.

Or as Leonardo himself said, "It previously happened to me that I made a picture representing a holy subject, which was bought by someone who loved it and who wished me to remove the attributes of its divinity in order that he might kiss it without guilt. But finally his conscience overcame his sighs and lust, and he was forced to banish it from his house."

And it's not that people then were more sensitive than people today; if anything, they were more crude and blunt. But the rarity of representational art in their lives meant that it had a stronger impact on the viewer than it does today. Or, in the case of music, a stronger impact on the listener. Storytelling the same. The important thing to consider is the enormous power Leonardo had to convince others simply because he could draw so well. It's been seriously argued that Leonardo was perhaps the greatest draftsman in Western history. Imagine what that must've meant to those who lived around him. He could draw a herd of flying elephants and make it look real. What *did* Ludovico make of this?

I'll go out on a limb, but I think Ludovico had fun with it. Imagine having your own artist on staff and during those long nights at the Castello Sforzesco, sitting in the semi-darkness with nothing to distract you, you might call the ingenio down from his tower to imagine some fanciful thing for you and divert the company. Perhaps he'd play his horse skull and tell you a story.

Leonardo had to learn how to deal with this new prince, and those around him, the ministers and attendants and whatnot. He was not an important man at the time, but a mere employee. After ten years or more he's still referred to in ducal court documents as "the painter" or "the Florentine." But I don't think a reputation was his first concern

at all; that's another historical view. He was using his life at court to finance his private life, a life of curiosity and learning and orgasmic freedom. The guy he becomes later is the guy he's working on now. Those worms he's cutting open "just to look" will later be part of a larger anatomy he'll build after cutting open dogs and cats and monsters found in the woods around Milan. It all goes in the mill.

The critical thing to consider is that while the careerist Leonardo we look for today seems to flounder and waste his talents on court entertainments, the actual, private Leonardo was hard at work studying and thinking and figuring things out like the flight of birds and the layering of rocks and the flowing of water, and even why tree branches fork as they do, along with—increasingly—his design for Ludovico's giant bronze horse. He lived in a grand time for asking big, obvious questions. Those years in Milan might've been the most fun he ever had.

Which brings us to those fabulous machine and weapon drawings, the giant crossbow and leg-chopping chariot and such. Every writer on Leonardo I've read takes these drawings at face value as Leonardo's designs for death, and then questions the morals of the man who made them. Yet, to say he designed military hardware is a misnomer. You don't turn on a different part of your brain to design military weapons, you're designing all the time. Some days it's hard to pick up a beer mug and not want a different handle on the thing, and a little better rim, and without the ugly figures on the side, thank you. It's what the world looks like if you're wide awake to the decisions others have made for you (especially this damn beer mug maker, who must've been drunk). Making things yourself, you're aware of how they are made by others—or mis-made.

But beyond this, scholars tend to believe in the sincerity of the war drawings. I don't. Ask yourself, *What would Ludovico do?* I think a power-mad thug with social aspirations like Ludovico probably thought of himself as a genius who used men like tools to achieve his results, and used Leonardo in the same way, even as his amanuensis.

What if the leg-chopping chariot (one of Leonardo's more ignorant ideas, if you ask me, one I had when I was twelve) was in fact *not* Leonardo's inspiration, but that of the ducal presence beside him, saying, *"Do this! Like this, Fiorentino! Bigger!"* and Leonardo grinning and thinking, *"This thing is about as likely to work as me turning into a fish."*

Ask yourself again, if you were a thick-necked Renaissance prince with social aspirations and zero talent for anything other than lying and thieving, and it's dark and everyone's sitting around bored, what would you do if you had Leonardo on staff and living right upstairs? I know what I'd do. I'd say, *"Leonardo, draw me a dragon. Give him wings."*

Which, if you accept the influence others like Ludovico might have had on the contents of his notebooks, creates a whole new way of looking at them. You can tell where Leonardo's thinking and drawing at the same time, but some of his deliberate well-drawn war machines have Ludovico stamped all over them and seem made for display purposes only. I contend Leonardo had a lot of fun with his ability to make the unreal look real, and even used this ability to help make a new kind of visual truth—a disingenuous one we're familiar with today, but which was considerably fresher then—something that looks real even though you know it can't be. There's a wink behind it all. The kind of drawing that instantly becomes an insider's joke, like the *Vitruvian Man*. But I'll get to that later.

1485	Solar eclipse across northern South America and central Europe.
1485	Multiple earthquakes occur near Taishan, China.
1485	The first outbreak of sweating sickness in England.
1485	Leon Battista Alberti's *De Re Aedificatoria*, the first printed book on architecture, is published posthumously.
1485	Henry VII becomes King of England.
1485	Leonardo paints *Portrait of a Musician*.
1485	Diogo Cão carves another stone pillar near the Yellala Falls.
1486	The Medici giraffe arrives in Florence.
1486	Botticelli paints *The Birth of Venus*.
1486	Aristotele Fioravanti, Italian architect and engineer, dies in Russia (b. 1415).
1486	Diogo Cão dies in Africa, modern day Namibia (b. 1452).
1487	Hongzhi becomes Emperor of China, Ming dynasty.
1487	*Malleus Maleficarum*, the witch hunters' manual, is published in Germany.
1487	Aztec emperor Ahuitzotl dedicates the Great Temple Pyramid of Tenochtitlán with thousands of human sacrifices.
1488	Michelangelo is apprenticed to Domenico Ghirlandaio.
1488	Bartolomeu Dias rounds the Cape of Good Hope.
1489	Begun in 1444, the Palazzo Medici in Florence is completed.
1489	Leonardo paints *Lady with an Ermine*.
1489	Typhus first appears in Europe during the siege of Granada.

HORSING AROUND

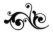

Ages 33–37

THERE IS NO mention in Leonardo's surviving notebooks of the plague that devastated Milan during this period. A third of the population—up to 50,000 people—died. Did Leonardo stay in town or hide in the hills? My guess is that if the Duke was hunkered down somewhere for a year or two, or even three, Leonardo and crew would hunker there as well, along with the rest of the court. Most likely inside Castello Sforzesco, the overbuilt fortress on the north side of town, rather than in the city itself where corpses were stacked up and left for days. Who knows where he was, but he survived (again), and was clearly affected by such massive death. No one knew about germs yet; the notion then was of vapors and spirits. They couldn't see them but they had their suspicions. Aristotle's notion of spontaneous generation (flies and maggots born from shit or dirt, or just out of the air) would not be disproved for another 350 years.

Yet Leonardo was clearly thinking about the plague. In a notebook at the time he sketched a model city plan where the clean streets and fresh air and shops are all on top, and the sewage and work animals and other unpleasant things all kept below ground. "In this way," he wrote, "you will disperse the mass of people who are now herded together like a flock of goats, filling every corner with their stench and spreading pestilential death." He also advocated for circular stairwells so there would be no corners in which to piss—

another problem at the time. Then, even more than now, piss pots are never where you need them.

What's interesting is that the Grim Reaper prowling around did not seem to concentrate his mind on one or two things, as one would expect, but rather caused it to scatter even further. It is during this period that his notebooks swell in every direction. He starts designing knives and handles, exotic, beautiful stuff, and creating domed structures like temples or mosques, but Christianized, as well as inventing stories and parables and puzzles of all sorts. The talking rock story came from this time. And most important, during this period of plague, he began his anatomies, or at least began leaving evidence of them that survived. These notes seem rather speculative still, more vision than viscera, but he was probing ever deeper. Something was pushing him. Maybe the plague had him locked up at the castle for months at a time and he couldn't get out. Perhaps he was turning in on himself, growing more introspective, staring at his toes a lot.

Then in 1488, Verrocchio died at age fifty-three. As a former student, Leonardo might've heard the news sooner than most. He knows a lot of dead people by now, and it's only going to get worse.

It's also during this period that he painted another of his weird-wonderful portraits, this one of Ludovico's mistress Cecilia Gallerani, a picture known today as *Lady with an Ermine*. Brilliant things have been written about this painting and I can add nothing but to point out that there were acres of illustration being done elsewhere by other painters at the time, attempting to show marching armies and valiant combat and the flash of swords, but it's all static and frozen in place. Not a finger wiggles anywhere, not an eye twitches. Leonardo's sitting girl, however, *moves*. The motion you see is the motion of her mind flashing in front of you. Someone has just distracted her, she glances to the left—*Ludovico!*—and simultaneously pauses stroking the half-wild critter in her lap, which has also turned to look. It's the ermine that's amazing here and it's the ermine that completes the off-stage effect. The first time I saw it, I think I blinked. A deeply clever composition.

Given the ineffable brilliance of the piece, how long it took Leonardo to compose and paint is anyone's guess. More than likely he was late finishing again but when the time finally came to reveal it to Ludovico and Cecilia and the rest of those know-it-alls at court, it was surely worth the wait. *"I know it's been some time since your lordship requested this likeness of Lady Cecilia, but it is now with pleasure that I reveal..."*

And then the gasp. Anybody betting against the gasp? There's magic in those oils and everybody saw it, especially Cecilia. She'd become a member of an extraordinarily small club: she'd been immortalized by Leonardo. Which basically meant she could never look that good again. It was all downhill from here. I wonder if perhaps he didn't overdo it, if he didn't make her too beautiful and too charming, if such a thing was even possible in a court painting. Would such a superb version of yourself not later seem a reprimand and judgment on the passing of time? Interesting that the only portrait of Ludovico done by Leonardo was executed in paint on a wall and it flaked off. Just like *The Last Supper*. I believe there is psychology at work here somewhere.

WHICH BRINGS US to the horse. The accepted story is that sometime in the late 1460s, Ludovico's older brother, Galeazzo first conceived of, or borrowed, the notion of honoring their father Francesco as the founder of the Sforza dynasty with a triumphant statue of him astride a monumental horse. Word of this commission spread and reached Florence at about the same time Verrocchio was beginning work on a similar monument for the city of Venice of Bartolomeo Colleoni. It was probably in Verrocchio's shop that Leonardo first heard of Sforza's planned statue, fueling his desire to get out of Florence and find a way to Milan. As Leonardo famously wrote, "He who does not try to surpass his teacher is mediocre."

And yet, the statue Leonardo first offered to make in his introduc-

tory letter was still not commissioned eight years later. Apparently, Leonardo had not been Ludovico's first pick, or even his second, even though he was right there in the castle, raring to go with a hundred ideas, but Ludovico remained uncertain about him for the longest time. Years, in fact.

This is the part of Leonardo that is the most ephemeral and hardest to comprehend hundreds of years later. What aspect of him—his demeanor, his language, personality, dress—caused this hesitancy in others? We see it again and again, and will several times more, but whatever that thing about him was, it left no fossil record. My guess would be an ambiguity, a constant either/or he had that others interpreted as distracted perhaps or not sufficiently committed. Not straight forward enough. The sense one had that things came out of Leonardo from the side, seemingly by accident. Something over which he had no control. Schedules meant nothing to a man like this.

Vasari describes him as a hail-fellow-well-met, always ready with the joke and handshake, but that just doesn't ring true. And of course, Vasari never met Leonardo and what he wrote was equal parts hearsay and nostalgia he got from Francesco Melzi or Paolo Giovio. The Leonardo he depicts was a lot like himself, I suspect.

Eventually Ludovico overcame his doubts and granted the commission to Leonardo, which set off an immense effort on Leonardo's part to further master not only the composition of the rider and horse and plinth upon which to place them, but also everything he needed to know about the art and science of bronze casting—all in addition to figuring out how to scale it up to the immense dimensions Ludovico wanted. The horse itself would be twenty-four feet high, and the rider another ten or more. Casting on such a scale created many problems that even a master caster would have difficulty working out. Before long, the rider of the horse disappeared from his drawings and it was the horse alone he focused on. How Ludovico felt about all this is not known, but he must have agreed: the horse would be enough for now. The rider would have to wait for later.

* * *

TODAY THE GREAT horse is a mythical beast. No trace of it remains, but what the project reveals quite clearly is Leonardo's working method when given full rein and steady funding. To prime the pump he needed to measure and weigh and contemplate every single aspect of a thing, so he started with a survey of local horses he admired, looking for a model, and found several, measuring every inch of each beast. This measuring, of course, is really just another way of looking closely and dwelling. An ocular absorption of the living surface.

Leonardo's method seemed always to start from models, which he'd then enhance and improve over time. The "over time" part was crucial. His imagination was gradual and required multiple cycles but in all things tended to start with the specific, revisited over and over. It was this *dwell time* that produced the variations he worked up.

He lived in a quieter age and liked to grind ideas to a fine dust. Isaac Newton was the same. This continual return to the mental mill was a way of holding off depression and occupying the mind. Leonardo was visual and thought in pictures and might've been synesthetic as well, leaving thousands of drawings and sketches; Newton was an alchemist and mathematician and calculated logarithms out to fifty places, filling his pages with incremental proofs for the even most self-evident principles, taking nothing for granted. This grinding quality I think was as critical to Leonardo's imagination as were the sudden flashes of insight. Boredom was part of the process. For Leonardo, it was time-expensive, but it allowed him to see deeply.

During this time he illustrated Fra Luca Pacioli's polyhedrons and other mathematical shapes, showing his amazing ability to model a thing in space, rotating and viewing it from different sides. Acrobats must think like this. And choreographers, too. And engineers, for sure.

According to Martin Kemp (the big dog of Leonardo studies), beyond geometry and modeling mathematical shapes, Leonardo was especially good at visualizing interior architectural space. He could see volume and shape, and he could *handle it*, so to speak—inhabit

it, walk around in it. Like an engineer or choreographer, he had a ca-
pacity for visualizing movement in space. Same for his understanding
of horses. And for birds as well. Movement in space. Leonardo's gift
in all cases was his ability to "see," and then clarify what he'd seen by
drawing it on paper: seeing it twice, in effect, a two-stage process with
lots of time in between.

Perhaps he made flipbooks? A zoetrope? It seems he was always
searching for ways to animate his drawings. His chalk study of a raring
horse shows this clearly. Animation is an ancient desire. A horse head
on the rock wall at Lascaux shows a similar movement, turning toward
you; a rhinoceros at Chauvet shakes his horn. The Chinese genius
Ding Huan invented a kind of animation machine similar to a zoe-
trope in first-century BC China. Animation of any sort was a miracle
then, and a double miracle if you ran it backward. Both would be first
time experiences for the viewer, a condition we can no longer imagine.

But Leonardo always seemed to work from models. His imagina-
tion was reality-based and preceded, most often, by increments and
iterations. He seemed *very* methodical in his own weird way, given to
what we'd call "obsessive tweaking." In fact, obsession created his fo-
cus, brought him back to the problem over and over. It also exhausted
him. This process of innovation was another of his great personal dis-
coveries and could come only from intense self-observation. In many
things he was his own model, and his own audience.

THE CURSE OF Leonardo's life was his inability *not* to see alternatives
in everything, in knowing that every single thing he saw was just a
version of itself and could be improved. In person, this sense of endless
possibility may well have come across as indifferent, or distracted, as
if his answer to everything was "*meh*" or "*of course.*" Princes and other
leadership types all like the affirmative nod, the strong handshake, the
metallic click of a firm commitment, and Leonardo may not have done
that very well.

Things didn't stay simple with him long, that's for sure. You get him to commit and immediately he starts changing stuff and it was no doubt this endlessly plastic aspect of him that made him seem unsettled and unreliable. In this sense, his imagination remained untamed—not yet the institutional man, but instead a supremely gifted savage who lacked discipline and followed his own nose. If an original plan was too narrow, he ignored it. His search, after all, was for the truth behind a thing, be it a bronze horse or a woman's face or the intestines of a goat. It was not a question of legal contracts, but of truth and being able to express that truth pictorially, even if it took a while. Inspiration seemed very important to him. I think oftentimes he waited for it, looking for ways to trigger it.

Clearly, if the occasional results had not been so remarkable, no one would've put up with him for a minute. Everything about the man was a gamble. You just never knew. I'm not sure he knew either. I think Leonardo's approach was closer to, *"Let's see what happens if I do this ..."* Like musicians who turn every tune into a jam, looking for that next hot thing. Sometimes they find it, most of the time they don't, but they're always noodling, ears open.

What we do know is that after another five years of Leonardo measuring and weighing and consulting with bell makers and thinking his way through reams of paper, Ludovico wrote to Lorenzo in Florence to ask if he had a spare sculptor he might send north. Lorenzo wrote back that all the local talent was busy and he had nothing to offer. He did not add any reassurances concerning Leonardo. Lorenzo had his own history with Leonardo and it did not include personal endorsement or continuing support—i.e., the kind of support Lorenzo gave to Michelangelo, who was as straightforward and obvious as can be. Readable, in other words, if eccentric. By comparison Leonardo must've seemed exhausting and oblique.

That seemed to be the problem: Leonardo wasn't readable in ways that inspired confidence in others who didn't know him well. Those who did know him well, like his father or his uncle, or Verrocchio, or

Zoroastro with him now, didn't have that problem reading him, but others did. His friends knew that everything with Leonardo came in stages and nothing was as it first appeared. He liked to add layers and bend meanings. They knew enough to wait for it.

What is this endless fidgeting we can't see, this eye-shifting cognition that strangers in his life saw differently? If you knew nothing at all about the man and passed him on the street, what would you notice at first glance? Him looking through you like you were not even there?

Leonardo was living in the old castle by now, the Corte Vecchia across the square from the cathedral in the center of town. It had been the Visconti's palace, and then was occupied by Francesco Sforza when he came to power, and after that by his son, Galeazzo Maria Sforza. He eventually moved the court to the Corte dell'Arengo, later renamed Castello Sforzesco, on the north edge of town, leaving Corte Vecchia mostly empty. Except for the rare event held in the old ballroom or the inside courtyard, the castle had remained largely unused, probably because the place was a gloomy pile of old rocks with medieval turrets and a bad pigeon problem, not to mention the moat outside breeding mosquitoes all summer.

Once across the drawbridge and through the courtyard, there were stone hallways and mysterious doors and probably some rigid design that made sense in the 1360s when it was built. I imagine it as an easy place to get lost in, or go exploring. You can bet Leonardo did just that, maybe even mapping it so his crew could find their way around.

For once, though, he had all the space he needed. The old ballroom was his "factory," as he called it, and he had other rooms for his study and lab, and for Zoroastro and any students. This ballroom, which Leonardo used to construct his bronze horse, had been frescoed by Francesco Sforza with heroes and heroines across the ceiling, and probably angels too. Big and damp is my take on it. Still, lots of room. He wrote, "Small rooms concentrate the mind, large

rooms distract it." Sounds like he moved around a lot, even at home, looking for the right environment to find the next thought.

That year he'd get to know Francesco di Giorgio Martini, who was one of the great inventors of the age. Leonardo had a copy of his book, *Trattato di Architettura, Ingegneria e Arte Militare*, and took a trip with him to Pavia to see the Veneranda Fabbrica del Duomo, which had foundation problems. I imagine they talked the whole way. During this time he began a treatise of his own on landscape, and another on hydraulic works, neither one completed. He also put on a theatrical production he called *Masque of the Planets* for the short-lived marriage of Isabella of Aragon and Gian Galeazzo Sforza.

In short, Leonardo stayed busy with the horse and other things, but most of his activity was probably in his head.

1490	Ashikaga Yoshitane becomes shogun of Japan.
1490	Catholic missionaries arrive in the Kingdom of Congo.
1490	Chinese scholar and printer Hua Sui invents bronze movable type printing in China.
1490	Merchants carry coffee from Yemen to Mecca.
1491	A comet comes within 873,784 miles of earth, the closest ever recorded.
1491	The ruler of the Kingdom of Congo is baptized by Portuguese missionaries.
1491	The siege of the city of Granada, the last stronghold of the Moors in Spain, begins.
1491	A great fire burns most of Dresden.

THE MIDDLE IS OFF CENTER

Ages 38–39

IT WAS DURING this period that Leonardo drew his now-famous *Vitruvian Man.* Everyone's seen it, everyone's studied it, but no one just comes out and admits there's something deeply strange about Leonardo's drawing, other than the spare set of arms and legs. What *is* it? What is it supposed to show? The context is not self-evident, not what it pretends to be—and that is a clue. I'm pretty sure it's a spoof. A very clever joke.

A little history first. Marcus Vitruvius Pollio was an architect for Augustus Caesar who wrote a book on design he called *De Architectura, or Ten Books on Architecture.* Probably the first treatise of its kind, it had an enormous influence on subsequent centuries but then finally was lost until it was rediscovered in 1414 by the Florentine humanist Poggio Bracciolini, who found a copy of a copy of a copy in the Abbey of St. Gall in Switzerland. Leon Battista Alberti reformulated Vitruvius' text in 1452, and it was through Alberti's work that the study of architecture based on the Vitruvian concept of man as the model of the world came back into vogue. It was part of the Renaissance attempt to rediscover how the ancients had achieved their beautiful art and marvelous proportions.

In the third "book" of *De Architectura,* Vitruvius expressed an already ancient belief that man was perfect in his proportions and was the model for creating perfection in all else. And Vitruvius' example

of such physical perfection was his own Caesar Augustus, to whom his book was dedicated.

Needless to say, this is a very human notion of perfection and has no support among the rest of the animal kingdom, then or now. That humans see projections of themselves everywhere and find themselves the glory of the universe has less to do with reality and a lot more to do with how enormously prejudiced and limited we are when we look around. We just see versions of ourselves everywhere. But the notion at the time was that humans were extra special, and once Christianity arrived we became the darling of God himself. Our natural perfection and ideal proportions became the model for all else, especially in the design of architecture, and most especially of temples and churches.

According to Martin Kemp, "The premise is that the human body is God's most perfect design, and he designed it with geometry that is functional. It's a reconstruction of nature along first principles, and there is no more divine principle in Christianity than the human body."

True enough for the Christians out there, but for the few agnostics like Leonardo, things looked rather different. And for a very simple reason: Vitruvius was wrong in his assumptions and Leonardo figured this out. Being a first-century AD pagan, Vitruvius' writings are a mix of myth and reality and tradition. This ideal form he saw was not inherent in the stone architecture so much as in the synaptic structure of his very human brain, which he then projected out onto all else. Vitruvius couldn't know that that's what he was doing, of course, but I suspect Leonardo guessed as much. He certainly knew human perception was unreliable, and he thought a lot about this unreliability and how to manipulate it through art. Human beings tend to view things in their own peculiar selfish way, and beauty is a big part of that self-serving distortion.

But beyond neurology there was another problem, of which Bracciolini and Alberti and others were aware—the Vitruvian

manuscript found in the Abbey of St. Gall had no drawings. Vitruvius' description of the ideal man laid out inside a circle or a square was described in words only. If there ever were drawings, they'd been left out over the centuries of copying by monks who could not draw. This created something of a mystery among literal-minded Renaissance thinkers; how to visualize this perfect model of mankind? If you measure a real human body you find that most of Vitruvius' proportions are correct (i.e., in the relative distance between the chin to the mouth, and mouth to the nose, to the eyes, to the forehead), but his proof (that man's proportions are perfect and symmetrical) is not. Vitruvius describes placing a man *on his back* with outstretched arms and legs which, from the navel out, would describe either a circle (the universe), or a square (the earth), because those two forms were perfect, and perfect things must harmonize.

And yet, for years no one could make Vitruvius's idea work, and for various reasons—the main one of which is that the navel is not actually in the middle of the body. Maybe Vitruvius thought it *should* be, but it isn't. In fact, species wide, it moves around; everybody's different. Nor would a man inside a circle fit the same way as a man inside a square.

In short, to draw exactly what Vitruvius described was impossible.

But that's precisely what Leonardo spoofed. No one could make it fit according to the rules, and then along comes Leonardo who not only centers the human figure inside a square (easy enough to do) but also includes a second set of arms so he can use the circle, on top of the square, which he has to draw extra large to make fit—a circle centered not on the navel but further down, closer to the groin where it needs to be to *look right*. Then, of necessity, a second set of legs. Nothing certainly that Vitruvius ever imagined, or intended, I'm sure.

Then, he turned the whole thing on its side so that instead of being a horizontal example as Vitruvius described, Leonardo makes it vertical, introducing gravity and shifting everything downward. Look at the feet, how they swell and flatten beneath him. This guy probably

weighs 160 pounds if he weighs an ounce. Leonardo placed a real person inside an abstract drawing. This is art, not math. The drawing is suddenly very different, and strange all over. What's more, it does none of the things it claims to do.

Vitruvius argued for symmetry and Leonardo answered with asymmetry. The artist as black magician. Creating reality out of illusion. He uses art to make Vitruvius' man fit. It's another flying elephant.

A spoof of a proof.

My guess is that Luca Pacioli was also working on the problem of how to make perfect forms fit together at the same time as Leonardo and, being a mathematician, Pacioli was doing it with numbers. When Leonardo showed him his answer, his perfectly beautiful and seemingly logical answer to all of the Vitruvian difficulties, no doubt Pacioli's very first response was, "*You cheated!*"

And Leonardo's response would've been, "*Did I?*" Pacioli would see it literally, and Leonardo metaphorically. It's a jazzy fix of sorts. It only *seems* to work.

He made it appear so by adding that secret sauce no one else had—beauty. If it is beautiful enough, perfect enough, it becomes extra true. The *Vitruvian Man* and the whole notion of perfection is more religion than science, and I think Leonardo glimpsed that, and adapted the proof to the question. Since the human view is for humans only, beauty persuades. It's a truth of sorts. Leonardo's left hand could make anything look right.

Perhaps such pictorial spoofs or jokes were only for his most sophisticated friends who knew the problems beforehand. Pacioli would get it, Martini would get it, his good friends Andrea and Bramante would get it, but for others it was just a pretty drawing. There are many examples in Leonardo's notebooks of visual humor. I would say his so-called "grotesques" are intended as darkly humorous, as is his monstrous drawing of a vagina, and the sketch *A Cloudburst of Material Possessions*, just to name a few.

What we miss about the *Vitruvian Man* is the social context in which he drew it and Leonardo's absolute deadpan delivery. Leonardo's wrap-around written description of Vitruvius' model man is only a paraphrase of the original text, but it sets the stage for the illustration to be taken realistically. Another of those Leonardo ideas that take a moment to register. I'm sure his friends had to look and think and look again before they would recognize what it was and laugh out loud. Something like a parlor trick, too clever for words.

Followed by one last laugh as they recognized the face and asked him if he might be the model of all humanity. It *was* his face of course. He'd put himself into the drawing. The same jutting lip and wide-set eyes, those cheekbones, that jaw, all that extra-thick curly hair long to his shoulders, perhaps exaggerated out of vanity.

He could only smile and shrug, of course. Gesture somehow with his hands, talking in that pictorial way of his.

There is zero evidence Leonardo ever presented his drawing as a legitimate proof of Vitruvius' model. It seems he drew it for himself and a few friends and otherwise kept it hidden away in a notebook. We see it differently today because we don't have the context, and tend to be besotted with the idea of Leonardo as full-time genius. The truth may be that Leonardo's most famous drawing is basically a fake proof to a false syllogism.

MEANWHILE, FIVE YEARS into the equestrian project, Leonardo was granted a second chance and surely redoubled his efforts. He produced still more fantastic drawings, and his head was no doubt stuffed to the gills with knowledge of casting and forging and all the problems the high water table under Milan created for him. Large-scale casting there was possible only above ground, instead of in a pit as normally would be the case. But casting above ground required an enormous mound of earth to bury the mold in, and this was apparently an ongoing difficulty for Leonardo. He *did* produce a giant

clay model, however, twenty-four feet high, in time for the wedding of
Ludovico's still-alive nephew Gian in 1490. But, no bronze horse.

Apparently, Ludovico had already provided the seventy-two tons
of bronze needed for the casting, but it sat untouched, perhaps in the
courtyard of the Corte Vecchia, waiting for Leonardo. Everyone was
waiting for Leonardo while he sat inside doing who-knows-what.

YEARS SPENT DRAWING and tweaking and designing and mod-
eling and preparing himself in every way suggests quite a bit of
second-guessing and retracing. And maybe it's this endless second-
guessing and retracing that was too evident, what others saw. And
there's apparently no model at all for the figure riding the horse,
Ludovico's father Francesco, the reason for the horse in the first place.

How did he talk about the project to others? Scholars imagine the
mute sage pondering and pulling his beard, but Leonardo might've
been quite vocal about his problems and his "all sides of the issue" dis-
course might've been bewildering. We don't know.

What is fascinating to consider is that Michelangelo also cast a
bronze equestrian statue of Pope Julius II that was about the same
size as Leonardo's in Bologna in 1507, and, knowing about as much
about bronze casting as Leonardo did when he started, got his done
and on the plinth in just over a year. In a sense, this illustrates a greater
point—the sharpest contrast with Leonardo is Michelangelo. Both gi-
gantic talents, they couldn't have been more different: one was tenta-
tive and withdrawn and somehow wounded, endlessly braiding ideas;
the other bold and assertive, knocking chunks off with his chisel.

Michelangelo's talent represented a push into the world, Leo-
nardo's a retreat from it. Michelangelo reflected the world, Leonardo
the self. Michelangelo's talent was out in the sun and fed off approval;
Leonardo's was in the dark, an underground talent, reactive, secretive,
often uncertain of itself, endlessly testing.

Whatever the multitudinous reasons for the delay of the horse (and there were surely more than we know) after ten years of work, he wasn't even half-finished yet. There was no rider for the top. I think Ludovico gave up on him. There were too many other things to worry about.

1492 Christopher Columbus meets King Ferdinand II and Queen Isabella I and gains their support for his voyage to the East Indies.

1492 Jews are expelled from Spain; an estimated 40,000–200,000 leave.

1492 Trsteno Aboretum, the first known arboretum in Europe, is constructed near Dubrovnik, Croatia.

1493 Columbus leaves Cádiz on his second voyage.

1493 Tupac Inca Yupanqui, the Inca ruler of Tahuantinsuyu, dies.

1494 Aldus Manutius prints Pietro Bembo's *De Aetna* in Venice; it is the first book to include the semicolon.

1494 The double-entry bookkeeping system is codified by Luca Pacioli.

1494 Spain and Portugal sign the Treaty of Tordesillas, thus dividing the New World.

1494 Columbus experiences a tropical cyclone and provides the first written European account of one.

1494 The Italian Wars begin.

1495 King's College in Aberdeen, Scotland, the first English-speaking university to teach medicine, is founded.

1495 Friar John Cor records the first known batch of Scotch whisky.

1495 Sculptor Donatello's *Judith and Holofernes* installed at Florence Cathedral.

CHAPTER II

A QUESTION TOO FAR

Ages 40–43

THE AVERAGE LIFESPAN in the Renaissance was forty years, and in 1492, Leonardo turned forty. And, like everyone else at the time, he looked it. He had already lost several of his teeth and much of his hair on top. Back then, most adults by that age had lost teeth, and hair is a matter of family and luck. Ser Piero's head probably reflected the morning sun as well.

But then, Leonardo doesn't know that forty is the average lifespan as there were no actuaries and insurance companies around to tell him, but he's a great observer, and as often as not, he's one of the older people in the room now. He was the same age as Ludovico, and Ludovico was always stressed about something and wearing down daily. Lorenzo de Medici, back in Florence, was reputed not to be doing too well, either. Life was hard, even for the wealthy. Trauma that would send a modern person into intensive therapy was considered a near-miss and a lesson learned. People lived hard back then, everybody was falling apart. Not even a prince could imagine living forever, and Leonardo had no illusions on his own count.

While Vasari and others since have portrayed an omnipotent Leonardo noticed by everybody in the room, the reality was that Leonardo was still at this point in his life an obscure artisan working backstage at the palace, rather closer to the end of his career than the beginning, at least in his own mind. And among those who did know him, he was

an acquired taste, I suspect. The reputation that had followed him from Florence was that of Verrocchio's pupil who had failed to finish several commissions, but who was apparently pretty good on the fiddle. In Milan he had done *Virgin of the Rocks*, which was reputed to be great, but it was in Austria and the subject of a lawsuit. And then *Lady with Ermine*, which hung somewhere else, invisible to the world. There was no art to point at that anyone had seen. People at Ludovico's court would have known him, or known of him, and those in the local art community perhaps as a producer of pageants, banners, costumes, and other ephemera. Eventually, there would be the large clay model of the Duke's horse, but it was the horse that was celebrated, not Leonardo. The importance of attributing works of art to specific artists was an idea being born during Leonardo's lifetime and one he would benefit from later in life, but at this point he was still, as far as anyone knew or cared, a ducal engineer fulfilling a commission. It was really all about Ludovico, not Leonardo.

Genuine fame was not his in any way that I can see, nor did he seem to be lusting after it. Quite the opposite. As much as anything, he seemed to be studying and doing research and lying low. Research not for a project so much as just to know and find out. Study for its own sake. Biographers who insist Leonardo's research was always purposeful and in preparation of some treatise or painting miss the point. If to know something you must first have a reason to know it, then your body of knowledge will remain small and limited by your own imagination and predictable needs. It is an institutional approach and shows planning, and likely represents institutional thinking about Leonardo as well. But if, however, you're one of those worthless flakes who study simply to know and be surprised and connect the dots, then the stimulation is endless, as are the ideas. Like any true explorer, Leonardo didn't have a map or a plan of action. He was improvising, finding his own way. A riff-style, lifestyle.

At this point he owned thirty-seven books, both manuscript and printed copies, on a variety of subjects, and leaves an inventory of the

titles. You can feel him growing. And time was precious. He could always stumble on a rock and fall on that left hand. Even a broken finger could render him useless. Life in Renaissance Italy was eggshell thin for Leonardo, an on-going act of improvisation and last minute rescue. It is only the hindsight of historians that has rendered him one of the great talents of Europe, striding purposefully forward, tossing off brilliance left and right . . . when at the time not a dozen people might've considered the nature of his talent at all, and they didn't know for sure. How could they? He was a local guy; they were local guys. These large overviews and assessments were impossible at the time and are the result of reading and consensus and, frankly, modern thinking.

There's a general agreement that Leonardo may have attempted the first of his experiments in mechanical flight during this period and sent some kind of machine off the roof of the Corte Vecchia and into the courtyard. In his notebook are entries from the early 1480s on flight and in 1486 his notes show an awareness of the different air pressures above and beneath a bird's wing—all of which has prompted much speculation as to whether or not he pushed a craft of some sort off the roof. If he did it was probably only the pigeons that saw it. There's no evidence of the result, broken bones or otherwise. He was perhaps later aware of the Italian engineer Giovan Battista Danti, who crashed onto a church roof in 1503.

So, this Leonardo—the constantly searching endless tinkerer—is the Leonardo who is probably the strangest to us. This Leonardo is all quirks and little art, but shows great potential—at age forty. This Leonardo might be known by those who encountered him on the street as an artisan with court connections, like his friends the Predis brothers. Or people simply knew him as the fellow who wore a lot of pink and purple, unusual in and of itself. Or, most likely, if Leonardo was really noticed at all by the average person in Milan at the time, it would've been for writing left-handed.

Lefties were quite rare, in part because children were normally

corrected early in life and forced to use their right hand, and because the left hand was considered dirty. It was also common knowledge and widely agreed that the Devil was left-handed. Judas as well. In many parts of Europe, left-handed priests were not allowed to baptize a newborn child. Why invite trouble? All of which created a situation where any remaining lefties stood out, especially when writing. Raffaello da Montelupo, a left-handed sculptor and architect, said that "many were astonished" when they saw him write with his left hand. Once, when he signed a legal document, the dumbfounded notary summoned ten colleagues to witness the amazing performance.

To witness Leonardo writing, not only left-handed but backward as well, must've seemed utterly alien to people. You might be excused for thinking this guy had been dropped on his head. What were those little puzzles he was leaving behind? What language was that? Turkish?

Such a person writing in public today would *still* draw a crowd.

I WONDER IF, as Leonardo turned forty and "success" continued to elude him, he expected to fail and feared it—or whether, deep down, he cared at all. Did he even think of his artistic career as a failure, or was he too preoccupied with other things? He certainly wrote about acquiring fame, quoting Dante: "He who uses up his life without achieving fame leaves no more vestige of himself on earth than smoke in the air or foam upon the water." But fame was something different then. A great work of ancient sculpture might be unearthed, an obvious masterpiece and yet the artist is not known. No doubt a celebrated work during its own time, what to make of such "fame" when it comes out of the dirt centuries later, mysterious and great? Fame gained, fame lost, fame gained again? I don't think Leonardo trusted it. Too much like the wind.

This was also a word-of-mouth culture. They read and wrote of course (some of them) but fame as most people knew it only existed as

talk on the street and in the salons. Fame during Leonardo's lifetime meant being known either by your work, or by your reputation, or hopefully by both. Leonardo at this point was still mostly reputation, and that was for his pageants, if he was known at all. The Duke's Ingenio. Or, one of them, at least.

DURING THIS TIME he was busy studying and improvising, and any improviser knows you must come up with ten ideas to find the one you can use. Leonardo was accustomed to ginning possibilities only to discard most of them in the end. The real "factory" was inside his head. Maybe Zoro was the person he bounced ideas off. We imagine a silent, contemplative Leonardo, but he might've yelled at people all day. In fact, you might not want to be around when he was doing his "experiments." There was a lot of struggle under the surface. After all, he was making this happen; life didn't drag him along, he had to keep pushing. And he was not a pusher by nature.

How fatalistic was he about the death and chaos around him? He was certainly neck-deep in it. If he expected to fail, to be consumed by time and history as all things were, then his attitude toward fame was more ambivalent and shaded as well. If only part of him wanted recognition, while at the same time all he really expected was annihilation, then the picture is considerably darker than it is usually told. It also makes Leonardo seem the only realist in the room for seeing the vanity of striving for fame in a world that is ultimately indifferent to our desires. "Fame," he wrote in his notebook, "should be depicted covered with tongues instead of with feathers and in the form of a bird."

But why would he want fame? For validation? I don't think he trusted people or history that much. He was overwhelmed by the ignorant certainty out there, most of it wrong. He worked for reasons other than validation from the crowd. Not to persuade others, but only himself. Like a tree waiting for the ax, he kept budding and

producing fruit, faster and faster, for its own sake. Because he could. Probably expecting most of it to rot on the ground, but that's okay. It was his response to oblivion. He was, after all, one of the oldest guys in the room. Time was short.

IT'S WORTH NOTING that other things happened in 1492 as well.

There was the Spanish Inquisition, and the exile of Spanish and then Portuguese Jews, which should not go unmentioned. The magnitude of those tragedies is beyond reckoning, even today. There's an old Jewish saying, "You kill a man and you kill ten generations." Imagine *those* ripples.

And then that whole Columbus thing. Surely, one of the most talked-about events in Ludovico's court and yet not a word about it survives in Leonardo's notebooks. Columbus was born in Genoa and was about the same age as Leonardo. Chances are they even knew people in common. Like many at the time, Leonardo was doubtlessly affected by the event, at least in small ways. Corn, and syphilis, would soon be talked about everywhere—especially syphilis as it soon appeared in Naples. Columbus's discovery of the supposed passage to Japan and the East Indies had to be the number one subject of the day, and would be for the rest of Leonardo's life, and yet, in his surviving notes, it's never mentioned.

Back in Florence, Lorenzo de Medici died at age forty-three. Death, everywhere, always. Do more, now.

It has been said before that if a Renaissance person was transported to modern times, what he or she would most likely notice first are all the old people hopping around and being lively. And second, that they all still had their teeth. Conversely, were one of us to jump in a time machine back to Milan in 1493, one of the first things we'd notice is how much shorter and older people looked than today. You lose enough teeth and you change your profile, as Leonardo well knew. Sun burns the body, diet ages a person, as does illness and stress.

Nervous disorders appear as skin disease, right along with mold and bacteria and the occasional wart from handling a frog. Leonardo was surely beginning to feel life catch up with him, so he made a change at home.

In July, Gian Giacomo Caprotti da Oreno came to live with him, a ten-year-old street kid he took in and whom he later called Salaì, which means "devil." We know what Salaì looked like because Leonardo used him as a model many times. His *St. John the Baptist* is an example: curly hair, Roman nose, playful look. Salaì would end up staying with him almost to the end and always remained a close companion. How close is anyone's guess. Maybe not sexual at all, but who knows? It was certainly intense. A few years later Leonardo wrote: "Salaì, I want to make peace with you, not war. No more war. I give in." It also appears Salaì was a petty thief.

Leonardo's private life is a mystery to us. All the evidence points to a solitary man with many acquaintances, but few friends. It's hard to say how "knowable" he was. Did he meet your gaze, or look away? Stand close, or at arm's length? Did he whisper or speak loudly? It was an age when you were rarely alone, so solitude meant something different than it does to us now. The sense of Leonardo is of a man who grew up alone roaming those hills as a boy, and was forever aware of the presence of others for the rest of his life. He wrote, "While you are alone you are completely yourself; and if you are accompanied by even one other person you are but half yourself." This is the interior view of a man who valued his ability to focus and maintain control, and who was well aware of what it cost him to make small talk instead. It suggests a serious person to me and I think he was careful of his time and who he spent it with. The advice he gives to young painters describes himself: "Quit your home in town, to leave your family and friends, and go over the mountains and valleys and expose yourself to the fierce heat of the sun." Leonardo made it seem solitude and distance from family and relatives were prerequisites for creative work as a painter. He went even further in a letter to his brother Domenico

upon the birth of his new son, wondering why "you are so pleased about having created a deadly enemy, who with all his heart desires liberty, which he will only get with your death." The man who wrote this was obviously carrying some kind of father wound, and it suggests in every way possible a bad relationship with Ser Piero.

Leonardo was not a family man, but he kept a substitute family around him. There were Salaì and Zoro and a few students almost always living with him in Milan. How much of this cohabitation was sexual is a modern tabloid question and difficult to answer. The atmospherics around his remarks and the few bits of evidence we have suggest Leonardo was probably active sexually as a teenager and young adult, certainly up to the time he left Florence and probably up to when Salaì moved in with him. But the older he got, the less sexual energy seemed to enter the mix. In fact, he seems to lose interest entirely. "The act of coupling and the members engaged in it are so ugly that were it not for the faces and adornments of the actors and impulses sustained," he wrote, "the human race would die out."

Whether or not that was his opinion seven days a week, we don't know, but the sense is that from about his mid-forties on, he was rather asexual, perhaps becaues of a hernia—which some say you can see in the pubic hairs of his *Vitruvian Man*. Freud's famous take on Leonardo is that all his sexual energy was sublimated into intellectual energy and that drove his relentless curiosity, so maybe a hernia was behind that famously remote demeanor.

The other individuals identified in his notebooks all seem accomplished and intelligent men. It was an age that prized cleverness, but how close he was to anyone outside his little group is another question. I think Leonardo was a great friend—if you were one of a handful of people—but otherwise wary and suspicious of others, probably because others were wary and suspicious of him. And as time passed, he became even more so, as did they.

There is an entry the following year in one of Leonardo's notebooks about a woman named Caterina coming to live with him. Some

scholars doubt that this Caterina was his mother, but, given that this woman was elderly and died a year or so after her arrival, and given that he paid for her funeral, she looks pretty motherly to me. What is much more interesting is why Caterina, who had several children in Vinci, came so far north to spend her last years with Leonardo. Because she missed him? Because they'd been close before? It was a long, hard trip to Milan, not easy for an old woman. Perhaps this closing act speaks to their early relationship and the important influence she had on his life. Caterina was about sixty-eight years old. Leonardo, who measured everything, was measuring himself. His frame of reference was continuously getting fine tuned.

That same year, he showed his great clay model of the horse to general applause. It was all he had to show. The horse was wonderful and huge, but it was clay, and missing its rider. Ludovico, happy for any progress, was nonetheless left waiting.

THE BEGINNING OF 1494 was also the beginning of the Italian Wars, which would eventually change everything in Leonardo's life. He was forty-two years old and preparing to cast his giant bronze horse any day now. He'd been working on the project for eleven years and Ludovico, no doubt, was breathing hard on him to get it done. His mother was ill and living with him and Salaì and Zoro and two, perhaps three other students. Money was tight and Leonardo worked on pageants and decoration for the castle as well. Probably paid by the job.

Sometimes he'd get a bat in the ballroom where he was constructing his horse and first flying machine. Sometimes two or three bats. I imagine he ignored them. He liked bats. He liked all flying things. There was probably a dog and a cat there too, to keep the rats down. And a chicken, maybe, for the eggs. Life in a medieval castle wasn't all red cushions and roaring fires. During the summer it was muggy and hot inside, not to mention dark and airless, and during the winter,

muggy and cold and airless. Still, it was better than most places in town, and centrally located.

Charles VIII of France had temporally allied with Ludovico to avoid fighting him, and had marched his army of sixty thousand south, bypassing Milan to occupy Naples, where he had some kind of ducal claim. But the occupation, and therefore the alliance, was soon to weaken and fail as the French troops began dying of plague. Their retreat back up the peninsula, however, would spread not only the plague, but the newly arrived bacteria that the French called the "Fiorentino disease," and which the Florentines dubbed "the French disease." Whatever you called it, occupied Naples was rife with it too. A bad time to be moving an army around.

South of Milan in Florence, Piero de Medici was removed from power and the Dominican maniac Girolamo Savonarola took over, leading the city into chaos and the destruction of its art. Pisa broke away and became independent. Luca Pacioli, the mathematician and good friend of Leonardo, published his *Summa de Arithmetica, Geometria, Proportioni et Proportionalita*, which introduced the concept of double-entry bookkeeping. It was a year of change and turmoil around him, but for Leonardo a year of relative peace and work, as far as we know.

Then, in November 1494, all that changed.

Ludovico, frustrated out of his mind and owing a lot of money to his father-in-law, the Duke of Ferrara, Ercole d'Este, decided to repay the debt by sending the seventy-two tons of bronze Leonardo had for the horse to Pavia to be made into cannon instead. No one could argue with the decision, but it killed the horse. Ludovico had given up on the project finally and at last. What this meant to Leonardo can well be imagined. He'd put eleven years work into it. He was forty-three years old and yet to make his mark in the world, and now his bronze was gone, up the river.

We don't know if he heard it from Ludovico himself, or some clerk sent to tell him, or maybe he discovered it only when the laborers

with signed orders and multiple wagons came to haul it off. I doubt Ludovico was big on protocol with his staff. It was probably a rude experience having it yanked away, and Leonardo's reaction was likely severe and deeply felt, to say the least. Totally pissed is another possibility. I'm guessing he was within days of getting started on his giant horse.

One of the compelling fragments found in his papers suggest he wrote an angry letter to Ludovico that he did not send. Wisely, I'm sure. Perhaps Ludovico had promised to replace the bronze later; we don't know. That same year, Ludovico's nephew, the recently married Gian Galeazzo Sforza, died mysteriously at the age of twenty-five. Poisoned, the court physician said. What Ludovico wants, Ludovico gets, and Gian and his new wife Isabella had started making too much noise, talking about "rights" and such.

It seems highly probable that along in here somewhere Leonardo began to realize he had a dragon by the tail in Ludovico, and couldn't turn loose.

IN 1495, HIS mother Caterina died, although it's not known exactly when. He must've felt at loose ends. They'd had a chance to reconnect, to know each other again, spend time together. Maybe he built her a special padded chair that rolled around and had gears underneath to help her stand up—one with a built-in tray and cup holder. He certainly showed her his twenty-four-foot-tall clay model of the horse, and surely he wanted her to see the bronze statue finished and on its pedestal. What she thought of all this is anyone's guess. Was momma proud of Leonardo? I'd say so. A mother's death is a watershed event in anyone's life, and must've been especially so for Leonardo that year. His losses were stacking up.

During the summer it appears Leonardo got his first chance as a military engineer. The city of Novara, thirty miles to the west of Milan, had been taken over by the retreating, plague-riddled French

army which Ludovico, having torn up his temporary treaty with them, decided to attack. He had them trapped behind city walls and probably expected to extract a huge bounty for their release. And because the French had not anticipated making such a retreat, they had not provisioned for it and were short on food. An heir to the French throne, Louis Duc d'Orléans, was part of the contingent trapped in Novara, and the situation was critical. Summer turned to autumn and still, the French refused to surrender to Ludovico's severe terms and high ransom.

What decided the stand-off in Ludovico's favor was not the plague, but the rerouting of the river that flowed through Novara and had kept the citizens at least alive up until then. Somehow, someway, *someone* on Ludovico's staff, with the help of Venetian troops, rerouted the river to flow away from the town, but no evidence identifies this engineer. But as a result of this rerouting, people inside the city walls started dying like flies. After more than two thousand people in Novara had died, the siege finally ended when the French negotiated terms with Ludovico. The survivors of Novara were described by a French ambassador as, "so lean and meager that they looked more like dead than living; and truly, I believe never men endured more misery." Add to the dead those who survived the starvation only to die on the road back to France, too weak to walk, and the total grows quickly. Who knows—three thousand? More? It was a disaster for the French and the French court, and Louis came away from it vowing revenge on Ludovico if it took an eternity.

There's no direct evidence, but Ludovico did have an engineer on staff who had claimed in his letter of introduction thirteen years earlier to do this very thing: "When a siege is under way I know how to remove water from the trenches." Was it Leonardo who engineered the river diversion? Had Ludovico finally taken him up on the offer? If so, its success might explain commissions he received in later years to reroute the Arno around Pisa and drain the swamps around Florence and Piombino.

Whether or not this accomplishment was listed on his resume later, the piles of corpses must've impressed Leonardo. Two thousand bodies is a good-sized heap, and would likely require burning, which makes for lots of oily smoke. Starvation is an awful death, too, and affects both young and old alike, there would be children tossed on the pile. As far as is known, this is Leonardo's first time in battle—his first time to see it and smell it. The carnage was everywhere in the city, along with the crows and the rats and the ants. What did it mean to him? What did he see, and what did he think about while looking?

IN THIS YEAR of death and destruction and wholesale slaughter, Ludovico was, reasonably enough, building his own tomb. He'd chosen the Dominican convent and church Santa Maria delle Grazie for this honor and began refurbishing it, first with a new choir, designed by Bramante, and then by commissioning Leonardo to do a large wall painting of Christ's final supper for the north end of the refectory where the monks ate. This was a huge commission for Leonardo— and also a huge problem, as he soon came to realize. The wall could be a bit damp at times.

Despite that, my guess is that Leonardo was already composing, eager to start something new, using the war, the slaughter, all of that is in his head. Or, more specifically, he's reacting, and that reaction is getting channeled into deep felt composition. Earlier sketches show this was not the first time he had thought about the subject of the Last Supper, it was a popular theme, but he's thinking about it all over again. He loved composing. As a close self-observer, by the age of forty-three Leonardo would know his own methods and ways of growing an idea, and he used this notion of opposites to stimulate himself. Death is a great sparker of ideas. He probably had a skull on his desk.

Maybe life and death had always been the two poles that animated his work, and the stimulation was just particularly high that year.

He'd lost his giant horse, then his mother, and then had a direct hand in causing the deaths of several thousand others. Maybe his response to all that death was a stronger sense of his own beating heart. Maybe the more rotting bodies he saw, the more he insisted on the beauty in his head, as if to balance and block the other things out. Was he trying to justify himself? And if so, at what eventual cost?

He worked from opposing internal forces and, in 1495, there was plenty of fuel to be ricocheting back and forth toward something. In one sense, this wall painting of the Last Supper he was planning was a form of therapy for him, a way of fighting against death. It also seems, in retrospect, an act of self-sabotage perhaps, his sense of annihilation and guilt heightened after the siege of the last few months and his part in it. It's as if he's sketching with a poisoned pen, conflict pushing him toward resolution. His art becoming a dance with death. Not posthumous death but actual death piled right outside his door, death in his nostrils while he sketched. That's what he was turning into art. That's what he was reacting to. That sort of composition has nothing to do with the rules of beauty; it's about survival. Right here, as he's first beginning to plan *The Last Supper*, Leonardo is on the cusp of his second life, the life he's known for today. He's about to enter the public arena and become the Leonardo of legend.

1496 Henry VII of England issues patent to John Cabot, authorizing him to discover unknown lands.

1496 Bartholomew Columbus, brother of Christopher, establishes Santo Domingo, the oldest city in the New World.

1496 Leonardo paints *La Belle Ferronnière*.

1497 Girolamo Savonarola's followers burn thousands of "immoral" objects at the Bonfire of the Vanities in Florence.

1497 Pope Alexander VI excommunicates Savonarola, then tortures and executes him.

1497 Jewish diaspora continues as King Manuel I of Portugal demands Jews convert to Christianity or leave the country.

CHAPTER 12

SHADOW BOXING THE SELF

Ages 44–45

ANOTHER OF THE internal divisions within Leonardo—one of many—was between the practical and the impractical, something he spent his life trying to reconcile. He was the impractical man making the argument for his own usefulness. One of the oldest arguments of his life, it probably started with his father. Drawing, which he valued greatly and needed to live, was treated by most country people as pure vanity, a marginal skill at best, not practical. This surely made drawing a guilt-ridden subject for him and perhaps explains his contrarian arguments later, especially about the superiority of painting to sculpture. This is Leonardo rationalizing himself, something he'd done before.

Despite such divisions (or maybe because of them), Leonardo's imagination seemed stimulated and united by opposites: age/youth, rocks/flesh, pleasure/pain, virtue/envy. For such a liminal personality, the essential creative act for him was of synthesis, or the oneness of all, as opposed to the merely surprising or bizarre. For him, it was all about finding connections. This tendency to synthesize and integrate can be seen not only in his machine drawings—which are based on existing technology, yet combine the functions of two machines into one, automating them—but this desire to integrate may be visible in some of his paintings as well. Consider the unisex *St. John the Baptist*, or in the bestiality of *Leda and the Swan*. It seems to be the

general direction of his thinking at the time, and perhaps gives us a look through his eyes. He was a problem solver at bottom and believed if he tried hard enough, he could always find the ideal solution.

THIS PARTICULAR PROBLEM-SOLVING task probably started the afternoon Leonardo walked over to the Santa Maria delle Grazie and then stood looking at the wall Ludovico had chosen. It was stucco, and the lighting wasn't great, and the kitchen was on the other side, which only increased the dampness. The longer he stood there and thought about it, the more problems he found, and the more problems he found, the more it all crystallized into a single large dilemma—he didn't want to do the painting on this wall. But he also knew he couldn't refuse.

One side of the problem was clearly his continued survival at court. Ludovico wanted a wall painting done, and Leonardo couldn't say no, although he probably tried.

The other critical, not-to-be-ignored requirement was that the painting adhere to its surface, and for this reason wall painting was almost always done in fresco. But fresco allowed for none of the oil techniques Leonardo relied on to achieve his effects. (It was "not my art," as he wrote in another letter to Ludovico, also wisely torn up.)

How, then, to reconcile these two irreconcilable demands? He could not do his best work in fresco, but knew that any other painting technique might not last very long. He was given an assignment he could not fulfill, at least not to his own satisfaction. He must have felt totally helpless and exposed and frustrated. The dragon was whipping its tail again and Leonardo was hanging on, trying to improvise, not knowing what to do. His choices were few.

One possibility would simply be to give in and paint it using conventional fresco technique. He wasn't comfortable with that, but he certainly knew how to do it. The problem with fresco was that he couldn't tear it up or paint over it. Leonardo's genius was in his second

thought, and in his thirty-second thought, not necessarily in his very first thought, as was necessary for fresco. His method was improvisational, by which I mean evolutionary and reactionary and growing by the smallest of bits and pieces, a technique that simply required multiple layers to work—and fresco was only one layer deep.

Another possibility would be to paint it like any other painting, but on a fifteen-by-twenty-nine-foot surface of wood or canvas, and hang that on the wall—allowing him to work in his studio. The transcript of any discussion with Ludovico on this is lost, but I suspect when Leonardo mentioned that fresco was "not my art," but that he could satisfy His Excellency on wood or canvas, Ludovico instantly feared it being stolen and hauled away and insisted it be painted *on the wall*. In this sense the obvious fault for the rapid deterioration of the painting in the years immediately following was Ludovico's simply because he didn't listen and picked the wrong painter for the job.

On the other hand, he was right about it not being stolen.

In any case, it didn't pay to argue with a man who had the stink of two thousand corpses on his hands while he was in the middle of building his own tomb and contemplating perdition. Talk about bad timing.

"JUST PAINT THE *damn wall!*"

Leonardo knew that he, not Ludovico, would be blamed for any failure, yet he had no choice but to paint it and see what happened. The basic physics of the thing were against him. It was a damp wall. The whole room was damp. That problem now became his task: he had to figure out how to do the mural and not make a mess of things. From the beginning, it seemed an ill omen. So he began messing with his paint, experimenting, laying down layers of undercoating in an attempt to seal the stucco.

What seems most Leonardo-esque in all this is the clear sense that he knew it might fail, he didn't expect it to last, and yet he poured

himself into it anyway, as if the risk to the painting freed him to do his best work. As if it involved less responsibility somehow.

After eleven years of effort and the loss of the commission for the horse, how else does he put himself into anything new? What can he trust? Who? Everything becomes a temporary project eventually. Life is a temporary project. Fortune is fickle. As Leonardo famously said, "When fortune comes, seize her firmly by the forelock, for, I tell you, she is bald at the back." He's not just talking about opportunity, but about enthusiasm itself, a gift of fortune, for it too fades away.

Leonardo seems mysterious to us in part because of his self-canceling, passive/aggressive nature that repeatedly makes beautiful things that disappear when the lights go off. His spectacles and pageants, the mechanical problems he solved that no one had asked for, the paintings not of the famous but of the obscure, the anatomies he sniffed and coughed his way through but didn't publish, and all those notes on fragile paper. He wrote about fame, not just for his students, but because it was his greatest fear. He feared having it and he feared not having it. He held steady between the two. Resolute indecision. It was as if he knew, as did Shakespeare a hundred years later, that it all really is just vanity. Everything passes away. Shakespeare didn't publish his plays, either. Modern Americans slap their heads in astonishment at this notion, but for a fatalist like Leonardo, who was always experimenting with mediums (some that worked, some that didn't), an existentialist painting, one that recognizes its own doom, doesn't seem impossible.

I think that was his fallback position if it turned out he was wrong about the paint he was messing with.

Legacy, fame, reputation—these things make you cautious. It seems clear to me that Leonardo was after something else. His view of the world is, like so much else about him, oblique to us, but it obviously made sense to him. After all, he was a deliberate and thoughtful person. He was not just experimenting with different kinds of paint, but with his life, his reputation, and most especially, his relationship

with Ludovico. From a reasonable point of view (i.e., just about every writer who's written on Leonardo) he wouldn't do anything to jeopardize the painting.

THE CASE IS made by Ross King in his excellent *Leonardo and The Last Supper*, that Leonardo had many reasons for believing his experiments with oil paint on a wall would succeed. Alberti had suggested the practice in his book, *On the Art of Building*, and Leonardo knew of at least two examples of oil paintings on walls in Florence, one by Veneziano in the chapel of Santa Maria Nuova, and another by Uccello and Papi in San Miniato al Monte.

And in fact it may have worked reasonably well if he'd actually used conventional oil paint for the job, but, Leonardo being Leonardo, he had to customize things. In the case of *The Last Supper*, Leonardo added oil to egg-based tempera paint, to create what he called "oil tempera." It did not work.

Was this an honest mistake, or his intent? Stand on that cliff a minute. Look at it from his point of view. You're going to jump and the chute might not open. Do you mess with the chute? Try something new and untested? Some last-minute improvisation? What was his thinking here? The painting would take years to execute. By the time he knew if the paint worked, or not, it would be too late. He was aware of all this ahead of time. Did he shrug and then jump anyway?

His notebooks don't support any reading of his intent. What was in his mind and heart, we don't know. For all we know, it might've been pure willfulness. Even payback for the horse deal. He knew better than to paint on a damp stucco wall; Alberti had insisted on a dry wall for oil paint, but he did it anyway and the paint flaked off, just as he had probably feared. Those are the facts. We don't know much else but that Ludovico was behind it, making it happen, and he was a dolt.

IN 1496, LEONARDO produced another of his "see it and it's gone" extravaganzas, this on the subject of Jupiter and Danae, for which we have only sketches of the costumes. Apparently it was a great success and set tongues to clacking. Just prior to this, his mathematician friend Luca Pacioli had published *On the Divine Proportion*, and Leonardo illustrated it for him. They'd become good friends and the elder Pacioli had Leonardo fascinated with math, especially the math of perspective, which he begins to apply to *The Last Supper.*

But something else was up with Leonardo, something that belies the notion of him as a cool and calm character. In a palace document is found this note written by the duke's secretary on June 8, 1496, "The painter who is working on the camerini today caused a certain scandal, after which he left." We don't know what that "certain scandal" was, but it sounds unexpected and disturbing and resulted in Leonardo leaving the room, perhaps to keep from making things worse. Or was it a fight and he stormed out? The incident prompted Ludovico to inquire about replacing him with the artist Perugino, so it was no minor deal—and marked the second time, after the horse, Ludovico wanted to get rid of him. The cause of this blowout is not known, but Serge Bramly believes it is related to money and Leonardo going months without pay. I think it is likely, too, that Leonardo was struggling and frustrated creatively, and at moments just mad as a hornet over some small inconvenience, which speaks to the straining and stressing under the surface.

Add to this the fact that Renaissance Italy was a veritable petri dish of germs, and he could have been about tapped out. Half the population probably had a chest infection or runny nose or runny shit one day to the next. Maybe Leonardo was just sick or out of sorts that day. The duke's secretary might've been a jerk, too, enough to aggravate anyone, even Leonardo in his Buddha mode.

Then the floor fell away and things really went to hell.

Ludovico's daughter Bianca died suddenly in childbirth. Then, two months later, his young wife Beatrice d'Este, pregnant and danc-

ing half the night, miscarried and died as well. This triple blow caused Ludovico, at the age of forty-five, to lose what was left of his mind. He had a possible stroke, shaved his head, began wearing black, and hid in his room all day, coming out only to pray at the family shrine in the Santa Maria delle Grazie. Leonardo may have seen him there. If they talked, it was surely Ludovico urging Leonardo to finish. Time was short. He could feel it.

And he was right.

AT THE SAME time that Leonardo was starting *The Last Supper*, at the other end of the room was another artist named Giovanni Donato da Montorfano who was creating a fresco of a large crucifixion scene on the south wall. Like any two craftsmen, they watched each other. Or, at least Montorfano did. What he made of Leonardo's set-up of oil paints is anybody's guess. When he was busy, of course, Montorfano could pay attention to nothing but the drying plaster in front of him and getting his work done correctly, but early in the day, before work, while preparations were being made, he looked and wondered at what he saw. One can imagine their early conversations. Montorfano had grown up in a family of fresco painters, third generation. More than most, he knew what was going on. He knew about Leonardo's gamble with time.

He also knew Ludovico.

What Montorfano thought of all this we don't know, but after all was said and done, he'd been upstaged in a most remarkable and unexpected way—even if it did fall apart later. While the earlier story of Verrocchio throwing away his brushes after seeing Leonardo paint is surely Vasarian nonsense, in this case we can imagine Montorfano honestly thinking he'd suddenly become old and out of date. Professionally speaking, he'd been out-classed in ways he didn't even know existed in wall art. Most especially in terms of composition and perspective. Mother Mary! Made his own work look crowded, and busy, and *very* flat.

But then, he knew his work would survive, so the comparison in the room was temporary at best. Montorfano lived in Milan until his death in 1503 and naturally would come by on occasion and check on his own painting, so he probably saw the mold starting on Leonardo's. *"Such is life, eh?"* A thought like this might've kept him going at the end, adding months to his existence, living just to watch the little fungi grow and spread.

1497 John Cabot discovers Newfoundland.

1497 Amerigo Vespucci leaves Cádiz for his first voyage to the New World.

1497 Portuguese navigator Vasco da Gama's fleet departs from Lisbon for his expedition to India.

1497 Albrecht Dürer paints *Portrait of Dürer's Father at 70,* and *Self-Portrait at 26.*

1497 Nicolaus Copernicus records his first astronomical observation.

1497 Vasco da Gama reaches the Cape of Good Hope.

1497 John Cabot returns to England and tells King Henry VII of his trip to "Asia."

LEONARDO, EXPLODED VIEW

FLOATING UPWARD THROUGH *a confusion of dream and memory he begins to surface and rolls over on his back, adjusting the pillow behind his head, then slips back into his dream and notices the bird still flying beside him. It is a hawk and a rather large one, ignoring him as the wind fills their ears. He's been dreaming of flying half the night. It is a normal dream for him and he notices the familiar hills near Vinci far below. Something in the motion of the hawk's wings, something at the bottom of the stroke he seemed to see clearly for a moment. He thinks he notices something and it focuses him, starts to wake him up. He knew better than to open his eyes before landing and ending his dream too abruptly. He doesn't want to tumble out of the sky. It would be bad luck. He relaxes and looks again at the hawk's wings, the very tips blurring through the air, and tries to see once again, that little motion at the bottom. He just can't be sure, but it would explain so much. He must land first and make his notes later.*

It is still early, the sun not yet penetrating to the courtyard outside. He knows this without looking, just as he knows the bare wooden rafters above his head and the stone walls surrounding him. He has woken up in this room for over eleven years now and expects the stone floor to be cool beneath his feet—once he rolls out of bed. But not yet. He savors the last seconds of flight, the slow circling back to the ground, the wind around his wings, the hawk beside him matching stroke for stroke, almost a mirror image. He can feel the weight of the air, the resistance as he pushes against it. For him it is as thick as water.

Then it all fades as he nears the ground and before he's even cleared the tree tops he hears a grunt on the other side of the room. It's not the hawk, but Giulio, his apprentice who sleeps on a mat in the corner. The boy would sleep all day if left alone. These dark castle rooms made it all too easy to do. Leonardo rolls his head to the side and begins to blink. He would test his idea later.

Careful not to disturb Salaì sleeping beside him, he sat up and put his feet on the cool floor, drawing the blanket around his shoulders in the early morning air, searching for his sandals with his toes. It was vivid to him still—the hawk's wing at the bottom of its stroke, that instant of quiver and then the return to the top. That quiver was no more than a blur, but he thought he saw a direction to it. He thought it completed a figure-eight, which would mean the force was continuous and not interrupted. Of course. He knew, too, just how he could find out. Why had he not seen this before? The wing joint must rotate!

He bends over and pulls the piss pot out from under his bed and begins dribbling into it. Yes, he knew exactly how to test and see. He would do so today.

He waits, planning his morning. The penis empties the urine sack above and behind it, but the urine sack was a mystery to him. How it separates fluids from the other waste he is unsure. It must be by porous membranes of a sort. He would look for this very thing next time he skinned a dog. Hopefully the pores would not be too small to see, as his eyes were not as good as before. Perhaps, if he were to fill . . .

"Maestro?" Giulio sits up on his pallet and rubs his eyes. The boy was a total blank first thing in the morning and has to be told what to do. Leonardo smiles at him, still dribbling. "After you empty the pots, help Salaì with the fire. It is damp and the wood will be moist." He finishes, looks behind him at the still sleeping Salaì, finds his other sandal, and stands, careful not to bump the half-full clay pot. "Remind him about the costumes later," he says, and walks out of the room and into his retreat next door.

Having only a small window he lights two candles and arranges his

mirrors, then pulls his large notebook toward him. He saw a design while falling asleep last night and needed to catch it on paper. It was a border design and one he could use almost immediately. Sell it to a rug weaver, perhaps. Mornings were the best time to remember and think. His mind seemed clearer and more vivid early in the day before eating or talking too much with others, when his own voice was still the loudest in his head.

Several moments later, Zoro comes to his door, looking like he'd been attacked by the wind, his hair and beard pointing in several directions at once. He, too, had just gotten out of bed. "Your boy spilled the pot you sent him to empty. Broke it, too. Want me to kill him?"

" . . . No . . ." Leonardo shook his head slowly, distracted. "Just help him clean up. You and I have an errand later. Find our small cage, please. The one for birds. We are going to market. I want a pigeon with white wing tips. Then we will find a large shadow . . . but never mind. Help Giulio. I must finish here first."

1498 Vasco da Gama sails around Africa, discovering a maritime route to India.

1498 Niccolò Machiavelli is elected as second chancellor of the Republic of Florence.

1498 King Charles VIII of France dies (b. 1470).

1499 Leonardo finishes *Sala delle Asse*.

1499 Leonardo designs the *viola organista*, a piano/viola mix.

1499 The First Battle of Lepanto is fought; the Ottoman navy wins a decisive victory over the Venetians.

1499 Polydore Vergil completes *De Inventoribus Rerum*, the first modern history of inventions.

1499 Da Gama returns to Lisbon from India and is received by King Manuel I who was standing on the dock waiting.

1499 Michelangelo completes the *Pietà*.

1499 Gaspar and Miguel Corte-Real reach and map Greenland.

ACADEMIA LEONARDI VINCI

Ages 45–47

IT'S DURING THIS time that Leonardo seems to come fully awake. He was hearing praise for his new painting from ordinary people, perhaps several times a day. It was around this period that his little dab of fame began. He was probably feeling pretty good about himself. His notebooks are filled with observations and illustrations on architecture, decoration, geometry, hydraulics, and mechanics, so we know his energy was high. He was reading a lot, too, taking little side-trips where he studied fortifications or rocks or some such, capturing "weird worms in the woods." Then in the evening he attended debates and discussions and storytelling contests at various homes around town, all while putting on pageants and musicals for Ludovico, and, when time allowed, occasionally painting a portrait of the latest girlfriend.

His main focus though was on *The Last Supper*, a picture that continued to evolve. He was looking all over for a perfect Judas, resolving the problem piece by piece. He'd already decided to show Judas left-handed and grabbing his money bag. Now to find the right eyes, the right face. He considered using the face of a pesky prior from the monastery who had given him much grief over his scaffolding being in the way. The face of Jesus was still uncertain as well. The wall took him four years to figure out; Montorfano was done in eighteen months.

All art is channeled energy, be it music, painting, sculpture, or literature. Leonardo's time-consuming methods were a way of gath-

ering and re-gathering energy throughout the project. At best, most people start off with a burst and then dribble away by the end. This must have happened to Leonardo as well early on, but as a close self-observer he learned from it. He learned to leave and come back, to look with different eyes, different moods, different times of the day— all these things allowed him to see better and to better understand. He became a great editor of himself.

Almost from the start Leonardo's *The Last Supper* was a sensation. The unprecedented achievement was clear from early on and people started coming by to study how he got it. Part of the answer, of course, was the art of perspective, but the magic behind that was mathematics and Leonardo had a friend in that corner who had a profound effect on him and changed his thinking. And who probably improved the painting as well.

Luca Pacioli was an itinerate scholar and Franciscan monk who traveled from city to city and had come to Milan at the invitation of Ludovico to raise the general tone of the place. Known to history as "The Father of Accounting and Bookkeeping," Pacioli had already published his best known work, *Summa de Arithmetica*, and was the most famous mathematician in Italy at the time. Probably more than most people Leonardo met in his life, he recognized Luca as a man much like himself.

There were differences, of course. Pacioli was seven years older than Leonardo and looked to carry a little more ballast around the middle, and was nominally religious to boot (being a monk). But they had both started in vernacular abacus school and had survived by their wits as intellectuals and had the same sense of momentum in their life, coupled with a strong love of learning—especially when it came to the study of perspective, Pacioli's specialty. Meeting Pacioli when he did was fortunate for Leonardo and he was able to get the effects of the painting worked out precisely. His own math might not have been as good, nor his understanding as deep without Luca Pacioli's help.

And he had other helpful friends as well, engineers and poets and diplomats who answered his little questions as things occurred to him. *"Ask Benedetto Portinari how they run on the ice in Flanders."* Without a reference library, it was how he learned things. Socially these were probably some of the most engaged years of Leonardo's life. He was clearly well-connected with the city's intellectual and cultural elite.

An evening's entertainment at the time, other than public spectacles or court events, or long walks through dark streets, was mostly what we'd call house parties. So-and-so is having a little soiree on Thursday, bring your lute. These last few years in Milan probably represent the most settled years of his life, and maybe the happiest. Never again would he be in one place long enough to know so many different people so well, let alone people who liked him and understood him.

Pacioli described such an evening in his preface to his fourth book, *De Divina Proportione*, as an "excellent scientific competition" held at the Castello Sforzesco on February 19, 1498, where various creative types were gathered, including architects, engineers, inventors, and even clerics and theologians. That evening, Pacioli wrote, Leonardo "conquered all."

Exactly how Leonardo conquered all Pacioli doesn't tell us, or anything else about such evenings in Milan, but he did mention Leonardo elsewhere in his preface as "the most endowed with all the virtues, Leonardo da Vinci, the Florentine," and then mentioned the "sublime left hand" that drew the various abstract mathematical illustrations for his second book. He sounds like a very good friend.

What I find interesting about these various nights out—one perhaps a debating group, another a musical evening—is what they suggest about Leonardo's notebooks. Scattered within them are various statements or declarations which have been endlessly recycled in biographies as his pronouncement on one thing or another. I've quoted several here already in just such a fashion. What is always assumed in these citations is that Leonardo was writing to himself, and that he was writing some final conclusion which he believes to be true.

It seems to me that many parts of his notebooks suggest not private writing but semi-public writing, something like an open workbook on a side table in the shop. Interestingly, Pacioli recommended just such a work journal for businesses in his book *Summa de Arithmetica*, which Leonardo owned, where he advised keeping track of all transactions and inventory and making to-do lists. Keeping such books was still a new thing for businesses, and such a workbook might've been entirely new for artists' studios as well. Luca Pacioli may well have left his fingerprints here, too.

He also wrote one of the earliest books on games and magic, which he dedicated to Isabella d'Este. You can see why Leonardo liked him.

But the notion of an open workbook in the shop changes how we read the notebooks. Anyone could look into it: Zoro, Salaì, the other students, and (once they understood how he wrote) they'd be able to read him by using a mirror (a shop secret, I suppose), to see what he was working on, what he wanted them to know, even adding remarks of their own. They would have been assigned projects in the shop, at which some would succeed and others might fail, and someone in particular might fail for being much too ambitious. So when Leonardo wrote in the open workbook for all to see, "It is a poor pupil who does not go beyond his master," are we to read it as chastisement to a general kind of artist (as has typically been the case), or as encouragement to one in particular?

Change the audience, change the meaning.

Likewise, I wonder about some other of his remarks which seem summary and categorical and wonder if he wasn't quoting someone else, or, even more likely, sharpening his argument for that night's debate on the same subject. "Because I am not well educated I know certain arrogant people think they can justifiably disparage me as an unlettered man," he wrote at one point. And elsewhere: "Those who merely quote are puffed up by second-hand information; they are trumpeters and reciters of the works of others." A note to the self, a quote, a reminder to use a certain phrase, becomes an admonition

to the world—a very different thing. Even he might not agree with it a week later. One thing about Leonardo was that he was in constant flux and changed his mind often.

Leonardo's notebooks also speak to that vast subterranean world of ideas imagined but not published, not made, not patented, but as surely invented. Ideas come and go continually and most inventions are thought of dozens of times before a prototype is made, and then breaks and is forgotten before another prototype is made twenty years later and eighty miles away that *does* work—but it occurs in a small village and no one knows of it until the item is reinvented for the *hundredth* time, and the prototype works, and there are witnesses who can carry the idea away with them to their hometowns where it will be copied and improved. And somewhere along the way one of those guys will get credit for inventing it and be forever famous for his originality. Leonardo was part of that flow of constantly reinvented ideas. What survives of Leonardo's machine drawings is evidence of this.

His notebooks don't support any notion of psychological simplicity; they served too many other purposes. Some were work logs more than personal journals, although they served that purpose occasionally as well. Other notes seem of the moment, almost as if he was walking past when he turned and scribbled something for later, something he'd been meaning to do, something odd and Leonardo-esque: "Describe the tongue of the woodpecker and the jaw of the crocodile." I think he studied his notebooks, added to them, copied things out, even changed stuff and rewrote it. Cheap paper was only about seventy years old and was roughly contemporary with Leonardo's life. In a technological sense, he was born at the right time to be a doodler. Any sooner and he would've been drawing in a sandbox like Archimedes, or maybe on wax tablets at home. One thing we know for sure: he would've loved sticky notes. A match made in heaven.

Read in this light, the notebooks seem further evidence of a social life and intellectual engagement otherwise invisible to us. We get a sense of his personality and how he would prepare himself before

going out into the social whirl of Milan and the court of Sforza, a rarified social whirl that existed only as a microcosm of life inside the much larger city walls of Milan.

Outside the walls was another matter entirely.

EVENTS WERE CLOSING in around them but it's not clear if anyone fully realized this yet. Ludovico had personally set the clock ticking with the siege at Novara and was now within sixteen months of a major lifestyle change. Louis Duc d'Orléans, the French heir terrorized in Novara just three years before, had become King Louis XII of France and was now in possession of a very large and well-provisioned army.

What's more, there were a couple of things Louis wanted to do with that large army: one, reassert his ancestral claim on the duchy of Milan, and two, get his hands on Ludovico.

Around this time, Leonardo puts the final last detail in the final last place and the scaffolding finally comes down, revealing *The Last Supper* in all its glory. The painting instantly eclipsed the clay horse and everything else Leonardo had done, and became the single work for which he was known the rest of his life. And it was a favorite not just with the public, but with the monks who had it for a dinner companion each night. They loved it. Before long, it became a work of God and Leonardo was merely the conduit, the "sublime left hand." He no doubt heard this kind of talk. It didn't surprise him; it's the kind of thing artists heard back then. Most people he knew thought that way.

Along in here too he found time to paint another girlfriend portrait for Ludovico, this one of Lucrezia Crivelli, known as the *La Belle Ferronière*, another brilliant example of his skill with complicated clothing and mysterious looks. It's not, however, an arresting portrait and, as Leonardo's portraits go, it's actually rather sedate. One rather wishes for a wind-swept crag or a few cracked mountains behind her, maybe the earth splitting open, and that absence reminds us of the

power of Leonardo's backgrounds. The background here is black and as a result, there is no contrast or back lighting and seems almost half-finished compared to *Mona Lisa*, where the background comes to the fore, so to speak. With *La Belle Ferronière*, given other events occurring in the area during those last few months, he may have just run out of time.

Instead, he's steadily scribbling in his notebooks about various military devices or fortifications. Clearly Ludovico was looking over the city walls by now and not liking what he saw, and talked to Leonardo and the other engineers about it. In March, Leonardo traveled to the port of Genoa with Ludovico and took notes on the ruined wharf there. By late April, Leonardo promised (again!) to finish the *Sala delle Asse* by September. The reasons for the delay we do not know, but he'd only been working on it since the first of the year. The *Sala delle Asse* is a room in a downstairs corner of the Castello Sforesco's private quarters that Leonardo was painting to look like the middle of a forest, a bower. This does not sound like Leonardo's idea. What he did with it, though, is interesting. We know only what survives of the painted forest, which was uncovered in 1893, mostly the tops of several trees along one end of the room, and some roots and stones shown underground. And it's all done in tempera. Go figure. Maybe he'd learned his lesson. Or maybe not.

In October of that year, he was given a small vineyard by Ludovico between the monasteries of San Vittore and Delle Grazie, outside of town on the Porta Vercellina side. Whether this was a bonus on top of his pay, or in lieu of his pay (much more likely), Leonardo came into possession of a rectangular piece of land, perhaps with a small house on it. It's hard to say if he was happy with it, or accepted it reluctantly, but soon enough was thinking of ways to improve it. He couldn't help himself.

The only other good news was that down in Florence, the Dominican Friar Savonarola had been burned at the stake, condemned as a heretic by the Roman Inquisition. In fact, once he was thoroughly

cooked they got his bones and burned them again, and then crushed them to dust and threw the dust in the Arno river—and even then certain rabid followers jumped into the water to retrieve and swallow what relics they could. Botticelli was one of these rabid followers, but there's no evidence he jumped in the river after bone dust.

BACK IN MILAN, safe and secure for the time being, Leonardo was dreaming again of his horse. Perhaps Ludovico has promised more bronze. We don't know, but Leonardo hadn't turned the idea loose yet. Maybe another opportunity would come along. Maybe he could sell the idea to someone else, a ready-to-go equestrian statue "out of the box." Or maybe he just couldn't let it go. He'd invested himself and couldn't stop thinking of one tweak or another that the horse would need. It was still alive in his head, long after it was officially dead and gone up the river. Goes to show his imagination did not work to the job order.

Leonardo was a passion artist in that sense, the pleasure being in his continual refinement and redesign of projects he knew well—whether there was bronze for it or not. The more intricate the project, the more exquisite the small solutions to one difficulty or another. Perhaps he just found it impossible to stop. He loved his giant horse. It would've been the biggest in the world.

By March and April 1499, change was in the air. If you were living in Milan you'd have to be in a coma not to know the French army was amassing on the border and preparing to invade. Their new king, the aforementioned Louis XII, had claimed the duchy for his own and was expected to arrive in the city sometime in late summer. People were not sorry to see Ludovico go. He was a gouge and a thug, and he'd raised the taxes so many times he'd lost any popular support he'd ever had, and he knew it. His seems a personality that pushed and pushed and pushed until something broke; he didn't have a reverse gear. In response to this growing crisis, Ludovico threw more festivals

and feasts and did what he could to rally public support, but nothing worked. Leonardo, finger in the wind, began making preparations to leave. We have no idea what his last meeting with Ludovico was like, or even if there was a last meeting at all. Ludovico might have been too busy to say goodbye to his staff, or do much else except pack up and run.

Leonardo tallied up his money and wrote that he had 1280 lire, which he used to pay salaries to Zoro and Salaì and the other apprentices, and perhaps other debts as well. There are also directions for hiding his money from looters should chaos break out. He was living in the Corte Vecchia (Gian Sforza's widow Isabella was living in another part of the castle) and the place was fairly open, despite the moat and drawbridge which probably didn't work anymore. It also faced the city square where any insurrection would likely begin.

On September 2, 1499, Ludovico packed what booty he could carry and headed out of town with various retainers and family close to him, looking to rally his ex-in-law, the Emperor Maximilian some 240 miles away in Innsbruck. What we do know is that the day following Ludovico's departure from the city, Milan became lawless. The chronicler Corio relates:

> The mob gathered at the house of Ambrogio Curzio, and destroyed it completely, so that almost nothing of value could be found there: and the same was done to the garden of Bergonzio Botta, the Duke's master of payments, and to the palazzo and stables of Galeazzo Sanseverino, and to the house of Mariolo, Ludovico's chamberlain, recently built and not yet completed.

This last house may have been designed by Leonardo. He knew these men and had probably been to their homes. Clearly this is what Leonardo feared would happen. He probably should've gotten out of town days before, and may have been the victim of his own slow start. We don't know if his personal apartments were ever disturbed when

the city fell, but he was there in the middle of it, probably behind locked doors, as prepared as he could be. A terrifying four days.

About midday on September 6, the French army began pouring through Milan's gates. It's likely foot soldiers entered first, directed by officers on horseback, several thousand filling the streets before the cavalry arrived, and then the wagons and support troops. The population of the city swelled fifty percent in just a few hours, everything packed tight. No resistance was offered, but the chaos of the past few days was evident and the army set about establishing order in the usual military fashion, by clubbing folks into compliance. It appears that Leonardo knew a few people in the French Court, probably having met them during their earlier foray into Italy. He mentioned Jean Perréal, who is a painter with Louis, and Comte de Ligny, the army commander with whom it seems he met, and others as well, including Cesare Borgia. Perhaps he wanted to secure his title to the land Ludovico gave him. His apartments do not appear to be disturbed. He does not mention it anyway. It nevertheless seemed prudent to him to leave the city he'd lived in for eighteen years. He doesn't feel safe. His connection to Ludovico was too strong. Perhaps the French were also quartering troops in the Corte Vecchia and they needed the ballroom. Milan was an occupied city now, a chaotic place. Anything could happen. Even going outside was dangerous. Drunk soldiers were everywhere. Leonardo transferred his funds to a bank in Florence for safekeeping, and began packing up his stuff.

On October 6, 1499, Louis XII, grand master of the Order of St. Michael, the Order of the Porcupine, the Duchy of Orléans, and now King of France, entered in full regalia to take formal possession, followed by his royal court and retainers. Marshall Trivulzio presented the key to the city to Louis, who in turn appointed Trivulzio as the temporary governor. In an attempt to win popularity with the public, Louis reduced the Sforza taxes by a third. Where Leonardo was during all this we don't know.

But we do know that, sure enough, a few days after his arrival,

Louis XII heard about *The Last Supper* and asked to see it, and sure enough, as Ludovico could've predicted (being of the same ilk himself) Louis wanted to take it with him. He inquired if it could be taken off the wall, or if the entire wall could be cut away and carried back to France. The answer to both questions was no, of course, and he had to leave it where it was, much to his royal annoyance.

IN A NOTEBOOK, Leonardo listed the things he and his crew needed to do in preparation to leave:

Have 2 boxes made.

Muleteer's blankets—or better, use the bedspreads. There are 3 of them, and you will leave one of them at Vinci.

Take the braziers from the Grazie.

Get the Theatre of Verona from Giovanni Lombardo.

Buy tablecloths and towels, caps and shoes, 4 pairs of hose, a chamois jerkin and skins to make others.

Alessandro's lathe.

Sell what you cannot take with you.

IT WAS THE end of December and it was cold. A bad time to be on the road, but Leonardo felt he had no choice. Luca Pacioli was with him, along with Zoro and Salaì. They may have traveled with several others as well, there being safety in numbers. Clearly, a lot of people wanted to get out of town if they could. Leonardo's entourage headed

for Mantua, the home of the Marchioness Isabella d'Este, sister of Beatrice, and a young, rich, patron of the arts. And, a fan of Leonardo's. They'd met before in Milan. The Sforzas and d'Estes were two of the most influential families in the Lombardy area, and Leonardo knew he could turn to her for refuge. Or at least thought he could.

BUT MUCH MORE interesting than what was waiting for Leonardo on the road during this awful journey, I wonder about what he left behind. Especially the trash in his rooms at the Corte Vecchia.

He'd lived in those rooms for eleven years, so they must've appeared as settled, perhaps half-filled with the stuff one accumulates over time—the interesting rocks or dried plants collected on walks that would have to be left behind. That colorful peacock feather on the wall would stay, as well as the fossilized seashells he'd gathered high in the mountains.

Going through Leonardo's trash after he'd left the old castle would've been fascinating. Someone did. Were there drawings on the walls, doodles, reminders? Hash marks measuring little Salaì's growth? What about stains and scorch marks from Zoro's metallurgical experiments? Or the splatter where they mixed the paint? What about his work table, home to so many creations—that stays too? And then the old abandoned pots and pans with crap burned into them, melted mysteries stuck to the bottom, never to be clean again. Old wooden models made for one project or another, like his plan for the Milan cathedral, too big to be carried away, or the flying machine hanging from the ceiling. Momma's old wheelchair. Half-burned papers in the fireplace. A trash archeologist might've gone mad in there.

Instead, French soldiers took over.

1500	Leonardo draws *Portrait of Isabella d'Este*.
1500	Spanish navigator Vicente Yáñez Pinzón reaches the northern coast of Brazil.
1500	Emperor Go-Kashiwabara accedes to the throne of Meiō era Japan.
1500	In the Second Battle of Lepanto, Venice is beaten again and loses its Grecian holdings.
1500	The last wolf in England is killed.
1500	A total solar eclipse causes widespread panic; Christians in Europe believe it is the end of the world.
1500	Leonardo begins *The Virgin and Child with St. Anne and St. John the Baptist*.
1501	Michelangelo returns to Florence and begins work on the statue *David*.
1501	Italic type first used by Aldus Manutius at the Aldine Press in Venice.
1501	Portuguese navigator João da Nova discovers Ascension Island.
1501	Ismail I is enthroned as Shah of Azerbaijan, declaring Shi'ism compulsory under penalty of death.
1501	Leonardo paints *The Madonna of the Yarnwinder*.
1500s	Diogo Dias discovers Madagascar and reaches the Red Sea.

CHAOS ON THE HOOF

Ages 48–49

WHAT WAS GOING through his mind as that icy wind cut into him on the retreat from Milan? No doubt wrapped in blankets and even leather trying to stay warm, Leonardo, now in his late forties, was starting over again—not something he welcomed, but a possibility he had always expected. It was life as he knew it, chaos on the hoof. The duchy of Milan was large and rich, but there were larger and richer powers than Ludovico, and they would determine the future. Live as well as one can, as long as one can, then hightail it out of there.

Leonardo was headed for Mantua, ninety miles away, during the coldest time of the year. A journey like that would take at least four or five days on horseback, longer if people were walking. The condition of the roads was a concern; accumulating snow could close the mountain passes overnight. Without a highway department, things could happen and the traveler wouldn't know about it until he stepped off the end of the road and fell into a hole. You had to stay alert *all the time*. A horse could slip in the snow, or a wagon lose a wheel. There was also the possibility of being bushwhacked anywhere along the way. People you met going the other direction were not necessarily your friends.

No doubt Isabella d'Este knew of her ex-brother-in-law's troubles and of his flight northward to Innsbruck to escape the French, and surely must've expected refugees like Leonardo and Luca Pacioli

to wash up at her gate sooner or later seeking hospitality, which she would graciously give—if you were a potential trophy for her collection. She'd had her eye on Leonardo for some time and had even asked for the loan of his *Lady with Ermine* from the Lady herself so she could compare Leonardo's work with the Venetian painter Bellini. Leonardo hoped she would welcome him and his party because she would see it as an opportunity to get work out of him.

Her reputation preceded her. Isabella d'Este was a demanding patron who would occasionally sue a painter if he did not do as she wished. She was only twenty-five years old at the time and had grown used to the world obeying her every command—trust fund babies being about the same everywhere, even then.

He couldn't have been eager to deal with her, but by now he knew the ways of power and wealth and how one got around them—mainly by yessing it to death while he looked for a side door. That would be his method with her as well.

A four or five day journey would mean three or four nights spent somewhere along the way. Vacancies at the inn? Scarce, I'd think. We know nothing about this trip, except for the obvious: it was very difficult and it was made under duress. The average temperature during that time of year was thirty-four degrees Fahrenheit, and the low at night well below freezing. What shape Leonardo was in when he arrived we can only guess. Sleepless, dusty, chilled to his bones, he was no doubt solicitous and apologetic for his unexpected arrival and asked of the Marchioness, in his best courtly manner, if he and his friends might have a corner somewhere for their weary selves. If my reading of Isabella is correct, she probably kept him up late, chattering at him and wanting his opinions, ignoring the signs of fatigue. I imagine the heat from her fireplace made staying awake very difficult. Coffee would not be served for another hundred years.

He stayed there less than a month. Time enough to restore his strength and warm up. Being a visitor had to be hard for him. He'd lived in his own rooms the last decade and was accustomed to an in-

dependent life, and here he had to follow the schedule of the house and of the Marchioness, girl that she was. It was wearing to be a visitor all day, every day. After a while you'd be more comfortable in a tent outside rather than in a palace and have to jump to your feet every time someone entered the room. He was probably planning to leave within days of his arrival.

Isabella got him to promise to do her portrait and he did a preparatory sketch of her, tap-dancing for his dinner, but he was only there a few weeks and work on her portrait seemed to stop the moment he walked out the front door and started his way slowly to Venice. It was February, and nothing was melting. If anything, it was getting colder. But, whatever the conditions outside on the road, it was better than staying inside the d'Este castle with the young Marchioness. Crunching snow, Leonardo headed for Venice.

In better weather he would've surely found much to interest him on such a trip, but under these forced and brutal conditions, he wanted it over with as soon as possible. It was another four to five days, though, and probably not any easier than the first jag from Milan. He'd rested, recovered himself, mostly, and was getting exhausted all over again.

Venice, too, was feeling the effects of Ludovico's indiscretions. As a diversionary tactic, he'd encouraged the Ottoman Turks to move against them and the Turks had done just that, and at the moment were less than fifty miles away from Venice and threatening to sack it. Negotiations between the two were intense. Leonardo probably headed there in hopes of securing work, most likely for defensive fortifications. We have a sketch for scuba gear from this time. Leonardo tried and failed to persuade the Venetian Council of Ten to employ him, even after traveling to Friuli to inspect the area and design a dam that could flood the Isonzo Valley as a defense against the invading Turks. It was an old idea. Ancient, even. Perhaps Leonardo knew Brunelleschi had designed the same thing in 1430 for the defense of the city of Lucca, and they didn't buy it then, either. Too expensive,

too complicated, too big a mess afterwards. No thanks.

With time on his hands, perhaps Leonardo had a look around town. As he well knew, Venice was a center of book printing. Pacioli's book *Summa de Arithmetica* was one of the very first published there. Pacioli had contacts in the city. Did Leonardo visit Paganino Paganini's print shop with Pacioli? Did he stand among all the debris and the drying paper hanging from strings and watch the Gutenberg press at work? Did he handle the pages? Examine the binding of finished books? Consider the possibilities for himself?

Gutenberg had printed the first book, an illuminated Bible, two years after Leonardo was born, and then, like many publishers since, immediately went bankrupt. Printing was one of the most important innovations of Leonardo's lifetime. Living on the cusp of change, he continued to acquire both hand-copied manuscripts and machine-printed books.

Simultaneous to this is the development of the copper sketching technique that made printing fine illustrations possible for the first time. He knew all this and thought about it, but in the end did nothing. He had a book in mind for the science of painting and had accumulated notes for it, but it was not organized yet. He had mentioned other books he wanted to write or had already started, on the flight of birds for example or the movement of water, but these books were only in his head and scattered through his notes, not ready for the printer.

It's worth asking, why didn't he just stay in Venice a few months and take the opportunity to organize his notes on painting, say, into final form and print it? It was winter, after all. He could have made the copper plates himself. He needed the money, and it was new technology, and would certainly spread his name far and wide, even to Rome itself. Commissions would pour in. And doing a portrait or two would pay for the whole thing. But he stayed only a few weeks, rested up, and left again. He must have felt profoundly unsettled and unable to focus. His life was inside out. He'd been flushed out of his hole and was running loose on the landscape. Not a creative situation

for him.

There are reasons why Leonardo did not publish in his lifetime, and they have nothing to do with technology or lack of opportunity. It had to do with *him*.

Leonardo was finding it difficult dealing with so many strangers. At least in Milan he didn't have to explain himself over and over. Here they saw only his eccentricities and not his past accomplishments. They knew nothing about him, or what they knew was wrong, and yet they judged him, made life difficult for him. Nothing good came from his time in Venice. He heard a report from Milan that French archers have used the clay model of his great horse for target practice and have destroyed it. More than likely his wall painting would be next.

Other news came in, even worse, probably in fragments and from several sources. People sought him out, they wanted him to know what they'd heard—Ludovico had regained the city. With hired Swiss soldiers he recaptured Milan and then proceeded to push the French out of his duchy—at least until he reached Novara on April 10 and his soldiers were either badly beaten, or refused to fight, or were bought off, depending on who was talking. Ludovico did everything he could to escape but he was surrounded by French soldiers and was captured finally, dressed as a servant and hiding in a crowd passing out of town, trying to look as small as possible. One of his paid Swiss mercenaries recognized him and the French grabbed him. Then they grabbed Milan back as well, and justice was swift.

Upon hearing the news, Leonardo wrote in his notebook:

The governor of the castle made prisoner. [This was the French governor who surrendered the Castello Sforzesco to Ludovico.]

Bissconte dragged away and then his son killed. [Visconti, a friend of his.]

Gian della Rosa robbed of his money. [Ludovico's physician and astrologer.]

Borgonzo began then changed his mind and so ran away from fortune. [Ruined]

The Duke has lost his state, and his goods, and his freedom, and none of his works was completed.

It would seem Leonardo got out just in time. He did not yet know that his close friend, the architect Giacoma Andrea, who remained in Milan, was imprisoned and would soon be beheaded and quartered, his head hung at the city gates. He may not know yet the fate of Ludovico after his capture, but it would be grim as well. Surely the rumors were running high.

Ludovico was in fact taken to Lyon, where he was paraded through the streets "like a wild animal," defiant and chained. His fury must've been something fierce. As well as his total astonishment. He probably expected to be ransomed and released. Instead, he was poked and stabbed and made to holler, then they humiliated him in various ways and finally threw him in a dungeon, deep in the middle of France.

Outraged at the news, his former father-in-law, the Emperor of the Holy Roman Empire, Maximilian himself, pleaded for Ludovico's release but, Louis XII, a man who enjoyed his revenge, refused to consider it. Within weeks of capture Ludovico found himself locked in a stone cell, tormented by his guards, and, like an imploding star of immense dimensions, he was shooting gas in every direction.

From this distance, what's interesting is how stupid power makes a person, and how reckless they are to get it back—even when they don't need it. Like an addiction they cannot give up, once that taste of absolute authority is on the tongue, most people are helpless to resist it. Ludovico had a small fortune, he had his near family, he had refuge at the palace with the Duke of Austria, Maximilian. In other words,

he could've stayed there and lived the soft life for the next twenty to thirty years and had his girlfriends and wine and whatnot, and died an old reprobate telling stories. But instead, he spent every ducat he had, and borrowed more, to hire Swiss mercenaries in order to retake Milan and the rest of the duchy, hoping to beat the French army. And then further hoping they would accept being beaten and just go home and forget about it, I guess. Instead, the French bought off his rented soldiers, captured Ludovico, and then threw him into hell.

Payback's a mother.

ACCORDING TO HIS notebooks, Leonardo studied the water in Venice, especially the tides. Being next to the sea felt so different from being in the mountains. You sense a broader world out there you only suspected otherwise, concerns other than your own narrow existence. In a sense, he'd come to the edge; the edge of land and the edge of his life. It was only his second time to view the sea, and his first real chance to study it. Perhaps Pacioli, another inlander, joined him in puzzling over the tides and how they came and went. What might cause them? Could it be true, as Seleucus theorized, that tides were caused by the closeness of the moon? Did that even make sense? Or were the tides a respiration of sorts, as Alpetragius claimed, part of the larger pulse of the Earth and Heavens? But if so, how could that be? The two of them swimming through poetic confusion, both thinking in metaphor.

Venice was different than any place Leonardo had been before. Even the air smelled different. Different vibe, different government, different sense of themselves. Very wealthy. There was no single ruler to appeal to, but ten. Leonardo probably impressed them with his plans, but not enough to close the deal. Again, something wasn't right. They needed practical solutions to real problems and not fancy ideas. It seems his only real success in Venice was with other artists, especially Giorgione and Palma Vecchio, who were impressed with

the work he brought with him, and what he was able to do with that amazing left hand right in front of them. But this was only a handful of people; he was just there a few weeks. Something impelled him forward.

In late April, once it had warmed a bit, he hit the road again with Pacioli, and walked, rode, or bumped in a cart all the way to Bologna, where they rested up before continuing on to Florence.

Travel was hard over rocky roads, sunrise to sunset, day after day, even when you weren't freezing. He arrived finally at the outer walls of Florence, exhausted, sore, the tops of his boots covered in a fine dust. Perhaps he stayed with his seventy-four-year-old father, Ser Piero (now on wife #4, child #11), or with Lorenzo di Credi in Verrocchio's old studio.

He had to start looking for work almost immediately. He offered his services as a consultant for building the bell tower of San Miniato, and for repairing the church of San Salvatore a Monte. Filippino Lippi heard of his plight and (being an extremely nice guy, apparently) passes to him the commission for an altarpiece in Santissima Annunziata. He is also offered hospitality by the monks there for whom he begins to draw *The Virgin and Child with St. Anne*. His cartoon was a big hit. People lined up to see it. I would guess, too, that he made a trip on to Vinci at some point to deposit one of his three boxes there, probably full of old notes and drawings, drafts of letters sent, all that Milan stuff. Also to visit with his uncle Francesco after so many years. Perhaps he told him about Caterina, and life at court in Milan, the castle he lived in, the diplomats and courtiers and fools. All of which must have seemed very far away while sitting there on the porch in Vinci, looking at the distant horizon.

Back in Florence, a monk wrote to his patron, Isabella d'Este, that Leonardo seemed to be living "day by day" and was "weary of the brush." She, of course, wanted to know what had happened to her portrait.

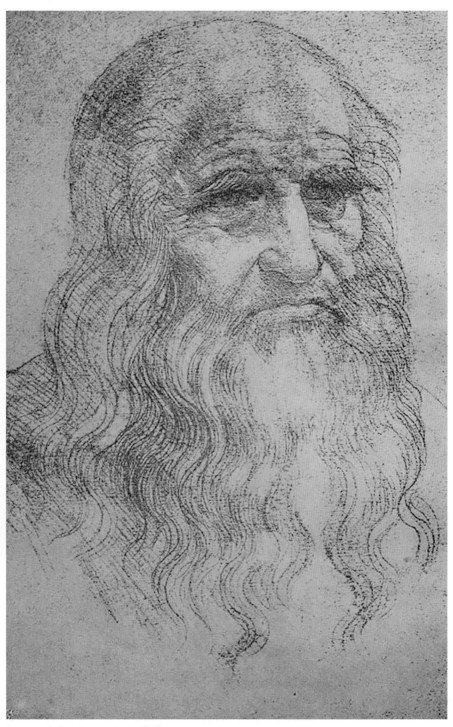

Portrait of a Man in Red Chalk

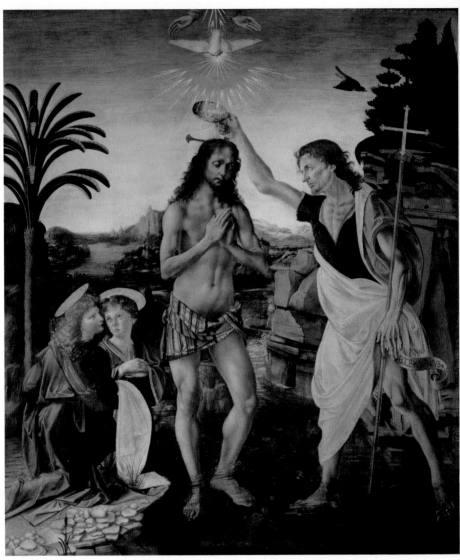

Andrea del Verrocchio's *The Baptism of Christ*

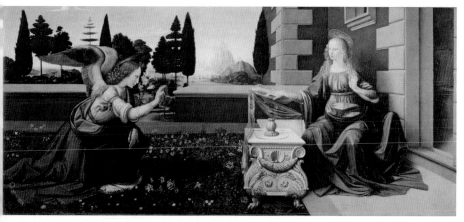

Annunciation

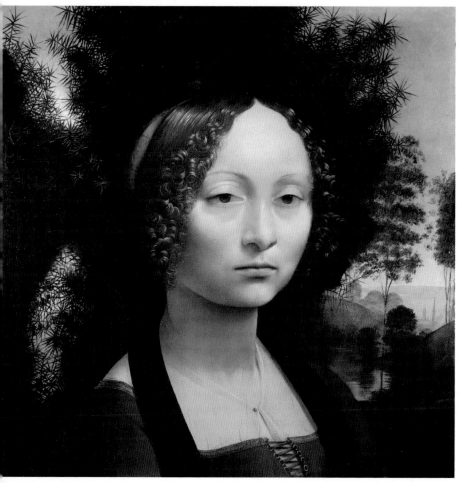

Ginevra de' Benci

Portrait of Luca Pacioli. Attributed to Jacopo de' Barbari

Ludovico Sforza, Duke of Milan. Painter unknown.

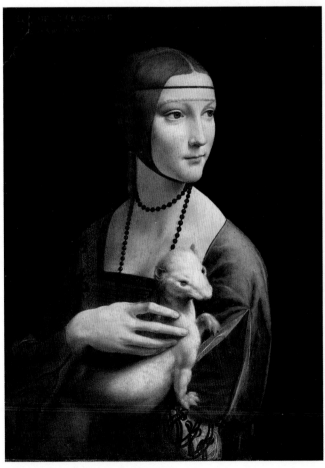

Lady with an Ermine (Bridgeman)

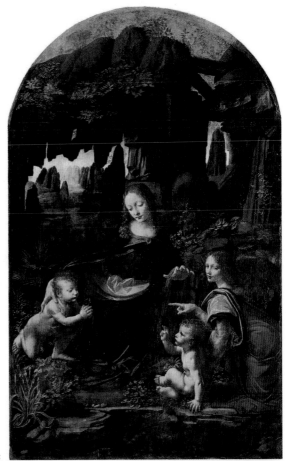

Virgin of the Rocks

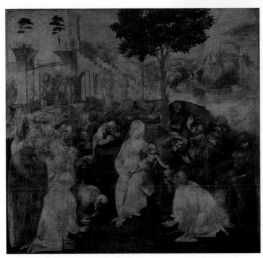

The Adoration of the Magi

St. Jerome in the Wilderness

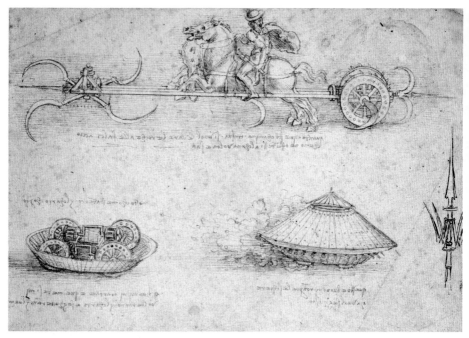

Leg Chopper and Tank (Bridgeman)

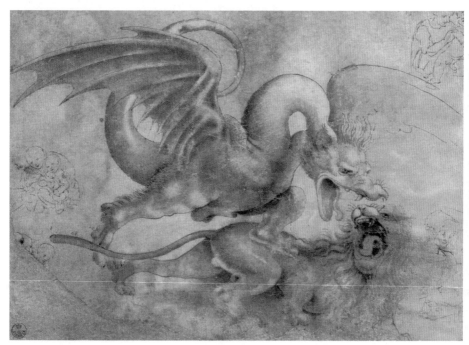

Winged Dragon Attacking Lion (Bridgeman)

Study of Facial Proportions (Bridgeman)

So-called "Grotesques" (Bridgeman)

Wardrobe Design for Theater (Bridgeman)

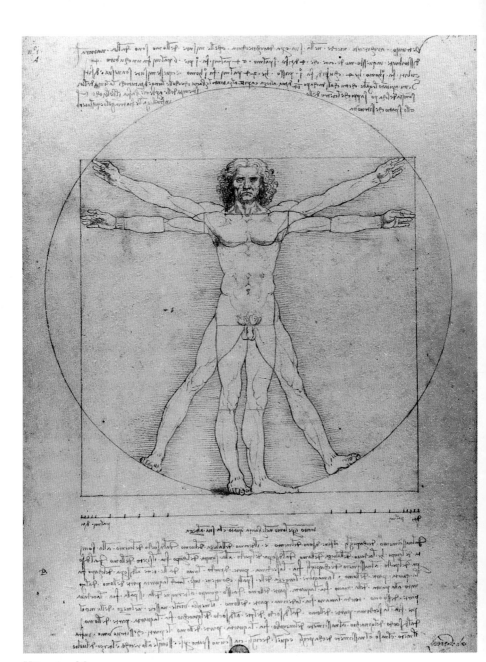

Vitruvian Man

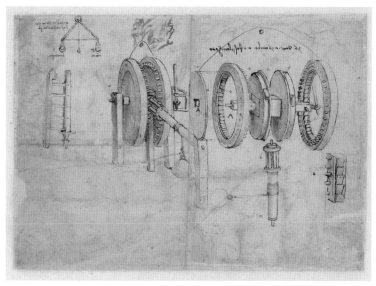

Pazzi
Conspirator
(Bridgeman)

Exploded View of Hygrometer (Bridgeman)

Artillery Barrage and Study of a Raring
Horse *(Bridgeman)*

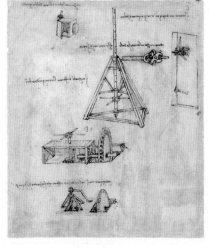

Device for Pulling Hinge Off
Cell Door *(Bridgeman)*

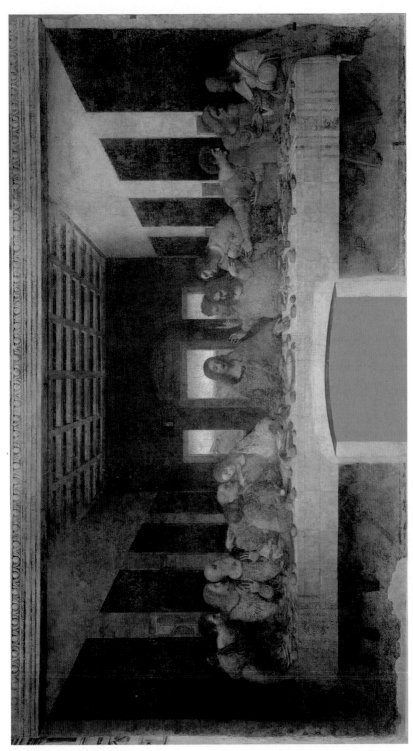

The Last Supper

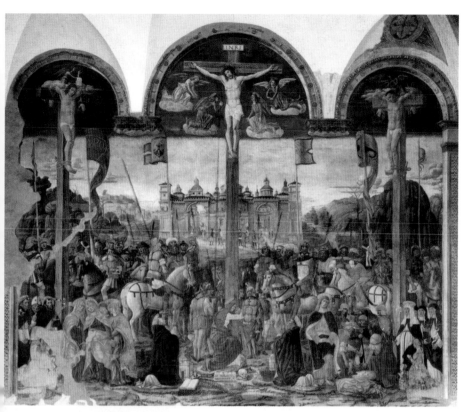

Giovanni Donato da Montorfano's Crucifixion fresco

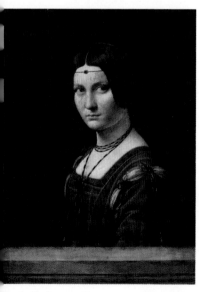

La belle ferronnière

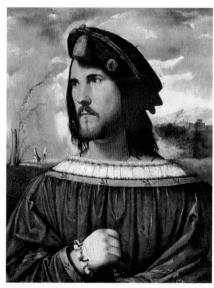

Portrait of Gentleman (Cesare Borgia)
by Altobello Melone

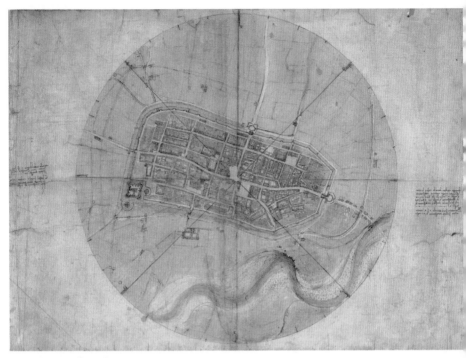

Aerial Map of Imola (Bridgeman)

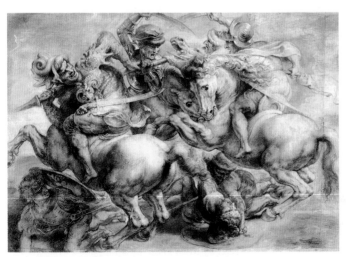

The Battle of Anghiari copied by Peter Paul Rubens

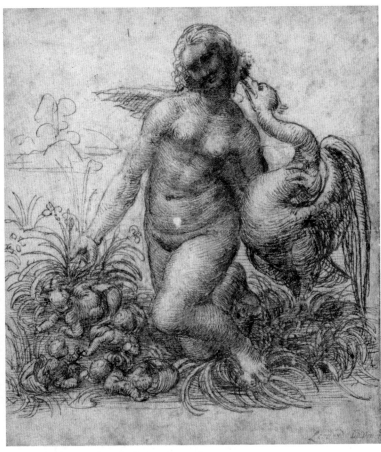

Study for the Kneeling Leda (Bridgeman)

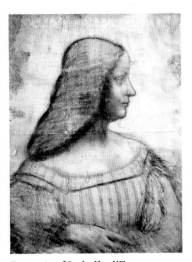

Portrait of Isabella d'Este

Study of Michelangelo's David (Bridgeman)

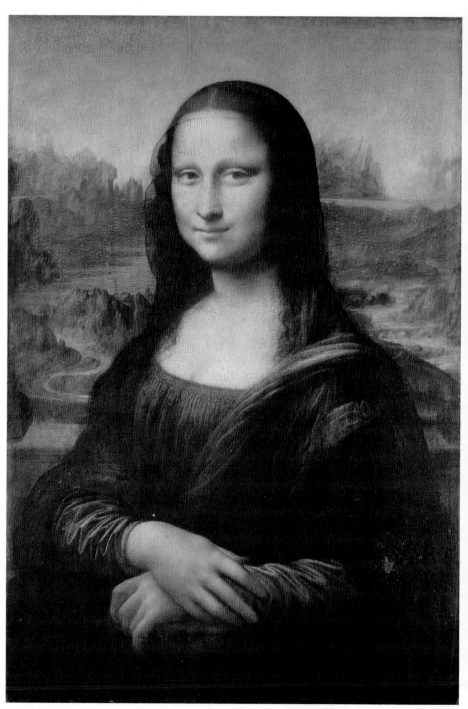

Mona Lisa

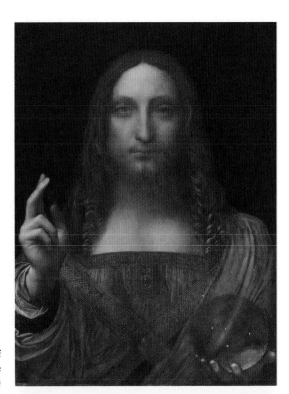

Salvator Mundi
(Christ Among the
Doctors)

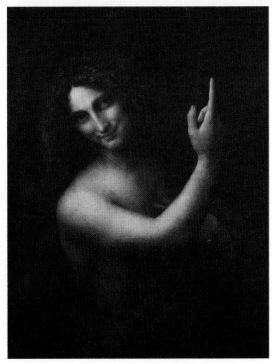

Salaì as St. John
(St. John the Baptist)

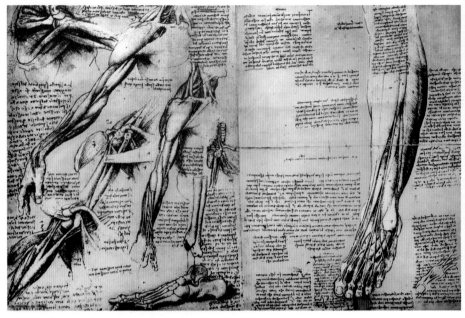

Study of Leg and Arm Muscles (Bridgeman)

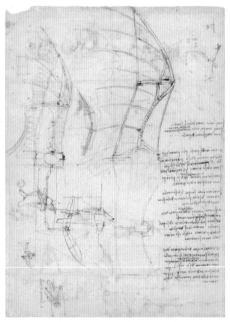

Study of Bat Wing for Glider (Bridgeman)

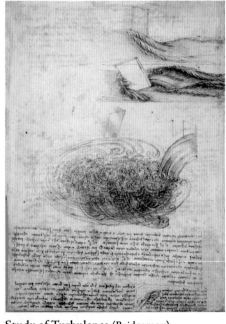

Study of Turbulence (Bridgeman)

1502	First reported African are brought to the New World.
1502	Portuguese explorers, led by Pedro Álvares Cabral, sail into Guanabara Bay, Brazil, and mistake it for the mouth of a river, which they name Rio de Janeiro.
1502	Columbus leaves Cádiz, Spain for his fourth and final trip to the "New World."
1502	Portuguese navigator João da Nova discovers the uninhabited island of Saint Helena.
1502	The Tempietto in San Pietro, Montorio, Rome, designed by Donato Bramante, is built.
1502	Francesco di Giorgio, Italian painter, sculptor, architect, theorist, and military engineer, dies (b. 1439).

MACHIAVELLI ENTERS THE MIX

Age 50, Parte Uno

CESARE BORGIA WAS a different person to different people. Some thought him the very ideal of princely behavior and clever strategic life planning; others thought him just another psychopath with an army. Placed in historical perspective, he seems now something of a bullshit artist who had a run of luck, which eventually dried up, as luck tends to do if tested too long. What Leonardo thought going into the deal we don't know, but I think he felt pretty dirty coming out the other side.

Borgia's story is one of extravagance and excess and utter corruption—as was the larger story of his family, which included a corrupt Pope, Alexander VI, who helped ignite the Reformation through his obscene lifestyle and sale of indulgences. Even more than Ludovico ever managed, the Borgia and their ilk were a black spot in Italian history.

And of course, Leonardo worked for one of them. Just as natural as grapes turn into wine, Leonardo was giving technical assistance to Cesare Borgia to aid him in his conquests. Why is that?

For some reason decent, regular people weren't hiring Leonardo, but perverse maniacs were. An odd pattern is developing, something I can't fathom precisely. It's the alchemy of his relationships, what some princes and bureaucrats liked about him but others didn't. Why did he affect some people this way? Maybe all the rings and long fingernails,

as some writers have mentioned? The extravagant clothes? Something in his demeanor? Leonardo was an acquired taste. I think I would've liked him, but then I like weird people in general, especially anyone who can write backward. Others, more settled and invested in the status quo, might have felt threatened by this wild creature of color and gesture.

The reason such relationships occasionally worked was probably because Leonardo was able to engage the patron's imagination, and then fuel that engagement to visions of perfection, using the magic of that left hand to make it all look good. Some of his more outlandish weapons of war drawn for Ludovico were of this sort, encouraging Ludovico to dream the impossible dream. *"Use me as your hand and arm, your Excellency."*

Freelancers know tricks like this and use them to this day. Ask any architect. But it was rare when Leonardo found someone with power and money willing to invest in him, simply because most people had little imagination—and rulers tended to have even less. And then many people just flat out didn't like him. Ludovico had been the wild card in the bunch. Ludovico would kiss a snake if it gave him what he wanted. But the Venetians weren't having it. Leonardo might as well been selling clouds.

Which is why it's very difficult for one-offs like Leonardo to relocate. They depend on others knowing them and accepting them, and the connections that come from that social network. A single success can resonate for years if a person stays put. Leonardo had connections all over the place, but most were only good for a bed and breakfast. Other than Milan, he was best connected in Florence, and it may have been those connections that led him to Borgia.

They'd met at least once before, when French King Charles VIII visited Milan in 1494 with Cesare in his retinue. Cesare's first impression probably came from Ludovico bragging on his own engineers, surely praising himself by praising Leonardo, encouraging Cesare to visit Leonardo's workshop to see for himself. And Leonardo was

standing right beside the clearly talented architect Donato Bramante, also in Ludovico's employ and who would go on to design St. Peter's Basilica in the Vatican a few years later. And next to him was Luca Pacioli, the famous mathematician, along with several other poets, painters, scholars, and miscellaneous philosophers. A regular nest of talent. It was probably Ludovico who first sold Cesare on Leonardo. Perhaps the Battle of Novara had become a point of pride for Leonardo as a military engineer. Perhaps as well Cesare actually did visit Leonardo's "factory" and saw the various projects underway. Perhaps he stood in the middle of that huge ballroom with the giant clay horse on one end, and the wooden flying machine on the other, and ten other projects in between, along with two or three of Leonardo's assistants lounging around, and decided, *This is a clever man indeed.*

By 1502, eight years later, the political situation in Italy was more chaotic than ever. The new French king, Louis XII, was back with an even larger army, and after recapturing Milan, he was eyeing Naples to the south, just as Charles VIII had done in 1494. What was different now was that the Pope was a player and much stronger than before, and as a consequence of that, Pope Alexander's bastard son, Cesare Borgia, was also a player and was carving out a duchy for himself in the Romagna—which butted up against the territory of Florence.

Cesare was a threat and Florence was terrified of him invading and taking over. He'd already massacred two populations in the area, and Florence did not want to be next. To prevent this possibility, the city (now the independent Republic of Florence, having exiled the Medici) sent two representatives to negotiate with Borgia, one of which was Bishop Piero Soderini, who was in charge of the delegation, and his second, Niccolò di Bernardo dei Machiavelli. The long and short of all this seems to be that Borgia was suspicious of the Florentine promises of loyalty and friendship and required proof of their good intentions. Something beyond money and free passage through their territory. What Borgia wanted was tech support, hence Leonardo was drawn into the deal.

Whether Leonardo knew anything about this beforehand is not known. Paul Slathern is the scholar here and he suspects Leonardo was drawn into the deal later by Machiavelli, which speaks to how improvised things really were. It may have been that Machiavelli had to gallop all the way back to Florence and talk him into it, but someway or another, Borgia wanted Leonardo, so Machiavelli played the cards he had and put the two of them together.

For a military engineer, it should've been a dream gig. Borgia was on the march, had battles lined up on his calendar, and needed someone who knew fortifications and bridge building and occasional river rerouting when the need might arise. Whatever Leonardo's response, he set out from Florence in July on an inspection tour of the localities Cesare already possessed. Apparently Machiavelli had brought instructions with him as Leonardo and Cesare would not meet for several weeks yet.

It also appears that he was being asked to spy on Cesare and to report his movements and plans back to Florence, probably to Machiavelli, who seems to have set this scheme up. But spying on Cesare was a good way to lose a hand, or a life, and whether or not Leonardo did it is unclear. We have no messages from him in disappearing ink. Machiavelli left no clue either, but I accept the judgment of scholars who take this seriously and claim Leonardo was a spy for Florence while working in Borgia's camp. The city of Florence helped get him the job, and in return expected information vital to its defense. These were brutal times and I'm sure everyone was double-dealing everybody else, and, I'm fairly sure Leonardo was not hindered by scruples of any kind regarding Cesare, but per usual he took care of himself first. Maybe he was a spy, maybe not. My tendency is to think Leonardo avoided that kind of back door stuff, but he could surprise me. Borgia seemed to bring out the worst in everyone.

What we do know is that Leonardo is on the move again, on horseback now with attendants (probably Salaì and Zoro) and guards to protect him on the road. It's summer and Leonardo is headed for Piombino

on the coast where he looks at the crashing waves and the gulls hanging motionless in the air, then he examined the swamp nearby and worked out how to drain it. He was following Cesare's itinerary so he must have had plans for the port. Then Leonardo headed back inland to the mountains and the city of Siena, where he remarked in his notebooks the interesting bell hanging in the church. He reached Arezzo a few days later, a fortification commanded by Cesare's lieutenant Vitellozzo, and Leonardo apparently drew a map of the area for him in exchange for an Archimedes manuscript Vitellozzo could get his hands on from plundered loot. So far, Leonardo seems to be running with thieves and was fairly comfortable with it. He's apparently wanted this manuscript for a long time. Luca Pacioli had told him where he could find it.

Leonardo on the road. Other than the floppy hat and robe and a good pair of walking boots, his kit would probably include a belt around his waist to hang things on. Leonardo seems a pocket kind of guy to me, and robes don't usually have pockets, so he must've hung a pouch from his belt, along with the small notebook he had for the purpose of gathering visions and examples and whatnot, as well as perhaps a small wine flask. Maybe a second smaller bag around his neck for coins so they aren't mixed in with the pieces of chalk and dead bugs and interesting rocks he picks up. A bag also for his home-made spectacles. And then probably a dagger on his belt, considering the times he lived in. Good for cutting his food, or even road kill, if it looked interesting and he'd not seen it before.

On the way he found himself back in the Apennines mountains, where he made notes for later maps and came across for the first time the five-arched bridge over the upper Arno at Buriano which he sketched and would later put into the *Mona Lisa*.

As a traveling companion he must've been irksome in the extreme, especially if you were in enemy territory and in a hurry to move on. Cesare had assigned him guards for safe passage, hardened warriors no doubt, veterans of bloodshed already, probably Spanish mercenaries capable of protecting his engineer if the need arose. And here was

the engineer, drawing a perfectly ordinary looking bridge, everyone standing around waiting for him. Sometimes, I would imagine, when it was hot enough and the flies thick enough and you'd waited long enough, you had to repress the impulse to just grab that damn notebook of his and throw it in the river.

Sometime in late July, Leonardo and group turned toward Urbino where Cesare's troops were looting the city after dispatching the lords and the ruler of the place (murder, dungeon) and were in the process of boxing it all up for transport. Rape, pillage, and yahoo! Leonardo wrote in his notebook, "Many treasures and great wealth will be entrusted to quadrupeds who will carry them to various places," making it sound like he was there for the heist. Then he sketched the stairs to the palace of the lately dispatched Duke of Urbino. Nice design, worth remembering. He might need it some time. Doing a little looting of his own.

We don't know anything about that first meeting again after three years between Cesare and Leonardo, but they met at Urbino. Machiavelli did record his own first meeting with Cesare, and it may well have been the same. It was Cesare's preferred mode of introduction. Apparently he liked back-lighting himself for dramatic impact and his face obscured. Machiavelli and Bishop Soderini had been ushered into a dark room where Machiavelli records:

> By the light of a single flickering candle which showed only dimly the tall figure clad in black from head to foot without jewel or ornament, the still, white features as regular as a Greek statue and as immobile. Perhaps the cold beauty of those marble features was already beginning to be marred by the pustules which led him later on usually to wear a mask.

He was referring to Cesare's growing syphilis problem. It was 1502 in Italy and syphilis was popping up everywhere. Thank you, Columbus! Only a few years before Cesare had been considered the "hand-

somest man in Italy," but now he was leaving the pillow wet at night. He was in a hurry to get things done, and not a guy you wanted to piss off.

However he stage-managed his reunion with Leonardo, Cesare surely sat with him and asked many questions about the fortifications Leonardo had observed, and his requirements to improve them. Purchases were authorized and orders given. He may have discussed tactics as well and what difficulties he might encounter on the road. And perhaps he asked about his lieutenant Vitellozzo, and if there were any signs of disloyalty in him. Borgia trusted no one and needed all the information possible, and other than riding out and looking for himself, he relied on others to report back and tell it accurately—and not just tell him what he wanted to hear, the bane of leaders everywhere. Leonardo and Cesare Borgia may well have worked closely together those few days in Urbino, but the notebook that contained the work of those sessions is lost to us.

Cesare is about to take off on a tear in a few days, leaving Leonardo and Machiavelli in his dust, but before that, for an evening or two, sitting around the banquet room in the Duke's seized palace in Urbino, Leonardo draws Borgia's face, and the drawings survive. In one of them Borgia looks asleep. Maybe they were secret drawings, snatched when no one was looking. Or maybe Cesare knew about it and wanted his portrait done. Or maybe they were drawn in an attempt to understand Cesare a little better. Drawing had been Leonardo's way of studying many things and these drawings may well be his philosophical musings on what this man was all about. Maybe the question troubled him. Headed into the campaign he was perhaps still unsure what to expect.

HERE BE DRAGONS

Age 50, Parte Duo

OUT OF ALL the false starts and half-completed projects and other missteps that might've characterized Leonardo's career so far, his biggest regret was still in front of him. Vasari's opinion was that Leonardo did not know his own talents but rather misunderstood them and I think he is right about that, and I think the proof is about to roll over Leonardo.

He is on the road again, along with Salaì and Zoro and a half dozen guys with long spears and swords riding horseback—lots of leather creaking, horses snorting, everyone's head bobbing in synch with the hooves. They're headed to Pesaro and then on to Remini and Cesena where he wrote in his notebook that the locals were idiots and didn't know how to build a cart so it would roll.

It's at Cesena in August that Leonardo received from Cesare this letter to establish his credentials:

Caesar Borgia of France, by the Grace of God Duke of Romagna and Valence, Prince of the Adriatic, Lord of Piombino etc., also Gonfalonier and Captain General of the Holy Roman Church: to all our lieutenants, castellans, captains, condottieri, officials, soldiers and subjects to whom this notice is presented. We order and command that the bearer hereof, our most excellent and well-beloved architect and general engineer Leonardo Vinci, who by our

commission is to survey the places and fortresses of our states, so that we may maintain them according to their needs and on his advice. Furthermore we order and command the following: All will allow him free passage, exempt from any public tax or charge either to himself or his companions, and will welcome him in a friendly fashion, and allow him to inspect, measure and examine anything he wishes. And to this effect, you will provide him with any men he requires and give him any help, assistance and favors he asks. It is our wish that for any work to be carried out within our states, beforehand each engineer be required to consult with him and conform to his judgment. Let no man presume to act otherwise unless he wishes to incur our wrath.

This is usually read as showing how close Cesare and Leonardo must've been, but I doubt it. All this stuff about "our most excellent and well-beloved architect" looks rather more like a mafia hug to me. Still, it was guaranteed to raise gates and lower bridges all over the region, and receiving it may have been a high point in Leonardo's life. He'd wanted just such a certification for years, and now he had it.

By early September he was at Porto Cesenatico dredging a canal. He planned to make it ten miles long and designed a machine that would haul away the loose dirt that diggers shoveled into large buckets. It's possible he even started to build such a machine, but there's no proof of it. Within a few weeks he was back at Imola, the city Cesare wanted to make his capitol. Leonardo drew up plans for various fantasy projects, a university and "Palace of Justice." Clearly spending a lot of time with Cesare, he was likely privy to it all: the planning, the heated disagreements, the many difficult problems of mounting a campaign.

At some point he heads up to the roof for some fresh air and notices the steady breeze through the place and imagines a windmill to harness it—fifty years before a Dutch guy would have the same idea and actually build one. The notion itself was in the air. For the Dutch

guy it was probably his one big idea and he couldn't abandon it. For Leonardo it's one more thing added to the heap.

But that's Leonardo in a snapshot: great idea, writes it in his notebook right away and then closes it tight and tells nobody about it, as that would just invite trouble. Nitwits are everywhere. Instead, he banks it for the future. That was his method: store his observations until a later opportunity might arise. He was a freelancer. His wealth was in these stored inventions, these notebooks full of ideas beautifully drawn. From a modern American retail point of view this is much too passive, but I think the critical thing for him was *having the idea*, not selling it or defending it or explaining it or branding it, or forty other things that would seize an ordinary imagination. I don't think he liked doing those things. Explaining an obvious idea is always onerous, selling it more so. New ideas should be a joy and not a burden. Life was just easier if he kept these notions to himself.

Along in here, unbeknownst to Leonardo or especially Cesare (both sitting in Imola), a meeting took place on the other side of the Romagna at La Magione between several of Cesare's commanders who had decided to abandon him and switch sides, becoming his enemies instead. Vitellozzo Vitelli is there, along with the Cardinal Orsini, who called the meeting, and three of Orsini's nephews, as well as Pandolfo Petrucci and Gianpaolo Baglioni, Liverotto da Fermo, and others who were willing to stage a coup and kill the scoundrel Borgia before he stole their fiefdoms as well. Needless to say, these men were every bit as nasty as Borgia, point for point, and were merely taking care of their own interests, not the public good. In any event, after nine days of arguing back and forth and vast amounts of confusion, they finally resolved to kill Cesare in a two-prong attack.

Cesare, of course, hears about the plot almost immediately; nobody can keep a secret. He becomes enraged and then has to bide his time. You can hear him breathing in the dark, grinding his teeth, spitting on the floor, not saying a word, brain running hot. Leonardo may have been sitting in the dark with him, sharing that one candle,

thinking his own thoughts. News of the conspiracy had even reached Rome and the Pope, Cesare's father. All of their plans for a Borgia duchy were on the verge of collapse. Cesare begins to consolidate his forces.

On the other side of the Romagna, Vitellozzo and the Orsini and Baglioni also consolidate their forces. A battle seems inevitable.

Two weeks later, when word got to Cesare in Imola of the now openly rebellious Vitellozzo Vitelli's approach to the city of Urbino with his army of twelve thousand, instead of fighting to defend it, Cesare ordered a tactical retreat of the troops under his lead commander Don Michele. This apparent sign of weakness set off an anti-Borgia revolt in the nearby town of Fossombrone, which shows how tenuous Cesare's hold on the population really was.

A game of "whack-a-mole" was not something that Cesare could tolerate, so he had Don Michele divert his army to the revolt in Fossombrone to squash the uprising once and for all. It was anticipated, however, that the city might close their gates and lock them tight so getting inside might be a problem.

And yet, Don Michele and his army were able to use a "secret passageway" into to the city to enter and take control of it, wherein a massacre occurred. These were mostly peasants armed with pitchforks and shovels, and they were mostly all killed, butchered by the badass Spanish mercenaries under Don Michele's command. The whole bloody town was killed. The point was made clear: you do not revolt against Cesare Borgia.

The interesting item here is that Leonardo was already in Fossombrone working on the city walls to make them more resistant to cannon and improving the defenses. He had obviously inspected all the walls before he began his improvements, that's just how he worked. He also probably knew about the secret passageway since it was in the wall he was inspecting.

What I've not been able to uncover is *how* this passageway was discovered by Don Michele on the outside. No one seems to know, al-

though the most likely link is obviously Leonardo. They both worked for the same guy. But how did they communicate? Did Leonardo send Salaì out the secret passage with a message in the middle of the night? Did he consider it his duty to notify Don Michele of the secret entrance? What did he think would happen if he did?

In any event, if Leonardo did facilitate the army entering Fossombrone, then he must've felt in some way responsible for the massacre that followed. For a mathematician like him it's pretty much a one-to-one equation. Who's responsible for that pile of bodies? Don Michele, whose troops hacked them up? Or Leonardo, who let them in to do the hacking?

Perhaps he was parsing just this kind of dilemma when he wrote in his notebooks, "It's not the sword that kills, but the man using it." This may be the rationale he used to keep his hands clean of the blood all around him. At least at first.

You wonder if he had any interest in the corpses lying everywhere. Several are surely lying open to examination already. He can't help but look at them. Within twenty-four hours, probably every fly within miles has found its way to the city. I'm guessing he felt bad about telling Don Michele about the hidden gate and really just wanted to leave the place behind. Maybe this whole war business was starting to grate on him.

The army spends a couple of days there, wiping blood off their swords and cleaning their boots, looting, eating, fucking, that sort of thing, when news comes that the combined forces of Vitellozzo and the Orsini and Baglioni were once again in motion and are headed their way.

Don Michele, sitting on a pile of stinking corpses, was probably reluctant to push his luck and therefore abandoned the city and moved his army westward, out of harm's way.

Problem was, Vitellozzo and company were coming full speed after them and didn't stop at Fassombrone but kept coming, and kept coming, and surprised them in the middle of the night at Calmazzo,

where Don Michele and his command staff (Leonardo included), along with the rest of his small army, were routed out of their camp by the much larger force and sent running for their lives. Don Michele's co-commander, Moncada, was caught and taken prisoner, probably because he was putting his pants on.

Routs are messy things. You can imagine waking up in the middle of the night to shouts in the dark and looking out your tent flap only to see the outer perimeter has *already* been breached and a wave of troops carrying hundreds of torches is nearly *in* the camp, and you have no time to think *at all*. This is a rout! Fortunately, Leonardo didn't mess with his pants but instead took one look, did some high speed calculations (he was really good with this "motion in space" thing), and immediately jumped on his horse and hauled ass, sensing his life about to end any minute, with Salaì and Zoro matching him step for step I'm sure.

Here we have the remarkable image of Leonardo, a man who dithered over every detail and took all day to pack his bag, a man who was late for everything he ever did, suddenly tearing out of town on horseback, hair flying, half-dressed, heels bumping that horse hard on both sides—running for his life!

And the consensus view is that Leonardo was an excellent horseman, so we can expect that the one time he really had to pop it wide open, he may well have been at the front of the pack.

The sad thought is he may have run off and left his bag—along with his personal diary and dream log. Who knows? Routs are messy things. Don Michele's scattered forces managed to eventually reassemble behind the barricades at Fano on the Adriatic coast and then made their way to Imola, mostly in one piece, probably still rattled and glancing behind them the whole time.

Don Michele and his corps of misery arrived at Imola on October 15, lucky to be alive. They would stay there for the next six weeks: Leonardo and Cesare and Machiavelli, who was the emissary from Florence, along with all those badass Spanish mercenaries and other miscellaneous riffraff an army collects.

All this running around is hard on a fifty-year-old. Cesare was twenty-seven and Machiavelli thirty-four, but Leonardo was not used to jumping out of bed and sprinting in the dark, especially after a whole day in the saddle. And in a battle zone there are no naps. No resting under a tree after lunch. Never a chance to stop and examine anything along the way as everyone's always in a hurry. It's impossible to write notes on a horse, and you're tired *all the time.*

Imola was a chance to recuperate and regroup, but supplies were short and Machiavelli became sick and had to be nursed for weeks and Leonardo probably had a hand in his care. They surely spent a lot of time together, probably with Machiavelli propped up in bed and Leonardo entertaining him with a toy bird or a balloon that would shoot all over the room. Pig lungs were especially good for this. Very stretchy.

Another of those moments in history when you wish you were a fly on the wall, along with all the other flies. With the singular focus a sickbed brings, Leonardo and Machiavelli talked about important things: beliefs and ideals and goals. Leonardo's notion that our study of science should include the arts, that both were the same pursuit of knowledge just by different means, surely influenced Machiavelli's similar belief that politics could be conducted on a scientific basis as well. They were both smart guys and clearly appreciated the other, and both were trapped in this cold castle in a city as good as under siege as Vitellozzo's army was camped just a few miles down the road and could be seen patrolling nearby, waiting for them to come out. Machiavelli suffered from a severe fever, which must've been common during the winter. Apparently, Leonardo was healthy during this time, but we know that only because he was busy making war machines and maps for Cesare.

Most all these maps are lost but the one that does come down to us, a city map of Imola, must've seemed a true astonishment to Cesare and his generals. They had never seen such a map before. It's a bird's-eye view, of course. Imagine the imagination that went into making it.

In his mind Leonardo had to hover over the city at about 6,000 feet to get it exactly right, fighting the wind the whole time. What fun he must've had. It was a labor of love, clearly, and immense abstract vision, all in service of Borgia. And considering that, it's almost obscene how brilliant this map is.

Behind it was all of the usual Leonardian research, but done very quickly. He had to construct a measuring device to pace out the streets, probably the thing he sketched in his notebooks called a "hodometer." Built like a wheelbarrow but with sprockets on the front wheel, it counted clicks over a distance and dropped a ball into a pan at intervals. All you had to do was count the balls and remaining clicks to know the distance you'd covered. Using this, Leonardo (or more precisely, Salaì or Zoro) walked every single street in Imola (probably accompanied by guards as the place was full of drunk mercenaries) and plotted it both by length and width and direction. An astonishing piece of work, which he then digested and cogitated and reimagined as the map we see today. A bird's-eye view. Maps before this were drawn from a hill nearby and mostly showed a lot of rooftops and churches, or perhaps only the city walls; Leonardo's looked straight down and showed you every part of the city precisely, especially the streets. In other words, a modern map.

The map of Imola that survives has his backward scribble so it must be a copy he made for himself. The version he made for Borgia was probably left behind or lost when Cesare abandoned the city.

Again, you might ask, why? Why such beauty in the service of war? Paul Strathern in his *The Artist, the Philosopher, and the Warrior*, thinks the map was a therapeutic response to the chaos around him. Which in itself suggests a certain exhaustion was setting in by now. Those six weeks in Imola spent enduring the cold and the fevers and the uncertainty of Cesare himself ranting and raving down the hall, surely left Leonardo no better rested than before, maybe less. And when disturbed, he worked to take his mind off things. That too is part of Leonardo's method. And when he wasn't working on his map,

he was designing siege machines for Cesare which would be built later in Rome. If all this activity is reflective of his mental state, something fierce was surely going on.

The twelve-thousand-man army stayed in Imola until they'd "devoured everything down to the very stones," as Machiavelli reported back to Florence, and were now causing a famine in town. Cesare left suddenly in a snowstorm with his troops on December 10 for Cesena with Leonardo and Machiavelli somewhere in that ten-mile-long train of men and animals pushing through the cold and the wind. I'd like to think Leonardo had finally discovered some trick of staying warm, but it's probably not so. He shivered right along with everybody else.

It was at Cesena that Borgia regrouped and called in one of his oldest and most trusted commanders, Ramiro de Lorqua, who rode in from Pesaro to consult with Cesare that very evening. Lorqua had known Cesare for years, since he was in school, and had been his enforcer many times in the past. Other than Don Michele, Lorqua was the commander he was closest to. Lorqua was a harsh disciplinarian and the people in various cities under Cesare's control had felt his cruelty many times, but he was loyal and obedient, everyone agreed. In other words, he was no better or worse than Cesare himself, and was probably just following his example, if not his exact orders. Lorqua was twice Cesare's age and known to have a fierce look in his eye and a large, intimidating black beard, and was even better known for being a heartless thug. However, when he showed up at Borgia's court in Imola, instead of being welcomed and warmed up after his ride, he was immediately grabbed and thrown in the dungeon.

Apparently Cesare's old friend Lorqua started confessing to all kinds of crimes once his shoulders were pulled loose and a few hot irons applied, not the least of which was knowledge of the plot against Cesare. Turns out he knew all their plans and spilled his guts, so to speak, probably hoping for some kind of leniency or forgiveness based on their many years together and close friendship.

The next day Machiavelli hurriedly wrote to the Signoria back in

Florence: "This morning Lorqua was discovered with his body cut in two on the piazza where he still lies, and all the people have been able to see him. No one is sure of the reason for his death, except that it so pleased the Duke, who by so doing demonstrated that he can make and unmake men as he wishes, according to their desserts."

At first sunlight Lorqua had been discovered laid out in the city square in front of the castle walls, covered with his finest cloak and with his two kid-gloved hands neatly severed and laid at his side. A spear stuck in the ground next to him had his severed head on top, long beard hanging. He was probably cut in half lengthwise, from neck to groin, that being the accepted custom of the time.

When Machiavelli wrote "and all the people have been able to see him," he was including Leonardo who was likely standing right beside him. And it's Leonardo who must be considering what this all could mean for himself. After Fossombrone, maybe one more hacked up body didn't impress him so much, but he did know Lorqua personally. They were about the same age. We can imagine there wasn't much crying over Lorqua's body, but whether he liked him or not, it showed the Duke's brutality, and that had to be scary. Leonardo was swimming in blood and there's no end in sight.

Four days later, after eating Cesena down to the very stones, Borgia pulled his army out onto the road again and they arrived in Sinigallia two days later on December 31. It was very cold.

What most people think of when they hear Cesare Borgia's name is Sinigallia. He made the place infamous with an act of treachery so black and so complete that Machiavelli was inspired to use him as the model prince in his own infamous book. It's a nasty piece of work, but it was masterfully done, if perfidy is your trade.

INSTEAD OF ATTEMPTING to describe that bowl of spaghetti that is the Third Italian War with its three-part alliances and double-dealings and switcheroos, let me just say instead that prior to this

Vitellozzo had his chance to kill Borgia, and flubbed it. This could be for a number of reasons. Vitellozzo was eaten up with syphilis, even worse than Cesare, and (like Cesare) oftentimes had a huge boil on his groin which pained him extremely and made sitting on a horse nearly impossible.

There was also the money problem. Vitellozzo didn't have the papal purse behind him and couldn't hire more cannon or mercenaries to mount a long siege on Imola when he had Cesare trapped there. Most historians think that Cesare was vulnerable and if Vitellozzo had just pitched all in, he would've conquered Imola and taken Cesare prisoner and we'd be telling a different story today.

But he didn't, and Cesare was able to rebuild his forces over the following few weeks and would soon resume his campaign. Seeing this, Vitellozzo and his fellow commanders decided their time had passed and it was best now to propose an alliance with Cesare, again, and get on his good side, again (I'm skipping over details like a plane over mountaintops), so they wrote to Cesare and Cesare pretended to agree to this alliance with open arms, writing back as if he'd missed his old buds Vitellozzo, the three Orsinis and Baglioni and Liverotto da Fermo, and was glad to see them coming back into the fold of trusted friends. Yes, he did.

They agreed and, as a show of goodwill, went ahead to occupy Sinigallia ahead of him and would be waiting for him to arrive so they could hand over the city to him personally. Borgia agreed to this and thanked them and asked only that they remove their troops from inside the fort so his own would have room to bed down. A simple request. Of course they agreed, moving their own troops outside and dispersing them on the fields around the town.

Long story short, before Cesare reached Sinigallia, an advanced guard of his own rode ahead to the castle and formed a cordon from the bridge over the moat to the front gate of the castle wall to honor Borgia's entry into the city.

Meanwhile Vitellozzo, the Orsini, and Fermo ride out to meet Ce-

sare, who, no doubt, greets them with something like the old school spirit. They hug, they slap backs, they smile into each other's eyes and squeeze hands and swear eternal allegiance to the Pope and to Cesare himself. Cesare thanks them from the bottom of his heart and even gets a little misty and asks if they would join him in entering Sinigallia in triumph. They all agree, of course.

They ride together into Sinigallia and approach the old medieval castle with its moat and high turrets and they cross over the bridge and in through the waiting honor guard—a cordon of men on horses lined up on both sides from the bridge to the gate in the castle wall, a distance of maybe fifty yards. Because of this cordon, Cesare entered first, and then Vitellozzo, the Orsini and Fermo, wishing to please him, had to follow immediately behind, separated from their troops by Borgia's guards on either side.

At this point they were in a funnel being pushed forward by notions of custom and honor and politics, and what happened next was that as soon as Vitellozzo, the Orsini, and Fermo passed through the gate and into the courtyard, the gate closed behind them. They dismounted and were led, without their guards, no doubt nervously looking around, into a building. Simple as that. They were cut off from their troops and alone inside the walls with Borgia and his squad of assassins—all of whom are smiling and staring straight at them. They were quickly disarmed, while outside the castle walls their troops were being butchered by the vastly larger army of Cesare.

What followed in the banquet room was the usual X-rated humiliation and begging and finger pointing, each conspirator blaming the other. Vitellozzo, in particular, humbled himself and cried like a baby and carried on, probably too long, pleading for his life, but Cesare had to excuse himself "for the necessities of nature," and walked outside to have a piss while Don Michele, who was there with his garrote, strangled both Vitellozzo and Fermo "in the Spanish style." The three Orsini would be held prisoner while Borgia communicated with Rome.

As this treachery was unfolding inside the castle walls, outside

two things were happening: first, Cesare's troops were running totally amok in the town, a rampage of looting and raping and murder among the local population of Sinigallia, which also included setting buildings on fire, pulling bodies apart, hacking every-which-way. Chaos on top of mayhem with an extra stir.

And second, Cesare's support staff finally arrived, including Machiavelli and Leonardo, who rode into the middle of the sacking. Fortunately Cesare was there on his horse, trying to subdue the chaos, saw them and called Machiavelli and Leonardo over to him, probably both for protection and so Cesare could tell Machiavelli what had happened to the plot against him and his long planned revenge for this day. The coup had been stopped, dead in its tracks. Machiavelli wrote as much back to Florence that very afternoon, adding:

> The town is still being sacked and it is now an hour before sunset. I am extremely worried. I am not even sure that I will be able to find a messenger to relay this message to you. I will write to you at length later.

When he wrote, "I am extremely worried," I suspect he was speaking for the both of them. On Leonardo's personal list of massacres experienced, this would be number three, if you count Novara a few years before, and Fossombrone just last month. And he had more coming.

January 1, the very next day, Cesare left Sinigallia smoking, with Leonardo and Machiavelli and army in tow, along with the three Orsini brothers. He also sent a letter to his holy father in Rome, who then sends a rather deceptive note to Cardinal Orsini, Alexander's "dear friend" (and secret instigator of the conspiracy against Cesare), to come celebrate with him the fall of Sinigallia. And Cardinal Orsini, thinking his family was getting credit for this victory, hurries over to the Vatican—only to be seized and thrown into the Vatican dungeon.

Old story, new players. Reputed to be one of the wealthiest and

most powerful men in Rome, Cardinal Orsini had his house plundered and his wife, mother, and daughters turned out on the street in nothing but the clothes on their backs. Their friends, in fear for their own lives, refused them help. They wandered confused and filthy and lost around the city for a while, sleeping with the beggars until one day they just disappeared. Cardinal Orsini died six weeks later in that dark papal dungeon, deranged and talking nonsense. He was an old man and easily broken. The Orsini were longtime rivals of the Borgia and at one time had nearly stopped Alexander's ascendancy to the papacy. This plot against Cesare was dissolving quicker than bread left out in the rain.

Cesare heard the news in the field. He was on the march again, headed north to Città della Pieve, where he received a message from Rome that all was well there. He stopped long enough to have Don Michele garrote the three remaining Orsini in a ravine nearby, just to finish off that branch of the family. Borgia's revenge was soon heard about all over Italy and impressed Machiavelli enough to write, "The Duke's actions are accompanied by a unique good fortune, as well as a superhuman daring and confidence that he can achieve whatever he wants."

Ah, the Renaissance.

ACCORDING TO PACIOLI, it was probably on this campaign that Leonardo built a bridge over a river to allow the troops and cannon to cross, and he did this by arranging the wooden beams in an interlocking fashion, no nails or attachments used. The more weight you put on it, the stronger the bridge becomes. I don't think Leonardo invented this technique of bridge assembly but rather learned it elsewhere and (like his windmill idea) had stored it away for later use.

Borgia kept marching his army north toward Siena, chasing down the last of the conspirators against him, Pandolfo Petrucci, a wily old man and much smarter than Cesare who kept slipping away from him.

Borgia's army consumed everything in front of it, destroying one village after another. Leonardo was probably riding at the head with Cesare to stay out of the dust that hundreds of horses could make, gazing with dull eyes as the bloodshed continued left, right and center. Leonardo leaves no record of this, nor does Machiavelli, but Johannes Burchard, Alexander VI's Master of Ceremonies, in Rome on January 23, wrote in his diary:

> Word has reached us that during the last few days the Duke has seized the fortresses at Sarteano and Castel Piave, and also San Quirico. By the time they reached San Quirico all they found were two old men and nine aged women. The Duke's soldiers hung these unfortunates by their arms and lit a fire beneath their feet to make them reveal where the local treasures had been hidden. The poor women, knowing nothing, or in any case not revealing anything, died hideously. After having smashed everything in the village the soldiers burned it to the ground.

Leonardo was there. He saw the same things everyone else saw. These villages weren't that different from Vinci, where he grew up. These old people looked a lot like someone he knew. It began to seem, truly, as if Cesare, bastard son of the Pope, was the devil himself.

Something seems to have happened to Leonardo along in here. He had to leave the campaign. He'd seen too much. Either Cesare recognized this, or Leonardo convinced him by puking on his boots, but somehow, someway, Cesare turned loose of his chief engineer and sent him off to Rome to begin work on his siege engines.

At this point, Leonardo may be starting to separate himself from his own species. He is repelled in every way possible by human beings and their cruelty to each other. *Pazzia bestialissima*, or "bestial folly," he would call it later in his notebook. Man was no longer the perfect creation upon which nature was modeled. We were not the apple of

any god's eye. Man was just another animal and behaved like one, lying to himself constantly about it. It was easier to respect a noble horse than to ennoble a man.

It was then I think some last thread of concern he had for the opinion of others and their protocols and fashions and opinions just faded away, and Leonardo gradually started to become rather different. For one thing, he stopped cutting his hair.

For another, he stopped eating meat. Described as a vegetarian traditionally, it's not known exactly when he stopped, but I figure it's somewhere along in here. The smell of charred skin had become too vivid to forget. He'd stopped wearing leather when he could. No more death hanging on him. He would not allow himself to become, as he later wrote, "a tomb for other animals, an inn of the dead . . . a container of corruption." And it was said of Zoro as well, "He would not kill a flea for any reason whatever; he preferred to dress in linen so as not to wear something dead."

Because it was so utterly unusual in Italy (or Europe) at the time, Leonardo's vegetarianism seems to be one of the things people remembered about him. For some he might've been the only veggie they'd ever met. An Italian traveler to India in 1516 wrote of meeting the Gujarati and describing them as "gentle people . . . who do not feed on anything that has blood, nor will they allow anyone to hurt any living thing . . ." And then he adds, as if to explain this strangeness, ". . . like our Leonardo da Vinci."

Leonardo left Cesare for Rome on January 24, taking a circuitous route to avoid any territory held by the remaining Orsini, and probably with an armed guard to protect him from ambush and robbery. A journey of several more days in the saddle.

Assuming Leonardo's health was good during this strenuous period (and I'm not sure of that), he was still living with a daily level of stress that was mind numbing. It's from this point we can look back to his time in Milan (as he certainly did) as that rare period where he

had a measure of security and excellent accommodations and the employ and favor of Ludovico, not to mention his health. A time when the conditions for having inventions and insights were favorable and he had the energy and focus to accomplish much. He missed it, badly. Now, since the collapse of Sforza, he'd been continually in motion with rarely time to sit and contemplate the world, much less ask and answer those questions that bedeviled him so much. Instead he found himself living according to the schedule of others, and their agenda, every hour of every day, and this was a change for him. And it likely left him angry and exhausted like it would most anyone. In Milan he had lots of private time to think and work and grow; on the road with Cesare he owned not a moment of his day that was not spent on murder and mayhem or the witnessing thereof.

His distress was probably severe enough that he'd asked Machiavelli to help him get excused from Borgia's service completely and returned to Florence where he was needed for the Florentine's own war with Pisa.

Once he arrived in Rome he met with Alexander and the Pope apparently showed him a letter from the Sultan Bayezid II of Constantinople, who was asking for an engineer to build a bridge over the Golden Horn, a bridge eight hundred feet long—which would've been the longest bridge in the world at the time—a project that surely appealed to Leonardo.

Several hundred years later, it was discovered that Leonardo had in fact written to the Sultan and offered his services. The letter, discovered in a Turkish archive, is translated and paraphrased into Turk, but is still much like the letter he wrote offering his services to Ludovico Sforza twenty years before, and similar too was his listing of his various skills, only here he did not mention military engineering among them. Nor did he mention painting, strangely enough, perhaps to avoid offending the Moors who were iconoclasts. He only wanted to build the bridge or other civil engineering tasks, like silage pumps

or windmills. There's a tiny sketch of such a bridge in his notebook, based perhaps on a bridge he saw under construction at Castel del Rio while surveying for Cesare, just twelve miles southwest of Imola in the foothills of the Apennine mountains. Mainly I think Leonardo just wanted to get as far away from Italy and his life there as possible, and building a giant bridge was the best kind of excuse.

Leonardo's connection to Turkey through his mother Caterina may be a factor as well. Perhaps he felt he might find some aspect of his identity there, something like a cultural home, something alien enough to look familiar, something he was still searching for at age fifty-one. Perhaps there was even some urgency behind this offer to relocate. After the devastation of the last two years, he might have been trying to rebuild his life one more time, and needed a patron . . . and was willing to wear a turban if need be.

BUT HE WAS in Rome and still working for Cesare Borgia, supervising the construction of at least two siege devices. One was a weapon that fired a fuselage of shells, probably like the one he drew for Ludovico, and the other project was a device capable of protecting and delivering three hundred soldiers up and over a city wall. We'd see it today as a staircase on wheels with a roof that the troops pushed up to the outside of the wall and were able to ascend without arrows being shot into their soft unarmored bodies.

In late February, Borgia left the siege at Ceri, an Orsini stronghold just twenty-two miles from Rome, to confer both with his father and with his chief engineer. Apparently he wore his mask the whole time. His face must have been a mess.

Somehow, some way, Leonardo was able to secure his freedom from Borgia and finally began the journey that would take him back to Florence, 180 miles away. A journey of seven days—plenty of time to contemplate his miserable situation. Once again, Leonardo was at a transitional point in his life. It's late winter, maybe it's snowing, he's

riding his war horse, his traveling bag full of dirty laundry and note-books. Salaì and Zoro probably riding with him. He's reconsidering all that he had been through with Borgia, and looking ahead to Flor-ence. He was certainly not returning the same man as when he'd left eight months before.

1503 Seville in Castile is awarded exclusive right to trade with the New World.

1503 The Battle of Cerignola is the first battle in history won by small arms using gunpowder.

1503 Nostradamus is born (d. 1566).

1503 The Italian engineer Giovan Battista Danti attempts to fly and crashes into a church roof.

1503 The Treaty of Everlasting Peace is signed between Scotland and England; it lasts ten years.

1503 Queen Isabella I of Spain prohibits violence against native tribes in the New World.

1503 Da Gama establishes India's first Portuguese fortress at Cochin.

1503 The Canterbury Cathedral is finished in England after 433 years of construction.

1503 The pocket handkerchief comes into general use in polite European society.

1503 Leonardo begins *The Virgin and Child with St. Anne*.

1503 16,000,000 kilograms of silver and 185,000 kilograms of gold will enter the port of Seville from the New World each year until 1650.

FLORENCE REDUX

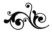

Age 51

ONCE BACK IN Florence it was as if he'd entered another world, the world of art and ideas and constant back-biting politics—the Florence he remembered from days of old. The brilliant sewer. But he also discovered a conceptual shift had taken place, one he'd been too busy to notice while on the road. The news must've come like a thunderclap to him.

Amerigo Vespucci, another Florentine and probably someone Leonardo had met, was anchored off the coast of Brazil (as we know it now) and studying the stars one night when he realized suddenly that Columbus had made an error in his longitudinal reading. A huge error. From 1493, when Columbus returned to his home port of of Palos de la Frontera in Spain, to this moment in 1502, when Amerigo Vespucci starts scratching his head and pulling his beard and recalculating his numbers, the belief had been that Columbus had reached the eastern coast of Japan, and then China. Columbus thought so and that's what he told everyone, and doubtlessly what Leonardo thought as well. This was based on a wrong notion of the circumference of the earth and Columbus's poor measuring skills, coupled with a complete and total ignorance of Japan and China. Anyway, Amerigo was considerably better with his astrolabe and came to a realization that dark evening that changed Europe and then all the world around it. He

looked with his own eyes and suddenly realized he wasn't off the coast of Japan at all, but instead that big black thing full of birds in front of him was a new continent. A new continent! This would be news in any age, but when it hit Europe in 1504, the news landed with an audible thump, followed by a long rumble. It almost seemed beyond belief.

It is why America is America, named after Amerigo Vespucci and his stupendous thought. Fortunately it wasn't called Vespucciland, which could've happened as well.

So what did Leonardo think about all this? Like landing on the moon in our own time, such news changed everything and affected how he saw his own world. It changed the context, the frame for him. I think it made smaller those things that had loomed large before: church, kings and princes, human institutions, the certainty of some scholars, and it especially shrunk to flea size Cesare Borgia. He was just another bug on the hill. He and his father both. Leonardo had that sense of deep time, of geological time, that's clear from his notebooks, and I think he saw events around him that way too—deep and broad. He tried to put things in context.

He was living in a transitional period but he couldn't know that. What he saw was the insubstantiality of things, the uncertainty of accepted truth. The possibility of the new and the clinging of the old.

Surely, this new continent changed how he thought about himself as well. This is a change that is impossible to trace, but how else could it be? That he doesn't apparently mention it in any of the *surviving* notebooks means nothing. Whether he wrote about it or not, we know he talked about it—and we know this because he talked to other people and that's what *they* were talking about. A new continent! Try *not* to talk about it. His world was suddenly a lot bigger, and people were a lot smaller. And that included him.

I also think it validated Leonardo and his suspicious way of thinking. I think it made him even *more* suspicious. Too many grave authorities, both in and out of the church, and court, had been wrong

about the world and here was the proof. Again. To know anything you had to think for yourself. They were probably wrong about the night sky as well.

It also likely fired his imagination from every possible direction. The romance of this great discovery, overturning all that came before it, was everywhere around him. Likewise there was talk about all the gold to come out of the New World and the opportunities that could arise there, as well as the immense savagery in the jungle. Cannibalism had been rumored. The Medici were sending another ship westward as well. It had been a Medici ship Amerigo Vespucci was standing on when he had his big idea.

About this time Leonardo added corn to his shopping list. An age of discovery is breaking out around him and he's having to play catch up. Exactly the spur any autodidact needs to reengage. Ships and explorers were returning from distant places and such news surely must've altered his thinking about all sorts of things. Leonardo got word that Cesare's siege of the Orsini stronghold at Ceri had been successful. It was reported elsewhere that Cesare had used unique devices in his siege and with a new kind of cannon he fired over six thousand exploding cannonballs into the city. This would all be Leonardo's work but my suspicion is that he's not taking much pride in it now. He's thinking of art again. It was his reaction to the horrors of war. There's evidence he might've begun sketching a local woman named Lisa around this time. If so, she comes out of a bone yard. You can still see it behind her.

This sketch would become another portrait of an obscure person. Why, when he had Isabella d'Este offering him ducats (and probably others as well), did he choose instead the young mother and housewife of a merchant, Francesco del Giocondo, who happened to live across the street from his father Ser Piero, and who apparently never paid him anything? Rather seems like a control issue to me. To be in control, to paint as he wanted, for the reasons he wanted, he had to

steer clear of aristocrats and other bossy individuals. This painting was beholden to no one. There are no receipts, no records of payment, no schedules to dispute. What we know of the actual beginnings of the portrait is conjectural and oblique; it just began after some impulse in Leonardo, still alive after his time with Borgia, flared back into life. This would be a painting done for himself.

Leonardo entered fully into Florentine affairs during this time, much more so than he'd ever done before as a young man living there, and you could probably see him striding around town, reconnecting with all kinds of people. He was an acknowledged master now, the painter of *The Last Supper* in Milan, which was the one painting some people had seen , and of the cartoon done for the Santissima Annunziata, his *The Virgin and Child with St. Anne.*

And he was Borgia's chief engineer, the inventor of terror never imagined before. The rumors had preceded him. Borgia's reputation was in some ways his own. Mention his name and you hear, *"Oh yeah . . . Borgia's engineer? Nasty business, that."* The taint of Borgia hung on him, for both good and bad. There's no doubt he was debriefed by Machiavelli and others once he was back in Florence as to Borgia's intentions and methods.

Then late that summer came unexpected news from Rome.

PROBABLY TO ESCAPE the heat, Cesare and his father Alexander had dined at the palace of Cardinal Adriano da Corneto on August 6 in the garden which faced a pond, which in turn bred mosquitoes—one of which dived onto Alexander's soft papal flesh and stabbed away, while a few of his buds went for Cesare and the Cardinal. Divine retribution? We'll never know, but all three came down with malaria. Cesare and his father both submitted to the treatment of the day, which in the case of Cesare's high fever, caused all his skin to peel off after he was dipped in oil and ice. Alexander's doctors began draining his blood, which was called "blood letting." In one day they

"let" thirteen ounces out of his body. This was intended to help. For twelve long days both father and son hovered near death, one of them drifting ever closer . . .

When word spread that Pope Alexander had died, and his evil son was hanging by a thread, there was little grief seen in the streets. Alexander would not be missed. He had debased nearly everything he touched as pope, not just by selling offices and indulgences by the gross ton and making obscene amounts of money which he spent on orgies and lewd dancing and trunks full of jewels, but his straight-up abuse of power which has affected the world ever since. It was Alexander who, in a series of bulls he issued, divided the New World between Portugal and Spain, giving the bulk of it to his native Spain of course, and then he endorsed slavery, sanctioning three-hundred years of human misery in the Americas. This was to help development in the New World and win him influence with Spain.

The pope's body was exhibited to the clergy and citizens of Rome, but was covered by "an old tapestry," because of rapid decomposition. According to Raphael Volterrano, "It was a revolting scene to look at that deformed, blackened corpse, prodigiously swelled, and exhaling an infectious smell; his lips and nose were covered with brown drivel, his mouth was opened very widely, and his tongue, inflated by poison, fell out upon his chin; therefore no fanatic or devotee dared to kiss his feet or hands, as custom would have required."

After the funeral, while his coffin was being returned to the papal chambers, his guards began fighting over some gold candleholders and Alexander's putrid body accidentally fell out of his coffin onto the street and was left out there overnight as no one wanted to touch it.

In the scramble that followed, Cesare (hearing the remaining Orsini were all rushing his direction) made his way out of town more dead than alive, carried on a litter, trunks of papal gold and jewels loaded on his many wagons headed out of Rome. Then, after a few months of flailing around and double-crossed confusion, Cesare Borgia lost the support of the new pope, Julius II, and then his com-

mand over the papal forces, and was eventually thrown into prison for his past crimes, where the bugs start eating on him.

BACK IN FLORENCE Leonardo was thinking about war again. He had no choice. It was the age in which he lived. Everybody was fighting somebody else. Florence was involved in a struggle of its own with Pisa and as a consequence had lost its access to the sea—a matter of some importance to the merchants in town. Most scholars think Machiavelli worked up the scheme to divert the Arno river away from Pisa only after getting the idea from Leonardo in the first place, who then was proposed for the job of master engineer-planner. During their time together in Imola, Leonardo probably told stories, and his first battle at Novara does seem excellent material for a night's entertainment. And if Machiavelli believed that Leonardo could do the same with the Arno, then he would've carried this idea with him the last several months and proposed it to the Signoria, not just as a way to end the battle with Pisa, but to also help his friend Leonardo get away from Borgia.

Florence had a history of warring with Pisa. One of Leonardo's half-brothers had died in a battle with Pisa ten years before. Florence likewise had a history of attempting to divert the Arno and starve the Pisans into submission. This was an old idea they'd tried before. Dante had wished total destruction upon the town. But Leonardo's plan was different, and the drawings he made of his plan created an illusion of certainty that made it seem all so real. This was continually the effect his drawings had on people, and he used this to his advantage over and over. It also got him into trouble when it seems he not only convinced others a project was feasible, but convinced himself as well. This seems to be the trait that Vasari detected, and must've been mentioned to Vasari by others who knew Leonardo. That left hand was magical, even to him at times. He drew things not just to know them, but to possess them as well, and this required an act of belief,

even of transference. I wonder if he recognized this in himself. If it was part of his internal method to believe something into existence. A shaman trick.

In an age before images were a common thing, Leonardo was the artist/magician who plucked living objects out of thin air. To the average person it was as if his thinking was more real than everybody else's. Certainly more concrete and vivid. And surely more convincing as well. You could see it.

But, you ask, would this beautiful and detailed plan actually work?

You'd have to build it to find out, but it certainly *looked* like it would—and that is all important. What we call "verisimilitude," the appearance of being real, was a dividing line that ran through his life. That left hand could deceive anyone, including him, and had at times in the past. Maybe he'd become wary of his own magic.

To others certainly art that beautiful was a powerful thing, especially if you'd not seen the like of it before. And the man who could make it so easily was a man you had to be on your guard against. He can make you believe anything. Some knew that, most didn't.

Unfortunately for the city of Florence, their guard was down and (coupled with Machiavelli's eloquent persuasion) Leonardo's magic worked once again; they accepted his scheme for diverting the Arno river and formally adopted his plan. Actual digging would begin in late summer.

IN MACHIAVELLI, LEONARDO had a friend in high places who could get him gigs, and now that friend arranged for him to paint a huge panel in the newly expanded Great Council Hall of Palazzo Vecchio. The subject was the Battle of Anghiari, a Florentine victory over Milan in 1440. Leonardo was no doubt grateful as he needed the money—it seems Borgia might've stiffed him.

Leonardo begins composing in his head a full size cartoon, an attempt to capture the entire struggle of war in a single instant, the

same as he had done in *The Last Supper*, looking for an emblematic moment that would tell the tale. His head is full of images from the past year. He will never lack for images of war again. The problem is too many images. He's looking for something with depth, with complex meaning, not the usual one-dimensional, romantic cliché, like a fight for the standard or flag or some such. And he seemed to look for that right idea a long time. Months go by.

But then, at some point he realized that if he took just such a cliché as a fight for the flag and subverted it by making it *too real*, by finding its extreme horrific limit, he would have such an image as spoke to him—and likewise spoke different things to different people. He needed a moment of battle that the casual looker would nod and approve of, but those who studied it more deeply would see lurking underneath something else, something subversive. Leonardo loved ideas that showed motion and anticipated the viewer's thoughts, and a fight to the death over a wooden stick with a cloth on it was perfect. His subversion took the form of showing us the fury of battle at its absolute insane and moronic limit. A stupendous moment of bravery, in the conventional sense, that is simultaneously stupid beyond words. Lunatics on horses. This will not be a painting about glory, but about the insanity of glory, reflective of Leonardo's evolved feelings on the subject of war.

At this stage in his life I don't see how he could draw it any other way and not choke on the effort. Still, he has to work it out on paper and in the process of working it out brings to it his art, his skill, a lifetime of learning, and finds himself glorifying even what he abhorred. In spite of himself *Anghiari* was becoming a thing of beauty. I wonder what he felt about that conflict, if there was turmoil in his own mind about beautifying death and insanity. I think he found his pen harder and harder to move, as if he'd fallen into some kind of dilemma.

The notion that Leonardo was a cold and analytic artist who composed out of some remote intelligence and at a low pulse is wrong; his art was tied to his emotions and depended on them to an extraordi-

nary degree. Leonardo was probably driven by his emotions every bit as much as most artists, not less. And he knew it. "Where the spirit does not work with the hand, there is no art." Without the emotion (or with too much) he could hardly move his art forward at all. Machines he could work on in any mood; art took something extra he didn't always have: the ability to leap into and become his subject, to inhabit its skin, to be in two places at once. He counted on inspiration, he always had. Without it, he was left making excuses and blaming the weather.

The subject of the battle had been assigned to him; its purpose was to inspire the governing council. The composing was very slow and he no doubt went through many iterations before he found that moment pure enough and ambiguous enough to speak. And yet he's depicting the very thing he wants most to forget, the horrors of war, revisiting it over and over to complete the cartoon. Clearly he's having to push himself here.

He needed the money. He'd twice withdrawn fifty ducats from his savings, and the fifteen ducats he was being paid monthly for painting the council hall was badly needed.

1504 Columbus uses his knowledge of a lunar eclipse to convince
 Jamaican tribesmen to provide him with supplies.

1504 Ẓahīr-ud-Dīn Muḥammad captures Kabul.

1504 Venetian ambassadors suggest to Turkey the construction of
 a Suez Canal.

1504 In Germany, Matthias Grünewald paints *Crucifixion*.

1504 Raphael paints the altarpiece *The Marriage of the Virgin*.

1504 Filippino Lippi dies in Florence (b. 1457).

1504 Drought and famine in Spain.

1504 Michelangelo completes the *David*.

1504 Hieronymus Bosch completes *The Garden of Earthly
 Delights*.

FIGHTING THE BATTLE

Age 52

HE'D BEEN ASSIGNED the Pope's Hall in Santa Maria Novella as his studio for making the full size cartoon of *Anghiari*, but the place was run down and needed repair before it was usable. Bad windows, leaky roof, it seemed abandoned. Probably had leaves blowing across the floor. Leonardo's probably sleeping there as well, along with Salaì and Zoro, and who knows? He's got all of his stuff there too, including the 116 books he'd managed to acquire at this point. A veritable library, books piled everywhere. He made an inventory in a notebook. Elsewhere, either Salaì or Zoro wrote, "Money's really tight around here!" To pay the bills Leonardo had to focus on the details of the Anghiari slaughter when the details are already too many in his head. He could smell the details, they were in his nose still. The effort now was to sort them out and arrange them.

It was from this chaos he eventually began creating the center-piece of his cartoon: a nightmare mass of entangled bodies colliding, each fighting the other to a slow death, over-topped by crossed swords raised for the final chop. And near the center of this colliding mass of flesh, where it can easily be missed, he placed the single insane eye of a terrified horse—and it's looking straight at *you*.

It would make a tremendous statue. Every face and gesture in it, of both man and horse, seems taken from life and deeply felt. It must've exhausted him to compose that cartoon. This is what fury looks like

when you can smell its breath and are close enough to be sprayed by spit and blood. This is hell itself. Even the horses are biting each other. It's complete and total annihilation, self-inflicted. For a flag.

Leonardo doesn't seem to be guessing here. There's no romantic spin at all. No gaps in his knowledge he has to fill in. Nothing left to measure. He knows what crazy looks like up close. The composition has a polished, digested quality to it that shows a deep familiarity with battle. He's looked, and seen, and reimagined what he's seen, and then revised that, over and over, striving for some kind of beautiful equivalency, some kind of art to be made from all that pain and squealing death.

Or at least in his own private world that's what the Signoria was asking him to do. They would not ask any other painter to do that, but that was the task for Leonardo: take what you find most abhorrent and make it pretty for the councilors and notaries of Florence while they do their greedy business below it. Thank you, here's another fifteen ducats.

He really does try, I believe that, but the painting is all wrong for him. It's hard to focus. He continues to work on the cartoon in his studio when he can but it's a misery. He actually wants something peaceful and calm. Something like his *Lisa* left standing in the corner. When he has a free moment that is where his imagination goes, that is what interests him. He works on it every day, at least in his mind. How to capture that sense of a life flickering, a thing so enormous and fragile, something he'd glimpsed over and over in the last few months and years? We know now he experimented a lot and that there are three earlier versions under what we see, his ambition for the painting growing, his vision deepening.

But his heart is not in this *Anghiari* battle, even though his pocketbook is, and it *is* a very prestigious commission. He pushes himself forward while still finding twenty diversions. He's designing machines again, musical instruments, an excavator, the mill of Doccia, and a sluice gate for Vinci Lake. Having learned from his experience

in Milan, he also designs and has built a working platform for his wall painting that could be raised and lowered all at once, based on an accordion design of moveable pivoted crossbeams. He's even fiddling with his flying machine again. It does seem as though he's mad with ideas for just about everything under the sun—except painting that wall. The sheer number of diversions speak to his coping mechanisms and reluctance to face the task. There is too much death still hanging on him. He wants away from all that. It must seem like something he has trouble explaining to himself, something he can't find words for. He's blocked.

No telling how much time he spent alone playing his *lira*.

Still, he has not finished his cartoon and no painting has yet been started and city officials were becoming worried. It's been almost six months. Machiavelli was sent to talk to him.

Perhaps Leonardo attempts to explain, or perhaps he equivocates. Maybe he shows Machiavelli the nearly finished cartoon that's been pricked and ready for transfer. Or about to be pricked, or will be pricked as soon as he finishes this part over here. No doubt they did a lot of circling the room but a new contract was drawn up, generous to Leonardo and forgiving of the delay—if he will only begin painting the wall! He can even have more time with the cartoon if it can be seen he's also putting actual paint on something, if only an undercoating and perhaps a sketch or two. Motion of some kind, please.

ABOUT THIS TIME a rare event occurs, and that is Leonardo's presence at a public discussion where a transcript was kept. The city had convened artists and inventors and other craftsmen to consider and advise them on the placement of Michelangelo's statue of David, newly finished and still standing in his roofless studio at the Cathedral workshop, which is where the gathering takes place.

This meeting is a historic snapshot of artistic Florence in January 1504. Aside from Michelangelo standing in the corner and probably

scowling at everybody, there was a roomful of talent milling around and finding their seats. It was very cold and their words became small clouds as they spoke. In a couple of weeks the Arno would freeze solid and you could walk across it. Leonardo was probably wrapped up like a Bedouin herdsman in a sandstorm, trying to stay warm. He knows everyone in the room, and they know him. Botticelli is there, Lorenzo di Credi, Perugino, David Ghirlandaio, and Filippino Lippi, who's not looking too good. Even a clock maker and a guy named "Curly the Goldsmith" are in attendance. An august crowd, the crème de la crème, hobnobbing and whispering jokes behind their hands and everybody looking at everybody else, judgmental as hell, as such gatherings tend to be.

Michelangelo's giant *David*, brand new and shiny white, stands in the corner. Originally it had been meant for the roof but it was found to be too beautiful for such a remote location so a place must be found for it in the Cathedral Square. Where, though? These various artists had been gathered to help the council make their decision.

I suspect though that as a group they were rather more alike than different, even given their occasional wild individuality. Their values were those of the marketplace, their politics that of expediency and conditioning. Their religion was that indigenous to the area. Botticelli was a fervent Christian, a follower of Savonarola. Michelangelo a deep believer as well who saw himself as an instrument of God. All these guys were superstitious and men of their time—all except for one. The guy in the purple robe, wrapped up like a Bedouin, sketchbook in hand. Everybody noticed the new beard.

It takes some chutzpah to pull out a sketchbook in a crowd of artists and draw in front of them, especially that crowd. The others there surely noticed. He draws the giant David standing before him, or at least a version of it. His *David* is a thug and kind of stupid, all muscle and no brain, and the sketch survives. But, except for his insane interpretation, he gets the statue exactly right, every knot and bulge. The guy sitting next to Leonardo looks and nods and smiles.

Michelangelo is watching from the corner. Lots of electricity in the room.

The discussion began with the First Herald of the Republic addressing the group and stating his belief that the city has been cursed by Donatello's statue *Judith and Holofernes*, which at that time occupied the central location before the cathedral. He goes on to describe a vision of evil descending from the sky he personally experienced that was brought on by Donatello's statue and explains why it *must* be moved elsewhere and Michelangelo's *David* placed there instead. The *David* would send the right message to the world and keep everyone safe. This seems to be the official point of view and seems to ascribe a kind of witchcraft to *Judith* that has been harming the entire city for years now. (At the very least, it speaks to the power of art on the Renaissance mind.)

What the First Herald was trying to do is persuade people and he's attempting to do that by scaring them. And it probably worked, at least for some. Others expressed caution about such an aggressive-looking statue as the *David* in such a prominent place, and wouldn't it bring trouble to the city as well? Another was concerned about the effects of the weather and suggests placing it under the Loggia where it will be protected, and more out of the way. The twenty-nine advisors in attendance divided basically half and half on placing it, either under the Loggia or out in the open replacing *Judith*, but for a variety of reasons.

Only one person objected to the placement in a central location because of concerns for decency: "I confirm that it should stand in the Loggia, where Giuliano has said, but on the little wall, where they hang the tapestries on the side of the wall, with 'ornamento decente,' and in a way that will not spoil the ceremonies of the officials." Meaning it would be better out of the way under the Loggia, and with a fig leaf attached. There was probably a laugh after that. Everyone in the room was smiling; they probably knew what was going on.

Who was this person with this prudish concern for public decency? Was it some blue-haired matron standing in the back of the room? Surely not our man Leonardo, a fellow who drew porno for his friends on occasion—not *him*, surely?!

Yep, it's Leonardo, upholder of public morality, scourge of evil.

What is going on here?

It seems some bad blood had developed between Leonardo and Michelangelo. The dating of when it started is imprecise but the odds are good that it's been ongoing and Leonardo is responding to a previous rudeness. In his book *The Lost Battles*, Jonathan Jones argues that it was Leonardo who first raised the issue of "ornamento decente," planting the seed which then matured even before the end of the meeting, when it was agreed (as a compromise) so as to not spoil the ceremonies of the officials, that *David*'s giant phallus be covered with a bronze thong made of twenty-eight small fig leaves which would be attached to the statue.

Was Michelangelo fit to be tied? Did he object? Argue? Pitch a fit? Point an accusing finger at Leonardo? Or just stalk away? We don't know, and the transcript doesn't say. The follow-up didn't happen until the following summer, according to the writer known as Anonimo Magliabechiano. Probably before the giant *David* (well-covered by now) was moved to the Cathedral Square, so Michelangelo had been stewing over it while in the process of installing the newly required thong to his precious work.

As reported by the Anonimo Magliabechiano, one day Leonardo was standing on the Palazzo Spini talking casually with a few people, apparently about Dante and a certain passage in dispute, when Michelangelo walked by, close enough that Leonardo gestures to him and says, "Perhaps Michelangelo can explain it to us."

At which point Michelangelo spun on him in such a way that, the Anonimo wrote, "he wanted to bite him." Michelangelo then shouted loud enough for others to hear, "'You explain it yourself, you who designed a horse to be cast in bronze but couldn't cast it

and abandoned it in shame. And those capons of Milanese really believed in you?' And having said this, he turned his back on them and left. Leonardo remained there, his face turning red."

This is a fascinating moment for many reasons, one of which is Michelangelo's tooth-and-claw response to a simple question about Dante, which suggests some pent-up anger on his part, and two, in that clever way that crazy people have, he knew just which button to push to wound Leonardo and leave "his face turning red." He said that Leonardo had abandoned his bronze horse *in shame.*

As Jonathan Jones points out, Leonardo lived in a shame-based society. A shame-based society is different than our own guilt-based society in that guilt mainly addresses the individual, whereas shame reaches to the whole family and even ancestors.

It strikes me that Florence being a small town in many ways, people knew other people's business. This was especially true within the arts community. Leonardo's father was dying, or may in fact have just died at this point. It's not known if Leonardo reconciled with his father or not, but it is clear that Ser Piero ignored him in his will and gave his wealth and land only to his legitimate sons, *not* to Leonardo. I see these two incidents near enough to resonate together, both in Michelangelo's mind and Leonardo's. Michelangelo was very close to his father. Shame was in the air. Leonardo's face is red. Who knows?

It was an awful summer for Leonardo in 1504. Not only was he still trying to finish his large cartoon while his father was dying on bad terms with his gay/bastard self, but the city council is complaining because the painting is not yet started and again sends Machiavelli to talk to him, his good friend who is in hot water on his account. They talk. If he'll just start painting, he can have more time for finishing his cartoon, like we said. Everyone's trying to be reasonable here. Try again, Leonardo, for the sake of Florence and your own lasting fame. And besides, contracts have been signed, Leonardo. The Signoria is anxious that the new Palazzo Vecchio

not be left in a half-completed state. They've heard all the stories, Leonardo. The painting must be finished.

Leonardo agrees to try again. It's clear he was fighting a major block, and it's surely because he found it hard to lend his imagination to massacres and epic bloodshed and empty causes. Who can blame him? He's depressed. It's also during this time he records a dream he had of himself as a baby and of a bird coming down to his cradle and hitting his mouth with its tail. He's likewise thinking of his mechanical bird again and begins sketching his Leda laying an egg.

Did he help bury his father? Handle the body? Was he allowed to? What was their last meeting like? Too many corpses, they filled his mind. He wanted to escape, to fly away.

Leonardo was not an institutional man like Machiavelli, for whom the project is more important than himself. This is probably one of the biggest distinctions between Leonardo and Machiavelli, and between Leonardo and most people of modern times who not only accept the presence of all controlling institutions, but the values and schedules those institutions impose.

Today people know you can't argue with an institution. Leonardo didn't seem convinced of this. He probably saw the council of Florence as men whom he knew, and their expectations for the job's completion were just different than his own, and based on less information. It could wait a while longer.

Nevertheless, he had signed the contract and was fretting a bit more over his cartoon when another bombshell dropped: the eight-man council of the Signoria had decided to stage a contest between Leonardo and that excitable maniac Michelangelo. They would *both* be doing large paintings for the Great Council Hall of Palazzo Vecchio.

What Leonardo thought when he heard the news is not hard to guess. He no doubt felt totally bushwhacked and boxed. A competition is a very different thing than a work of art. You hire him to make art and then turn it into a contest, you only make a difficult task impossible. No doubt he tells Machiavelli this, but nothing can be done. The

Signoria's decision is final. Leonardo's heart is no longer in it. He feels he's in a fight now. He fears failure and now doubly so with Michelangelo huffing and puffing at the other end of the room. Everyone will be watching. This whole summer has been one long downward spiral.

It's frequently said (first by Vasari) that competition was the secret sauce in the Florentine Renaissance and everyone benefited from it, but I'm not so sure. I think Vasari was talking about himself more than anything. I think competition and conflict repelled Leonardo as much as it excited him, as it does many people. Forcing him into a contest was the exact wrong thing to do.

A few weeks later, Michelangelo's giant *David* was moved through the streets of Florence to the Cathedral Square. It was moved on fourteen greased logs rolled in front of it and took a team of forty men, four days to complete.

Guards were assigned to protect it after rocks were thrown at the statue the first night. No evidence identifies who the mysterious culprits might be.

THAT FALL THE work on diverting the Arno river away from Pisa began. Leonardo was only the general planner of this large project, not its actual on-site engineer. That was a man named Colombino, who apparently changed the plans in various significant ways, so perhaps Leonardo wasn't entirely responsible for the disaster that soon followed. Not that he wouldn't be blamed anyway.

To dig the canals and build the sluices required two thousand men digging steadily all day long, and another thousand soldiers there just to protect them from attacks by the Pisans, who could see what was going on and didn't like it. Then one day a storm blows in and disaster struck everywhere at once. Eighty men drowned when a wall collapsed and a reservoir emptied, farms flooded in every direction. The cost to Florence was huge: over seven-thousand ducats by the end. The engineer in charge, Colombino, had hurried up the work schedule and

made some other compromises, and next thing you know, Leonardo's reputation is in the mud. Again. Welcome back to Florence. And by the way, where's our painting?

AT THE END of that awful year he picks up another job as a military engineer, which gets him out of town temporarily. Leonardo goes to the seaside town of Piombino to design its new fortifications (never built) and to take a side trip to Vinci and see his uncle Francesco. Getting out of Florence for a while is a good thing for him. Go to the coast and breathe a little salty air, watch those gulls hover and clear his head. The fortress he eventually designed was the result of studying the effect of cannon on vertical stone walls. He created instead concentric earthen berms meant to deflect cannon balls, and soldiers. Radical design. Michelangelo must've seen these plans because twenty-five years later he created something very similar for Florence.

After Piombino, Leonardo took his side trip to Vinci, spending time with his uncle who is sixty-eight and perhaps not in good health, all that vino catching up with him. In fact Francesco would die shortly after this. He changed his will so Leonardo would get his property instead of his other, legitimate nephews. This would end up in court, but the gesture speaks volumes both about their relationship, and Leonardo's relationship with his father as well (especially if one sees it as an attempt to make up for Ser Piero's hard heartedness).

The year 1504, a year we think of as epic in the life of Leonardo, looked to him, I suspect, sitting there on the porch in Vinci, Uncle Francesco reclining beside him in the shade, rather more like a bust.

1505 The Portuguese sack the island city-state of Kilwa in East
 Africa, killing the king for failing to pay tribute.
1505 Vasili III succeeds Ivan III as Grand Prince of Muscovy.
1505 Portuguese merchants establish fortified trading posts on
 the east coast of Africa.
1505 Bermuda is discovered by Spanish explorer Juan de
 Bermúdez.
1505 Martin Luther, frightened by lightning, vows to become a
 monk.
1505 Raphael paints *Three Graces*.
1505 Poland prohibits peasants from leaving their lands, thus
 establishing serfdom.
1505 Hongzhi, Emperor of China, dies (b. 1470).
1505 Ercole d'Este I, Duke of Ferrara, dies (b. 1431).

CHAPTER 20

JUMPING OFF THE CLIFF

Age 53

ONCE BACK IN Florence, to stay in compliance with his contract for the *Anghiari* painting, Leonardo bought supplies and finally installed his custom-built platform. Then he prepared the wall, and with his half-finished cartoon he began to transfer the centerpiece of his drawing: the fight for the standard. But once that was done and he began actually painting, a new problem came to light. There was something wrong with his paint.

It appears he was experimenting again, just as he had in Milan on *The Last Supper*, and this time with even worse results—the paint would not stick to the wall. Bad walnut oil was blamed in this case but the truth wasn't bad walnuts, but rather just one nut. He wouldn't stop messing with his paint!

But, to ask Leonardo to stop tinkering is like asking a shark to stop swimming. He figures he'll get the paint mixture right this time, he figures maybe linseed oil is the answer, or maybe something else . . . only to see it fail again. He'll have to start over and prepare the wall once more. The answer is out there. He'll find it. He just needs more time.

Problems kept popping up. Multiplying, in fact. It must've been amazing to watch him up there wrestling with himself.

* * *

MOST BIOGRAPHERS BELIEVE that Leonardo attempts to fly some version of his air machine around this time. No doubt this is a result of having the Pope's Hall available to him to build the thing. He's not had such a space since Milan, five years earlier, where he may have constructed some kind of machine and flew it off the roof of the Corte Vecchia and scared the birds, but facts are vague. Since then he's thought about it long and hard in order to be prepared next chance he got to build one. Now that he finally has his big bird built, he writes about it in his notebook, as if leaving it open to be read by others. As Jonathan Jones points out, it's a shamanistic mix of bird and human spirits: "The great bird will take its first flight from the back of the great swan, filling the universe with amazement and filling all chronicles with its fame and bringing eternal glory to the nest where it was born."

This proclamation also has a certain carnival barker's quality to it and is written on the cover of a notebook that contained his studies of birds and flight. A second, almost exact quote of this appears inside the notebook, the so-called *Codex On The Flight Of Birds*, and it is dated April 14, 1505. The day before his fifty-third birthday. Did he make the attempt on his birthday? Perhaps this flight would be his present to himself. He probably wrote it there first and liked the proclamation so much he transferred it to the cover and edited it a bit. Leonardo edits everything: everything he says, everything he sees, and probably half of what he thought. It is his default mode. Always tweaking.

He has to transport this "device" from the Pope's Hall north out of town and up to the top of Monte Ceceri, otherwise known as "Swan Mountain," and while doing so he was surely seen by all sorts of people who most likely followed him up there. How would you keep this a secret?

We know now, from subsequent attempts at flight by others, that the first effort never goes smoothly. Some part is broken during

transport and another item is left behind in the workshop, and a rope comes loose and the covering worn. And then, once you arrive at the launch site, things don't snap together quite the way you'd hoped and some last minute improvisation is required to get the covering attached back to the frame, and something else bent back into shape, and all this is no doubt very frustrating. Especially so if you're trying to be the first person in history to do something. You'd expect a little cooperation. His mood is a combination of ecstatic hope and angry frustration at all the stupid stuff that can go wrong.

It would appear from the evidence, or lack thereof, that the attempt to fly did not go well. I assume that simply because a successful flight would be impossible to hide. Not only would Leonardo tell people about it, but he would've surely added a whole extra chapter to his *Codex on the Flight of Birds* describing his success. Maybe even changing the title to *Codex on the Flight of Birds and Men*. Wouldn't he love to publish that? But it didn't happen. I don't believe he flew an inch. Or rather, I suspect it was Zoro who was younger and stronger and probably the one lying in the sling when the contraption was pushed off the hill and into the air.

Thank goodness photography had not yet been invented. Our whole notion of Leonardo would change if we could see him leaning out, looking down at the wreckage and Zoro's twisted body among the rocks.

No one can claim to know why his flying machine failed because it's uncertain which, of several designs, he actually attempted to launch. His best bet was with his glider, but that lacked a vertical tail so if the thing flew at all it was in a single wild spiral before nose-diving into the earth below, accompanied by the changing oscillation of Zoro's scream all the way to the bottom.

Poor Zoro. Still, I'll bet he dined off that tale for years.

One reference to Leonardo's attempt to fly does exist. It comes from a descendant of a friend, Fazio Cardano, who wrote in 1550, "Vinci tried in vain."

So, no glory for Leonardo. He heads back to his studio to prepare his paints and have another go at the centerpiece of *Anghiari*, all while Zoro is groaning in the corner, distracting him. Perhaps he's supplying him with wine and canapa (cannabis), an ancient pain reliever well known at the time and grown in herb gardens all over Tuscany, or something else perhaps. Or more likely, Zoro is supplying himself with pain relief. He was a considerable herbalist in his own right, as was Leonardo. But we don't know.

HE MAKES ONE last attempt at painting the wall. Then something happens. He stops painting, apparently frustrated, and leaves the hall not to return. What happened?

Either he received a letter from the Council asking why he is not painting, or he anticipates receiving such a letter in the near future, so he prepares his response, which he quickly writes in his notebook so he won't forget it:

6th June, 1505, a Friday, on the stroke of the thirteenth hour, I started to paint in the Palace. At the very moment I applied the brush, the weather deteriorated and the bell resounded, calling the men to their deliberations. The cartoon tore. The jar of water being carried broke and water spilled. And suddenly, the weather broke and it rained vast quantities of water until evening. And the atmosphere was like night.

There's a certain jumbled quality to it, a mixing of causality, perhaps even an attempt to charm the facts. It reads to me like a draft of what he would write (or have someone write for him, since he couldn't write directly to people) in a letter explaining his abandoning of the painting. Others have pointed out how this seems to signal a bad omen and wrong luck and how superstitious Leonardo really was at bottom, which I don't doubt, but I read it rather differently in that

I think he was also describing a moment of uncontrollable pique. I think this moment of throwing up his hands is analogous to him doing the same with Ludovico's secretary and storming out of that meeting years before in Milan.

And this is not the sort of thing that normally ended up in his notebook—he rarely explained or narrated himself, so it's telling when he does. It might indicate that Leonardo is losing his temper and feeling he'd reached his limit with people. The notion of him as the cool operator is not right. This is part of the blowback from his time with Borgia. His tolerance for bullshit is severely limited these days.

If the painting's not working, then it's not working. I'm done.

The important thing to note though is that by walking off the job and not returning and completing the painting, he was putting his friend Machiavelli in a really bad spot, and affecting maybe his entire career as a civil servant—not to mention that other hit to his reputation, the whole Arno/Pisa thing. Leonardo was leaving a lot of people in the lurch, himself not least of all, but he just couldn't do the *Anghiari* painting. Whatever psychology is at work by this point, this hyper-aware, extra-sensitive man who lived in the penumbra of large ideas and small gestures and smoky air (*sfumato*), was ricocheting off the walls and felt totally exhausted. Today we'd call it, in our own poetic fashion, PTSD. I prefer what Albrecht Dürer called it: melancholia. That would've likely been Leonardo's word as well. *Malinconia.*

I DOUBT HE could stay at the Pope's Hall after they stopped paying him in August so Leonardo and his crew moved somewhere else. Hopefully they've found a new place to live, ground floor, no walk up. He's painting again, small things like his Lisa, and his perverse *Leda and the Swan* (woman + swan = eggs, don't ask). He's writing about the "body of the earth" and "the soul of the bird," busying himself

with math problems, trying to "square the circle," which means he's probably hanging out with Pacioli again. In other words, he's diverting his attention away from the larger world of contracts and friends and conflict, and into small controlled spaces where he could function and feel alive and somewhat expansive. His notion that "art breathes from containment and suffocates from freedom" is an expression of that sense.

Jones refers to Leonardo's drawing as a trance-inducing ritual for him, but I think there were others as well. Working math problems, dissecting worms and mice, studying the rushing rainwater after a storm, playing the *lira*—anything, really, to keep him from thinking too broadly out of the box. It was certainly how some people handled stress back then. Isaac Newton did much the same when he was depressed and bored and could do nothing else but recalculate logarithms. Never has higher math looked so sad and forlorn than in his workbook.

It should be said though that boredom is often a precursor to innovation and Newton's time was not wasted, nor was Leonardo's. These are rhythms largely lost on us today with our endless diversions and clocks and notions of consistency, making it unusual anymore to meet a mind that runs at its own pace and not the pace of others. This is what Leonardo was trying to get back to. It's how he grew up. He knew where ideas came from, and it wasn't from the confusion of the crowd.

1506	At least two thousand converted Jews are massacred in Lisbon, Portugal.
1506	Christopher Columbus dies in Valladolid, Spain (b. 1451).
1506	Lourenço de Almeida reaches the Maldives and Sri Lanka.
1506	The classical statue of *Laocoön and His Sons* is unearthed in Rome.
1506	The Swiss Guard arrives at the Vatican to serve as permanent palace guards.
1506	Pope Julius II lays the foundation stone of the new St. Peter's Basilica in Rome.
1506	Pope Julius II personally leads his troops into Bologna.
1506	Tristão da Cunha sights the islands of Tristan da Cunha, naming them after himself.
1506	King Philip I of Castile dies (b. 1478).
1506	Leonardo paints the *Virgin of the Rocks* II.

CHAPTER 21

I'M OUTTA HERE!

Age 54

LEONARDO'S ESCAPE FROM Florence was thwarted when the Signoria refused to let him leave. His past was catching up with him at this point. His reputation haunts him. Even before this Great Council Hall contract was signed, everyone knew all the stories of abandoned projects, starting with the *Adoration of the Magi* here in Florence in 1482 (still incomplete, still in storage at the home of Giovanni de' Benci, Ginevra's brother), right up to Ludovico's great horse in Milan just a few years ago. Machiavelli must have been extra persuasive on his behalf, vouching for Leonardo's reliability and trustworthiness, as did Leonardo himself, and contracts were signed based on that. Now, eighteen months later, with nothing but a half-finished puzzle on the wall, tolerance for Leonardo's excuses has evaporated completely.

Paint the damn picture!

You can imagine the pressure he felt. Everywhere he goes there's someone to remind him, to ask him, *"How's it going at the Hall? Looking to finish up soon?"*

It's hard to focus on anything. The distractions are enormous. An old problem in Milan has resurfaced and he has to get back and deal with it, only he needs permission first—meaning he has to reassure the Signoria in Florence he'll return to fix the mess here, just as soon as he fixes the mess there. Sure, everyone says, nodding behind their hands. No permission is given.

Just finish the painting, Leonardo. You should be done with it by now. We've paid you a lot of money already. Fin-ish.

Leonardo no doubt made other attempts to complete the painting, or at least the centerpiece, throwing himself back into those swords and biting teeth over and over, and later visitors and the sketches they left suggest the centerpiece was mostly done, but was clearly incomplete and the background had hardly been sketched in.

As we understand it now, watching Leonardo *not* paint *Anghiari* must've been eerie indeed. He's there, in town, not far away, and yet the painting remained untouched. You see him occasionally elsewhere, on a side street walking quickly or outside the city wandering in the pastures and woods, talking to himself, gesturing, agitated, but somehow never at the painting. People are mystified and perplexed. Other painters especially. So was he, it seems.

Not much more is known of this time other than that Leonardo was not answering his mail from Isabella d'Este, who was reaching out now to the brother of one of Leonardo's past stepmothers in an effort to find him. He was probably lying low, gathering his strength. Perhaps he was physically ill, or just having a meltdown. He might work a bit more on *Anghiari*, or not. He writes notes on painting, reprises theories from his reading of Martini and his machine designs. He's living in his own head these days, seemingly in full withdrawal.

But knowledge for him is like wealth and it's during times of uncertainty like this he retreats and builds up the treasury. The main thing is, he keeps learning, always and forever, even during the worst of times. It seems almost a mania with him. Kenneth Clark called Leonardo, "The most relentlessly curious man in history." If this is true, it's because curiosity and speculation were his singular distractions from the chaos around him.

He couldn't control the external world, but he could organize and annotate and rearrange his studies on cosmology and water and astronomy, and further studies of anything that passed in front of him: architecture, anatomy, geometry, the flight of birds, optics. When

Leonardo is depressed and angry and under pressure, he burrows deep and hard and cogitates like a threshing machine.

Which raises an interesting question: What would Leonardo's life have been like if he'd been independent and had a bit of inherited wealth? What if, just assuming for a moment, Ser Piero had not been such a jerk but had accepted Leonardo as his gay son, and even facilitated him in his quest to study and learn and come to fruition? Would Leonardo have done better, or worse? Did he need the opposition of the world to spark his rebellion and creativity, or was opposition a bad thing that actually slowed him down? Doesn't that piece of small-mindedness on Ser Piero's part not resonate through the ages? This of course is historical conflation at its worst, but to imagine a Leonardo free of encumbrances and able to follow his every notion and desire, what might that have been like? I'm sure Leonardo asked the question more than once.

THE TROUBLE IN Milan was this: the dispute over payment for the *Virgin of the Rocks*, which originated in 1483 (because he did not compose according to the monk's design) was still going on, despite an attempt by Ambrogio de Predis, Leonardo's partner in the original commission, to paint a duplicate altarpiece to satisfy the Brothers of the Conception and receive the remainder of the money owed to him and Leonardo, some three-hundred ducats. The Brotherhood still refused to pay and a judge, after examination, decided that the new altarpiece remained unfinished and that it required Leonardo's magic left hand before it would be as good as the one originally offered to the Brotherhood, but which they first refused and Leonardo later sold to Ludovico.

Long story short, if the two painters wanted to get paid, Leonardo was needed to put the finishing touches on the duplicate *Virgin of the Rocks*, and de Predis had been writing to him, trying to get him up to Milan to do just that. Problem was, every time Leonardo petitioned

for permission to leave Florence, if only for three months, the Gon-
faloniere Soderini would stare at him like an old hanging judge hear-
ing another plea for mercy.

Finish the damn painting first!

Odds are Leonardo was going quietly nuts. Finally, in May 1506, af-
ter five months trying, he was able to secure the permission he needed
to leave Florence by posting a 150-ducat bond that he would forfeit if
he failed to return on time and finish *Anghiari*. And this agreement
was co-signed by his banker, who held his few remaining funds.

I guess he lost his bond money, because it would be twelve months
before he'd see Brunelleschi's dome again. And even then, he didn't
return to finish the painting but to deal with another lawsuit, this one
with his half-brothers over their uncle Francesco's will. One can only
imagine that Leonardo is out of his tree with all these distractions.

BUT, AS IRKSOME as Florence had become to him and the awful
things the city seemed to do to his head, Milan was a different story.
It seems almost as if he'd been able to resume his previous life there,
only with the French in charge instead of Ludovico.

Somehow, someway, a Florentine looks at Leonardo and his think-
ing gets complicated and draws up lots of contradictions and diffi-
culties and history and whatnot, but a Frenchman look at the same
Leonardo and it seems love at first sight. Before long there's a request
to the Signoria to allow Leonardo to remain a while longer as he is
needed there by the French Governor, Charles d'Amboise.

He probably stayed with de Predis and finished the *The Virgin of
the Rocks II* first thing so the suit could be settled and he could get
some funds. Interesting that he could step into a mostly completed
painting and turn it into the gorgeous thing that is in the National
Gallery today, but not able to paint the already complete cartoon back
in Florence without seizing up.

He can paint a Madonna, but not a mad horse. Or put another

way, with equal pressure to do both, he chose to paint the Madonna in Milan, even though it required much greater effort to get there, rather than finish the battle scene he'd drawn and settle things with Florence. One he could do, the other he couldn't.

It's this apparent lack of logic that prompts people to say Leonardo is an enigma. I think he's more like a cat—it's the viewer's purpose imposed on the cat that creates the confusion. Surely the Signoria of Florence, and most biographers, found him simply inscrutable on this point of finishing *Anghiari*.

I think a closer analogy might be a jazz musician from the 1940s or 50s, someone like Lester Young. Linear straight-line people (squares) couldn't understand him, but Lester swam in an ocean of music and what he had to protect was his inspiration, his "sound," his ability to find his own groove and hear himself in his own head, and that meant oftentimes doing things his own way. He didn't have a lot of options; this is how music worked for him, and it was fragile. I think it was the same with Leonardo. He wasn't being willful or bullheaded, as it must've seemed, but it was rather a case of just not being able to do anything else. And I suspect that as many times as he must've answered the question why he wasn't painting, his answer didn't satisfy. I think that's simply because Leonardo did not know why himself. He tried to finish the *Anghiari* and he couldn't.

It was those people who didn't understand the difficulties of art who confused the skill of the hand with the act of the mind. In all cases Leonardo did only what he could do, given the circumstances and his own limitations. We think of him as a universal genius but his own intense self-perception was of his limitations and lack of knowledge. That was a hole he kept trying to fill and never could.

He arrived in Milan during the summer and it would seem that by winter he's living with the Governor and staff and half the bureaucrats in town at the Castello Sforzesco. After some period of time he wants a place of his own and has to write a letter to the governor for permission to move out of the castle and into the city. One can

imagine Salaì and Zoro are billeted elsewhere and Leonardo would like other arrangements. Being a guest is tiresome work, and I think especially so the older he got. Leonardo needed space, both actual and psychic.

Tweaking de Predis' altarpiece copy was probably just the work of a few weeks—determined mostly by how quickly his glazes would dry. There was no composition involved, nothing to decide, inspiration not a factor; simply the task of making more lifelike, more perfect, the painting already done. A straightforward application of technique. Like a script doctor he could look it over and see the problems and what needed doing, or redoing, and execute it rather quickly. Leonardo, in a room alone, if he's got that focus on him, can do a considerable pile of work in a short time.

From his notebooks though, it's clear he spent that year in Milan with projects he seemed to eagerly accept. He begins designing a summer villa for the Governor with a large theatrical garden, and perhaps designed some canal work around Milan, as well as squeezing out another Madonna painting, this one called *Madonna and the Yardwinder*. A sugar-coated little jewel and quite a hit at the French court, the faces in it are adorable and the love of mother and child palpable, despite (or maybe because of) the threat of craggy mountains in the background. This may well be a working out of the background that would appear in *Mona Lisa* as well. It's clear that the reputation Leonardo left behind in Milan had endured, and even improved in his absence.

During all this time the Gonfaloniere of the Signoria in Florence, or his personal secretary, was writing increasingly testy letters to Governor d'Amboise calling for Leonardo's return. In their Great Council Hall is a half-completed painting too large to be ignored. It distracts everyone who sees it. Why has he not returned to finish?

In April 1507 King Louis XII of France arrived in Milan at the head of his army, and Leonardo created for his arrival a pageant which including flowered arches over the street he passed through. It seems

Leonardo is not only accepting commissions, but proposing them as well, doing what he could to dazzle. Up to his old tricks, it would seem. It's along in here he impressed the newly arrived Louis with a production of the musical *Orfeo*, which featured perhaps the ultimate "special effect" of the time: a mountain that "splits open to reveal Pluto in his residence." Add to this his description of many miscellaneous demons and minor devils and "naked children weeping" and you can imagine this vision of hell to be highly entertaining. Apparently the king liked it.

In January, Louis writes to the Signoria that he is "charmed by a small Madonna" (probably the *Yardwinder*) and wishes Leonardo to continue in Milan a while longer and perhaps do something for him. It's like a battle with long feathers, all this politeness and decorum, but behind it is Leonardo making a genuine effort to avoid returning to Florence.

Circle the mystery a dozen times and it won't go away; he abhors whatever is waiting for him in the Great Council Hall in Florence, something inside that painting. I think Leonardo was a lot more superstitious than people give him credit for. Just because he was ahead of his time in some things doesn't mean he was ahead of his time in *all* things. The painting had him spooked somehow.

The great unanswered question of his year in Milan is whether Leonardo visited Santa Maria delle Grazie to view his *Last Supper* and see how it had held up. I'm sure he did, and my guess is he didn't stay long. I'm sure as well he heard about it's deteriorating condition from just about everyone.

1507 The first recorded epidemic of smallpox breaks out in the
 New World.

1507 King James IV grants a patent for the first printing press in
 England.

1507 Waldseemüller publishes his map of the world, the first to
 show the Americas as a separate continent.

1507 Martin Luther is ordained a priest of the Catholic Church.

1507 The Portuguese occupy Mozambique.

1507 The Aztec New Fire ceremony is held for the last time.

CHAPTER 22

YOU AGAIN?

Age 55

IT WAS A year of travel, from Milan to Florence and back to Milan, twice, lawsuits going in both cities.

Vasari tells the story of Leonardo's return to Florence and his stay at the home of the wealthy art patron Piero di Braccio Martelli, where the sculptor Giovanni Francesco Rustici was also staying. The story describes Rustici's studio as looking like "Noah's ark . . . It contained an eagle, a crow who could speak like a man, snakes and a porcupine trained like a dog which had an annoying habit of pricking people's legs under the table."

Leonardo and a talking crow—what a scene. Probably a myna bird; he of course tried to talk back to it. He may well have spent the entire evening conversing with the bird, or trying to. Myna birds promise more than they deliver, but for a man who had imagined the world from a bird's point of view and whose greatest wish was to fly, meeting a bird you could discuss things with must've been purely exciting, at least at first.

I wonder if he sketched the bird. Like a crow, myna birds have a bright eye and lively look and their little brain, gram for gram, is among the smartest in the world. Ask a myna bird a question and it will consider it. I wonder if Leonardo didn't borrow that bird for a few days just to interrogate it further. If he did, he no doubt arrived at the conclusion most solitary thinkers arrive at when it comes to talkative

birds like mynas and parrots: the bird is better off living someplace else.

AT ABOUT THE same time Leonardo is talking to a bird in Florence, seven hundred miles away outside the small fortress of Viana, located in the mountainous kingdom of Navarre in northern Spain, Cesare Borgia was having his last adventure, sad though it be. Prison had not agreed with Cesare at all and at the very first opportunity he had escaped, leading to four years of manic dodging and struggle and scrambling around, followed by recapture and desperate re-escape, a broken shoulder poorly healed, plus all the usual nicks and bruises of being a convict on the run. Thirty-one years old, his bouts of malaria still came and went and his syphilis hadn't gotten any better so he was a sight to behold. It might be that he was able to escape so much because people were afraid to touch him. That's me guessing, I don't know. Exhausted, penniless, run to rags, he found refuge finally in the small kingdom of his brother-in-law, Jean d'Albret, where Cesare was taken in and returned somewhat to health, and even given charge of a small company of soldiers. He then volunteered to put down some local rebel bands running loose and causing trouble. A small item, the least he could do to repay the hospitality.

Once again it would seem that Borgia's pure, inscrutable confidence led him to assume a man of his stature could whip things into shape in a hurry, primarily by virtue of his own prime example and by barking orders. And he was no doubt impressive, especially with his mask on. His chainmail and breast plate and shield were of the finest materials and craftsmanship, not to mention his fine clothes and jewelry and such—all gifts of his brother-in-law, but for the gold papal medallion around his neck. The average Navarre soldier under his command was certainly impressed, but that only goes so far.

On the morning of March 11, 1507, Borgia and his troops had been camped on the road approaching Viana, a rebel-held fortress

he intended to besiege and capture. The main effort was to prevent the fortress from getting supplies, which is why Borgia parked his army squarely on the road. Nevertheless, during a thunderstorm and downpour that sent even the guards inside for shelter, the rebels were able to move a mule train through the camp and down the road to the fortress before the alarm was raised and confusion in Borgia's camp broke out. Immediately troops were sent in pursuit of the mules to capture them and while they rode out of camp Borgia himself, freshly woken from sleep, quickly put on his chainmail and armor and jumped on his horse to catch up with the departed troops—who weren't making such great progress in the mud, and he soon passed them as he was closing in on the mule train, which wasn't moving all that fast, either.

Cesare must've figured his own example of courage and bravery (*"I'll show them how the Duke of Romagna fights a battle!"*) would inspire his soldiers to spur their horses forward and follow right behind him. Whatever the problem with the Navarre troops, they weren't inspired enough to catch up and Borgia galloped forward on his own—right into an ambush. The rebel commander had sent three knights back to guard the rear of the mule train and they rode out probably expecting to hold off the many troops rushing up the road any minute now. Instead what they saw was one guy on a horse coming hell-bent right at them. The three fell on him immediately and a well-placed spear to the armpit not only knocked Cesare off his horse and onto the ground, but rendered that arm completely useless.

The three got to work and flailed away with all they had, stabbing him almost thirty times—Cesare probably still wondering where his troops were. Then all that fine handmade chainmail and breastplate and spurs and medallion with the pope's head on it and such, and his mask, that came off. And since his army had still not appeared, they helped themselves to the fine clothes as well, and the underclothes, plus his horse and saddle, leaving Cesare in the middle of the muddy road naked as a baby, bleeding from every part of his body,

and talking gibberish. He might've been delusional and refusing them permission, who knows. Or he might've, as some think, been committing suicide in the bravest manner possible and saying his last prayers. That's what his sister Lucrezia convinced herself of when she heard of his death weeks later. Whatever, without the luck of politics or family or money, or the confusion of the times, when it was just Cesare come blustering down the trail, sparkling like the night sky, you stick him and he comes down pretty easy. Surprisingly so. But then, they didn't know who he was. They were supposed to be terrified. Probably what he was counting on.

One of the departing knights placed a flat stone over his genitals, Navarre being a religious and decent place.

THAT SPRING LEONARDO finished his business in Florence and traveled back to Milan. The day after his birthday he received confirmation from d'Amboise of his title to the vineyard Ludovico had given him in lieu of salary. Other than the inherited property his uncle Francesco left him, this was the first land he had ever owned. He also received a "water right" granted by the king, meaning a tax on water moving through the canals, perhaps for work Leonardo had done. Had he been able to collect it, he might've had a small living from it.

The lawsuits dragged on regardless of where he was. He somehow got Louis XII to write to the Signoria in Florence to pressure the judge in the suit by his brothers. Leonardo was certainly not adverse to pulling strings. His success in large part was really within a small group of well-placed individuals who recommended him and gave him work, and defended him, people who were supporters of his, aristocrats mostly. To the general public he was just anonymous and odd. Increasingly, as his beard and hair grew long and his appearance changed, it was only his supporters who saw past the contradictions. In an obvious sense the experience of knowing Leonardo during this time was that of looking at someone who did not appear to be what

he was at all, which was an exquisite artist and intellectual. Leonardo hid all that.

Which, as it happens, frames him in such a way as to make his talent seem even more striking.

To know him was to see past his disguise, past all the distractions and contradictions, to the man improvising in the moment. Throw him a thought, watch him catch it. Ask him a question. Mention a book and he'll search his mind for it. Improvisational personalities have an alertness to them even into old age. They see everything and are constantly calculating. And the older and more fragile Leonardo becomes, the more he calculates.

IT WAS ALONG in here that Leonardo met Francesco Melzi, who would become his close companion and, years later, his executor. Fifteen years old at the time, Melzi was an aristocrat by birth who was also a gifted draftsman, who may have come to Leonardo first as a student. Very quickly though he became the amanuensis or secretary Leonardo so badly needed.

In an age when letter writing was crucial to any business, Leonardo always had to hire a scribe. He did not have a readable left-to-right script suitable for communication with governors and princes and had to depend on others to write for him. I think this is a real glimpse into his daily life skated over by historians; he had to function in many ways as if he were illiterate. He needed others to write for him, and he needed others to read to him when he encountered a Latin or Greek or Arabic or French text in someone's home. His fancy friends could all read it, but he couldn't. Leonardo was a vernacular talent, largely self-taught and terrifically uneven. He probably had a rural accent and his grammar, which was rather stiff in his letters, suggests it was loose otherwise. And when he did read in his native Tuscan, he read out loud, mouthing the words as was the custom of the time, tracing with his finger—resisting that impulse to reverse

everything. His notebooks are full of misspellings, letters reversed or scrambled, eccentric abbreviation, zero punctuation—and all of it backward, of course. Whole notebooks run back to front.

We think of Leonardo's talent as expansive and all inclusive, while to him it must've seemed a shrinking envelope he fought to keep open. At the time people didn't see the legend we see, but a guy with long, uncut hair who could only communicate with the world either by speaking, or drawing, because his writing was an eccentric code and inaccessible and meant for himself alone. Almost like a private script.

While the art world today sees this as evidence of his uniqueness and brilliance, those around him at the time saw it as a handicap. It would be nice to read Latin and nice to write Italian so others could read him. To be literate in the ways he understood literacy to mean. He called himself "an unlettered man" (writing it backward in mirror script) while defending himself against a charge of being uneducated.

I think it was easy to misunderstand Leonardo, so much so that when any new individual saw through the incongruities and did discover Leonardo's talents, he congratulated himself on his insight. Leonardo became that person's discovery. Not everyone could see it. I think this was part of the experience of knowing and supporting Leonardo: that sense that you had the unique ability to recognize him as he truly was, and not as the bundle of contradictions others saw. I think Leonardo was rediscovered ninety times in his life, and always by imaginative people. And I think this was very much a part of the French attraction for him—that they alone, the royal court, could appreciate those qualities that others, more trade-minded people, could not. And they were probably right.

For Charles d'Amboise, Leonardo works on a villa and the attached garden of delights. He works on a couple of paintings as well. That fall, he leaves with Melzi and Salaì for Florence again where Leonardo fears being restrained, if not arrested and thrown in the poky when he arrives. That whole *Anghiari* business will likely turn into a lawsuit as well. d'Amboise writes to the Signoria asking them

to allow the artist to return to Milan after his business in Florence is over to finish a panel painting "most dear" to the French King. More feather fighting.

PRINCIPALLY HE'S IN Florence to deal with the lawsuit, but lawsuits tend to be a series of short meetings spread over many weeks and months, in between which a lively fellow like Leonardo is likely to find other things to do. In this case, with time on his hands, he started cutting open bodies in the basement of a local hospital, studying the insides of people.

In late 1507 or early 1508, Leonardo records meeting an old man:

This old man, a few hours before his death, told me he had lived for more than a hundred years, and that he was conscious of no deficiency in his person other than feebleness. And thus, sitting on a bed in the hospital of Santa Maria Nuova in Florence, without any movement or sign of distress, he passed from this life. And I made an anatomy to see the cause of a death so sweet.

What fascinates about this notation is the scene implicit in the description. He's walking through the hospital, looking around. It's possible he's there to withdraw some money as the hospital's religious order was also his banker. But it's much more likely that he's there to do exactly what he describes, and that's to skin a body. Only he wants a fresh one, the fresher the better. So fresh in fact he can talk to it. A body under ordinary conditions during summer or winter in Florence will begin to putrefy almost immediately. In 1507, unless it was freezing cold inside, performing an autopsy meant working on an increasingly deteriorating pile of mess. Identifying the natural shape of an organ was nearly impossible as everything either flattens out after death, or swells up. At best, he could connect the parts as he tried to follow function through the various organs.

A fresh body was essential and that is what Leonardo is looking for when he walks the halls of the hospital. He found the old man lying there dying and apparently peaceful about the whole thing and went over to talk to him—the old man no doubt wondering who this hairy fellow with bright eyes sitting on the edge of his bed might be. They talk but we don't know about what. Other than the man's age and his feebleness, Leonardo records nothing else, and yet they talked for "a few hours." We don't know the man's name.

My question is whether he asked the old man if he minded being skinned, or if he mentioned the autopsy at all. Probably not. Didn't want to get the old guy too excited. The church taught that you were resurrected in the body you died with, and if you permitted an autopsy you could potentially mess up your afterlife, for all eternity, limiting your enjoyment of heaven. A serious thought I don't think Leonardo examined with the fellow, or even took very seriously himself. I rather think Leonardo talked soothingly to the old guy and got him water perhaps and wiped his brow. He was likely dying alone otherwise.

I think he talked to the old man as well to get a glance at his soul while it was still visible in his eyes. He wanted to autopsy him thoroughly, and that included the living part. Leonardo no doubt watched him die, watched closely that light go out, and then tried to determine why.

People don't often die conveniently in real life, so Leonardo may have lingered there a long while until the old man passed—but from that point on it was a race against time. The body was carried down to the stone basement where it was cool and where they washed the corpses. He no doubt had an assistant, and perhaps two.

It is telling that the notebook pages that show various internal body parts are not streaked with blood but are quite clean. Leonardo is looking and drawing, probably using candles and mirrors to amplify and direct the light, looking into cavities where everything was losing shape and color and swimming in juices. How did he deal with the fluids? There was a second person there, perhaps Salaì, who was

bailing and sopping, and even a third, let's say Zoro, who was likely doing some of the cutting and lifting so Leonardo could see which noodle was being hung on the fork.

What's amazing about all this is not just his cataloging of body parts, but what it is he's looking for. He probes here, and probes there, looks all around the heart, following connections, probing and probing, as much imagination as science at this point. Finally he'll get to the head, which he might take off but would surely open to see both the optic nerves and eyeballs, but especially the brain. Brains were tricky, as he well knew. They were a gelatinous mess and hard to handle. Best to view one still in the skull. Lots of saw work involved here, and the harder the three of them work and the longer they stay down there, the warmer the room gets. If they didn't start off gagging, they are now, but Leonardo ignores it and presses on because an opportunity like this was rare and he's looking for something: he's looking for the soul. He wants to know what animates the body and gives it life. The god-awful smell is not a problem. Rosewater on the hands will fix it later. That and walking in a strong wind to air out the clothes.

Shortly thereafter, when he was back at the hospital roaming the halls again, looking for potential bodies he could open up, he spied a two-year-old child. This time Leonardo probably didn't have a chance to talk to his subject but maybe the parents were there. He probably first determined the child was dying of something other than plague or cholera or anything contagious and that it would be safe to open up and breathe the body's fumes. Leonardo didn't know how contagion worked but believed it floated in the air and was inhaled. Determining the child had safely died, he took it again to the basement of the Santa Maria Nuova, this time in someone's arms instead of a gurney, and again with the help of others and using plenty of candles and mirrors and wearing his eyeglasses, he began opening up the little body. It was nearly impossible to see anything clearly in there, everything so shiny and tiny. He locates the heart and then records in his notebook, "I found everything to be the opposite to that of the old man."

Out of this before-and-after comparison he was able to draw the conclusion that the old man's veins had aged and clotted and he blamed this on "an over-abundance of nourishment," by which he meant rich food. We read this as suggesting cholesterol and that's another historical conflation, but his instincts were right that the blood changed over time and caused damage to the veins.

He no doubt tried to compare all aspects of the old man and young child so he looked at all the same parts, including the eyes and brain, only this time the sawing would be easy. Zoro probably commented on that.

The tiny organs were best lifted up for examination by your own long fingernail, which was more convenient than a tool that was likely too large for the small body. I assume because Leonardo did not remark on any other differences between the old man and the child, that it was a boy. I also assume that these drawings during examination were sketches which he then later elaborated into the drawings we see today.

These early anatomies are remarkable not just for the simple straightforwardness of Leonardo looking inside the human body instead of bowing to ancient authority and viewing it as a desecration, but also for the amazing amount of imagination that had to go into the autopsy to produce the drawings. He's not drawing what he sees inside that big red hole, but what he knows it must look like when alive. Even this early in his experience with autopsy, these were not the first open wounds and spilled guts he'd laid eyes on; he's already seen plenty of that, at Novara, Fassombrone, Cesena, Sinigallia, Sarteano, Castel Piave, and San Quirico. He'd seen a beating heart before. Large scale massacres carried out with swords at close range tend to expose most every organ of the body in some half-in-half-out state eventually.

It's important to remember too that he's returning to the subject of autopsy not for the sake of increasing mankind's knowledge of medicine, but for himself. Psychological creature that he is, he's looking in-

side these people in order to see inside himself. It's himself he's doing the autopsy on. It's his own soul he hopes to understand. In this sense Leonardo is a medieval man suffering the limitations of his time, but even though his goal of finding the soul was unreachable, it's what he found along the way that was amazing.

In his mind, his imagination, he explored his own guts. Not only probing and prodding himself, but seeing with his mind's eye the food in passage (which he thought was pushed by breathing) and the development of feces, which he also studied. His own and others. Perhaps Salaì's, too. (*"You want what?!"*) From the notebooks: "Salts can be made from human excrement . . . burned, calcified, stored and dried over a low fire; any excrement will yield salt in this manner, and once distilled these salts are very caustic."

And all this just because he looked, and drew what he saw with that magical left hand. The anatomical discoveries had no effect on medicine at all as he never published them and all those valves and nerves were rediscovered later by others, but what made his drawings significant then, and now, is how well they're imagined. He showed the inside of the body is beautiful.

As a scientist, Leonardo was always the artist first; it's his drawings that lend such authority to his every observation. It's the absolutely convincing technique of his draftsmanship that conveys the sense of so much knowledge behind it, whereas in truth it's only an image of authenticity, brilliant though it is. Often enough it's not the genius of Leonardo we celebrate so much as the appearance of genius so vivid and strong.

Knowledge is a communal thing and Leonardo was investigating for himself, seeing only with his own eyes, writing in private notebooks, backward and misspelled, what no one had written before. These were discoveries that were available to anyone alive at the time, of course, anywhere in Europe or the world, but few seemed to consider it, chained as they were by the rules and expectations of their culture. Leonardo's autopsies were possible in part because he was

an outsider to his culture (especially in Florence) but also because
conventional morality had no usefulness for him. Such morality had
punished him in the past and was the world of his father and church
leaders and princes and bureaucrats. Leonardo was able to function
as an innovator in part because he knew respectability to be too lim-
iting. The price paid for living within the rules was a head full of well-
regulated mush.

He wanted to look and see for himself, and half the time he was
utterly surprised at what he found. Why hadn't anyone looked be-
fore? These investigations show Leonardo at his rebellious best, nos-
trils wide, on the hunt, eyes open, surrounded by secrets begging for
attention.

"What can I cut open next?"

1508	Leonardo draws *Head of a Woman*. Begins *St. John the Baptist*.
1508	Michelangelo begins the Sistine Chapel ceiling.
1509	Constantinople earthquake destroys 109 mosques and kills an estimated 10,000 people.
1509	Henry VIII, age eighteen, becomes King of England.
1509	Raphael paints *School of Athens*.
1510	Sunflowers are brought to Europe.
1510	Leo Africanus travels to Timbuktu.
1510	The painter Giorgione dies in Venice (b. 1477).
1510	Sandro Botticelli dies in Florence (b. 1445).
1511	Portugal conquers Malacca, gaining control over all shipping between China and India.
1511	The first black slaves arrive in Colombia.
1512	Michelangelo finishes the Sistine Chapel ceiling.
1512	Copernicus publishes *On the Revolutions of the Celestial Spheres*, which decrees that the sun is the center of the solar system.
1512	Selim I succeeds Bayezid II as Sultan of the Ottoman Empire.
1513	Portuguese mariner Jorge Álvares lands at Macau, China.
1513	Vasco Núñez de Balboa discovers the Pacific Ocean.
1513	Juan Ponce de León, looking for the Fountain of Youth, discovers instead Florida, and then the Yucatán.

MILAN II

Ages 56–61

FOR THE NEXT five years it seems Leonardo was primarily located in Milan, although he made trips out to other small cities occasionally. During this same time, in Rome, Michelangelo began, executed, and finished his work on the Sistine Chapel ceiling, while Leonardo was still dabbing at his twenty-one-by-thirty-inch *Lisa*, not quite sure about some background detail yet, still tweaking the smile. The more time he spent with the subject, the more complex it became to him. The *Mona Lisa* was for Leonardo a philosophical painting, one which provoked thought and consideration, one in which he saw himself. The painting had evolved through stages and looked very different now from the painting he started in Florence. He's following his own imagination, allowing the painting to evolve. He's looking for a kind of truth.

Other than putting his notebooks in order, we have little idea what else Leonardo was doing after he moved back to Milan in May. Over the next few months and years he apparently drew a bird's-eye view of the city with a schematic map, lost to us now. It was probably similar to his Imola map but likely richer and more detailed, it being made outside a war zone and at his leisure. He also elaborated projects for a church, conducted further studies in comparative anatomy, cutting open both horses and humans, and compiled a treatise, also lost, on the anatomy of the horse. No doubt he dissected several, and those drawings I'm sure were gorgeous too.

This was presumably the period in which he devoted himself to works which required more planning, such as *St. John the Baptist*, and the *Salvator Mundi* (or *Christ Among the Doctors*), which was only rediscovered and properly identified in 2012, buried under a very bad over-painting. As many others have remarked of the cleaned painting once it was on display: Jesus looks quite stoned. "Red eye" doesn't start to describe him.

Even though Vasari listed herbs and their properties as one of Leonardo's areas of interest, this is one of those subjects that has been taboo around Renaissance studies. But the use of herbs for artistic and philosophical purposes was old when the ancient Greeks discovered it two thousand years before. In a rule-breaking and innovative time such as the Florentine Renaissance, inhaling a little canapa might've helped with the night's entertainment, especially if you played the *lira* and improvised a lot. We know it was around. After all, Pope Innocent VIII had banned the practice as sacrament during mass in 1484. How bad did the practice have to get before the Pope himself had to step in? Perhaps the reason the subject remains untouched is because Leonardo Studies arose with Italian Renaissance Studies in Victorian England, where some subjects were allowed and others weren't. Cannabis was one. Homosexuality another.

Barbara Reynolds in her biography of Dante points out:

> Knowledge of herbs and medicinal potions was passed from country people and herb-gatherers to apothecaries, and herb gardens were a common feature of monasteries. From the early fourteenth-century manuscript *Tractatus de Herbis* it is evident that the plant Canapa (Cannabis sativa) was known and available.

The caution now is to not conflate the present with the past, but I think we've done just that by imposing our own Christian notions of body and mind on people from an earlier time. To an ancient Greek,

to become intoxicated meant leaving your body and coming closer to the gods up on the mountaintop. What they called "ecstasy." Christians of course put God inside you; you can never be separated from God and God will know all and judge you, your body is a temple, etc., and so to become drunk was to defile the temple and insult God. They've got you coming and going. It's entirely possible though that Leonardo's pantheistic view of intoxication was rather more Greek than Roman Catholic. More Lucretius and less Leviticus. In any event, *Salvator Mundi* is a gorgeous painting of a Christ figure, floating or not.

They had canapa back in Jesus' time as well, but that's another subject.

Leonardo lived in the parish of San Babila outside of Porta Orientale, perhaps near some stables. He seems content to work on his *Lisa* and *Salvator Mundi* and three or four other works and continue his studies of the usual dozen things—water clocks and an automaton that marks the hours; astronomy, geology, hydraulics, the flight of birds, a theory of shadows, studies for producing "mixtures" resembling some plastic material, with references to Alberti and Vitruvius. Dating from the same period are notes on optics and the physiology of the eye.

It seems to me his notebooks served many functions, from open lab books where the apprentices were encouraged to read, to draft books of ideas he merely wanted to consider, or ideas for letters, to (at their most personal) his memory books. If he saw some machine or mechanism he wanted to understand and remember, or some gesture or look in an eye, or a pattern in a lady's lace or the curl of a finger, anything that he wanted to know and examine, he would copy. I think this is the essence of Leonardo as autodidact: constantly looking, constantly observing, noting, guessing, recording—all for later when he could peruse these thoughts more thoroughly and without distraction.

He copied ideas he liked and might later simplify them or other-

wise automate their function, but straight-up invention has been over-attributed to Leonardo. To really tell the difference you'd have to know everything he knew at the same time he knew it, to see what was influencing him and where his ideas came from. All we have are the notebooks, the end result of such a process, but scholars have attributed protean abilities to Leonardo based only on that bit of evidence—much of it missing a context to explain his intent in drawing it.

I also think he recorded so much of his mental life simply so he could own it. He didn't have a house or a stable of horses or any wealth to speak of, other than the knowledge in his head and that which was saved in his notebooks. Leonardo's reputation for invention is actually more the business of a squirrel saving up its nuts until they're needed. That was his bottom-most process: follow your inspiration of the moment and then archive the result for later when it can be useful. Inspiration must be caught while present. Everything for Leonardo seems either "now" or "later." He seems almost binary that way. A passive-aggressive approach that was probably a mystery to those around him, especially the more money-minded.

Some notebooks he could be separated from—those that were for sketching, grabbing things he'd seen on the streets or for problem solving, and those of letter drafts and old maps and projects abandoned, those he could store away in one monastery or another. But his working notebooks, and those for his shop, he kept with him, and as that pile grew, so did the box he kept them in when he moved. And he did keep moving.

WHERE AND WHEN Leonardo got the news is unknown, but no doubt it stopped him in his tracks. Ludovico Sforza had died in a dungeon in France.

It had been eight years now since he was first thrown into the hole. Prison had been extra hard on Ludovico. He was not his former self. Sleeping on hay and feeding off slop, nothing but a little window out

to the world, tormented by his guards, a trophy to be displayed to the casual visitor willing to climb the steps to look at him in his cell; he was utterly miserable. Amid other pitiful scrawls, he also scratched various stars and badges on the wall. The man who once had Leonardo to draw for him, was now drawing for himself, and not liking it as much.

Eventually he gained some small privileges and was allowed out into the yard occasionally to feel the sun and air on his face. But, unappreciative of the favor shown him, he bribed his guard somehow (with what?) and escaped the castle, but did not know the countryside and was easily recaptured and this time, as punishment, Ludovico was placed in an even smaller hole, deeper in the earth, without a window, a candle, or even a Bible to read, and no writing implements as before. He could only sit in the dark and listen to his own cellular decay, the pop and sizzle of dying synapses, memories disappearing as he sank into complete and total despair, all while scratching the endless dead flakes off himself. Ludovico, like every unwashed prisoner, was covered thick in dandruff. Food for the bugs that came out of his beard and woke him at night. Drinking at his eyes.

His heart finally gave out. Anguished to the last, he'd managed to lose what most people never touch. He was fifty-six years old, the same age as Leonardo. Word of his death reached Milan and the Brothers of the Order of Grace requested his body for the tomb he'd built, but they were notified that the body had been burned on an ash heap with other trash. Nothing of his belongings had been kept, everything had been thrown on the fire. His elaborate tomb back in Milan still sits empty.

DURING THIS TIME Leonardo travelled to the University of Pavia to meet and study with Marcantonio della Torre who was professor of anatomy there. Torre was young, only twenty-five, but he'd done many anatomies and lectured on them and I think Leonardo learned

a lot from him. Several writers insist that the great man went to Pavia to teach Torre, and perhaps they collaborated on an anatomy with Leonardo leading the way, but Leonardo was clearly the junior partner here, regardless of age. Most likely it was Torre who not only explained anatomy to Leonardo, but who demonstrated it by performing at least one anatomy for him, which Leonardo then sketched. I think some of those wonderful anatomical illustrations Leonardo did could well have an unacknowledged collaborator in Torre.

An anatomy demonstration would consist of Torre lecturing while an assistant did the actual cutting and lifting, all while Leonardo sketched like mad. One of Torre's assistants was Paolo Giovio, who later wrote:

> He (Leonardo) dedicated himself to the inhuman and disgusting work of dissecting the corpse of criminals in the medical schools, so that he might be able to paint the various joints and muscles as they bend and stretch according to the laws of nature. And he made wonderfully skilled scientific drawings of every part of the body, even showing the tiniest veins and the inside of bones.

Within months, Torre would be dead of the plague and his contribution to the science of anatomy left in the uncertain hands of Leonardo—where it would go into a dark hole with the rest of his notebooks and stay for three hundred years, largely unknown to the world. Melzi saved the notebooks but published nothing of the treasure left to him. It would not be until Vesalius published his illustrated anatomies in 1538 that the insides of human beings could be studied and the beginning of modern medicine begin. Leonardo was a critical thirty years ahead of the curve, which was far too much back then, but his drawings were so much better. Had the study of medicine started with Leonardo's drawings instead of Vesalius', half the capillaries and tendons and muscles in the body would be named

for Leonardo as the discover. That honor instead went to other anatomists over the next hundred years.

Again, the magic of that left hand, but it was attached to a cloaking, ambivalent personality who wasn't ducat-hungry enough to get the anatomy drawings published or otherwise didn't want to draw the attention of the church. Anatomies were not sanctioned by everyone, especially the church. There could be consequences. A knock at the door in the middle of the night. All such things Leonardo avoided if possible.

MACHIAVELLI HAD NOT been so lucky. He'd been caught on the wrong side in a shifting political battle. Cardinal de Medici had received papal permission to restore the family rule in Florence and so he marched the papal army in that direction, where the army of the Republican City of Florence, which did not want the Medici back in control, went out to meet on the field of battle. This army was organized by Machiavelli, and they were a complete and total failure at defending even the small allied city of Prato, ten miles from Florence, where the papal army entered and then slaughtered nearly five thousand people, as was the custom. Two days of rape, sack, and stabbing anything that moved.

The citizens of Florence prepared themselves for the worst while the finger-pointing and blame-placing began. The Medici supporters in Florence demanded Soderini's resignation from the Signoria, and that of his secretary Machiavelli. Machiavelli lost his position, his title, his citizenship, and was bankrupted and banned for life from the city he loved. The Medici, when they returned to power, wanted nothing to do with him.

A few weeks later an anti-Medici plot was discovered and Machiavelli's name was mentioned as one of the sympathizers. Apparently Machiavelli was living out in the country at the family house when he heard of this accusation and he hurried back to Florence to defend himself, somehow thinking the authorities would listen to him.

Instead he was immediately arrested. Then, as a test to see if he was indeed a sympathizer with the plot, they tortured him just to make sure. It's a stupid-simple idea, guaranteed to make a person say whatever you want to hear. Called "strappado," the Inquisitor ties your wrists together behind you, tight as hell, and then a rope is attached and run over a pulley up at the ceiling and your wrists are slowly lifted behind your back. When the bones come up against the limits of their sockets is when the pain might seem unbearable at first, but then you're lifted up off your feet and your skeleton is pulled backward and the pain moves beyond description and you're staring into some kind of white light as they continue to hoist you up in the air—when you are dropped, *almost* to the floor, and left to bounce and then dangle for a while. That final yank is what decides most people. Frequently, shoulders pop loose.

Then, you are asked again what you know about this plot against the Medici. If your answer doesn't sound right to the Inquisitor you're lifted again, arms behind your bunched-up back . . .

Everyone screams. That's just natural and does not count as a guilty plea.

Drop . . . bounce . . . dangle . . .

You're asked again, *"What do you know about this anti-Medici plot?"* You're about to pass out; your mind an empty crater, your body a single gigantic scream. The rope starts pulling you up again, the pulley squeaking . . .

AS AN INTERESTING historical sidebar, years before, Savonarola, the maniac monk who was partly responsible for driving the Medici from power, was also tortured this same way and quizzed about his so-called "visions" and other statements he made against the pope. After the fourth drop he confessed he'd made up the whole thing and it was the devil telling him to sin against the pope and none of it was true. They released him, and then burned him alive a few days later.

MACHIAVELLI, OF COURSE, was about to pass out, or already had once or twice, twitching at the end of that rope, rethinking his whole life. He was asked again after his third drop, and again after his fourth drop, and after his fifth drop and his sixth drop and all six times he was asked, he denied any knowledge of the plot. An innocent man telling the truth is occasionally a powerful thing. So they didn't burn him. Instead they threw him in the dungeon and left him there to pulse in the dark.

Machiavelli didn't handle prison any better than anyone else back then, despite his clear bravery otherwise. From his cell he wrote to the newly installed Giuliano de Medici, ruler of Florence, a poem pleading for his freedom and begging forgiveness.

Giuliano, I have a pair of shackles clawing into my ankles
And the pain of six drops clawing into my back . . .
These walls are covered with lice
So big and fat they seem like butterflies . . .
Amidst the stomach-turning suffocating stench . . .
A metal door slams closed, a prisoner rattles his chains,
Another about to endure the drop
Cries out: "Too high off the ground! . . .
But worst of all, to be woken near dawn
By the hymn accompanying the condemned . . .
I pray to you, let your mercy turn towards me
So that you may surpass the fame of your magnificent father
And that of your grandfather."

His dungeon poem was ignored, and he grieved and suffered and fed the bugs for approximately a month before an unexpected development occurred: On March 12 Cardinal de Medici, older brother of Giuliano, was elected pope, becoming Leo X. As part of the celebrations all over Florence, a general amnesty was declared for all prisoners and Machiavelli got out of his hole and walked back to his home in

the country seven miles away, his back killing him. Roughly a month after he'd raced to town to prove his innocence, a broken man hobbled home. I hope he got a ride on a cart. He was just forty-three years old. What was he going to do with the rest of his life?

THE OTHER INTERESTING thing about Machiavelli's description of his dungeon experience was that he probably gave us a description of Leonardo's holding cell over thirty years earlier. Might've been some of the same bugs, or descendants thereof.

IT LOOKS LIKE Leonardo spent some time in the country at Vaprio d'Adda, northeast of Milan at the Melzi estate, such as it was. Not a big place at all, it consisted mostly of a modest villa and the vineyards around it. He designed plans for expanding the house and other works, probably just entertaining himself. It may have been there in the country with time on his hands that he drew the now famous red chalk self-portrait with big eyes and beard. Writers commonly say he looks older than his age, but they say that without living in the sixteenth century with all the bacteria and zero dental care of the time. He looks fine to me. Others have even claimed the drawing must be of Ser Piero, or of his uncle Francesco, but the ages don't line up, and besides, the intensity of the gaze argues self-scrutiny to my eye. We look at ourselves differently than we look at others and this is a man analyzing himself, measuring, counting the years. The Leonardo in the self-portrait is a guy who has already out-lived most people, and most all of his patrons. At age sixty-one, he'd seen events rotate more than a few times, and nearly been trapped by those changes himself, so he looked at the world with some sense of fatigue and disapproval. Perhaps disapproval of himself. His *Mona Lisa* still sits on her stand in his workshop, unfinished, calling to him, perplexing him; manuscripts yet to be sorted piled behind her. His to-do list was a mile long

and nothing was getting done because he's been down at the river all day cutting open frogs.

He draws his own portrait in a moment of high energy and unusual interest when his mirrors were positioned just right and he could study himself objectively. It's not even a straight-on portrait but rather he's looking to the side, suggesting at least two mirrors, and as many as three or four. It's curious that as self-consumed as he was, he did not draw his own face more than once or twice. Rembrandt by this age would've done nearly seventy self-portraits. Leonardo didn't study himself that way. His own appearance was not interesting to him the way other artists usually find themselves. As far as I know, it's his only deliberate self-portrait, other than perhaps the face of *Vitruvian Man*, as I've mentioned before, which bears a strong resemblance to the old bearded Leonardo. Otherwise he seemed uninterested in his own face, at least as an object of study. Nor did he sign his paintings. It seems he preferred not to identify himself at all.

There is however a painting done by Bramante of Heraclitus and Democritus, the two ancient Greeks known as the Crying Philosopher and the Laughing Philosopher. Bramante painted himself as the laughing philosopher, and the crying philosopher Heraclitus was reputed to represent his good friend Leonardo and their many times together. The face of Heraclitus, and the *Vitruvian Man*, and the old guy with the beard, are the same. And in Bramante's painting Heraclitus has manuscript pages on the table beside him, the script running right to left.

Whether Leonardo saw it coming or not, the Holy Roman Emperor, Maximilian I, invaded northern Italy and pushed the French out of Milan, leaving Leonardo in an unexpected situation without his benefactors and uncomfortable perhaps with the new governor. Exactly what he did during this time is not known. Maybe he just laid low, packing his grip again. News of the invasion reached every part of Italy within days. Fortunately, in September of that year he was invited to move to Rome by his friend and new patron Giuliano de Medici.

It was a journey of more than four hundred miles that took about two weeks in winter on horseback, but I'm sure he was glad to make it to be some place safe again. The same Giuliano de Medici who had Machiavelli tortured and left in prison was Leonardo's good friend, brother of the pope. What Leonardo actually knew of Machiavelli's trials and tribulations at this point it's impossible to say. As the reigning Medici, and ruler over the city, Giuliano had a lot of blood on his hands, and I'm sure Leonardo knew about Giuliano's dungeons. Everybody knew about those. All those cries and pleadings and executions Machiavelli refers to in his poem occurred under Giuliano's authority. Did it trouble Leonardo? The older he got, the more his surprise at the world probably just ebbed away.

I wonder if Leonardo visited *The Last Supper* at all before leaving Milan, and what he thought of it now. People no doubt kept asking him that question. Everyone had seen the decay setting in. What had happened? Can it be fixed? What we don't know was his answer. Getting out of town he wouldn't be bothered by it any more. Like a lot of other things, he wanted to put it behind him. His *modus operandi*, one might say: make something new instead.

CHAPTER 24

ROME

Ages 62–64

FOR THE FIRST few months it's not known where he stayed in Rome but it might've been with Giuliano de Medici who later found him rooms in the Vatican's Belvedere, the pope's summer palace not then in use. Constructed only about thirty years earlier, the building was in considerably better shape than others Leonardo had occupied. He's given a stipend as well so he can maintain his little troupe and have room to work, but early commissions from the pope were slow to come. Leonardo was sharing the pope's limited attention with a couple of other artists hard to ignore—Michelangelo (the favorite) who at the moment was operating at full-throttle, and the new kid in town, Raphael. Those two radiated vitality whereas Leonardo seemed spidery and remote and kind of old. And all that hair! What's with that?!

Giuliano was one of those who understood Leonardo and saw through the appearance, whereas his brother the pope apparently did not. Pope Leo took Leonardo at face value and figured everything about him was just backward and perverse. There finally was some kind of commission from Leo, but as Leonardo dithered and delayed starting, messing with his oils and varnishes again, the pope said, in Latin no less, "Oime, costui non e per far nulla, da che comincia a pensare alla fine innanzi il principio dell'opera." Or, "Alas, this man will never do anything, because he is thinking about

the end before he has even begun the work." If Leonardo heard about the remark, someone had to translate it for him.

And this Medici pope had known Leonardo, or known about him, all his life. It was a harsh judgment, and stupid to boot, but the pope's opinion was based on a lot of years and a lot of stories from others, perhaps including his own brother. It was not just an observation in a moment of pique.

Clearly at this point in his life all the tales and exaggerations had piled up and taken root, and Leonardo had a reputation, good or bad, that, in the end, left him with a lot of time on his hands. Mirrors were relatively new to the age and Leonardo has been experimenting with them and gathering data and has explained to Giuliano how they can be arranged to catch the sun's rays and convert this into heat. Giuliano is interested in this solar energy to heat the large vats in his textile business in Florence, which was once again booming with overseas trade.

To build the parabolic mirror Leonardo hired two Germans (whom he calls Giorgio and Giovanni) who had skills making mirrors and casting metal, but somehow, someway, from the very start, the three of them did not get along. From Leonardo's point of view the two were slackers who did not work and were even attempting to "steal my secrets," as he complained to Giuliano.

From the two Germans' point of view, however, we get another glimpse of Leonardo with the bark off. Scallywags they may have been, there seems something almost immediate about their dislike of each other, almost as if from first sight, and Leonardo responded to that rejection by rejecting them. Why they responded that way we do not know, but we've seen it before.

Working for Leonardo might've been a bit more laid back and confusing perhaps, his workshop not what they were used to back in Germany. More improvisational perhaps, unstructured, a little like being in a jazz band with Thelonious Monk. Leonardo seemed to work intuitively through projects, not what your typical German craftsman

with rigid rules and methods might expect or feel comfortable with. Maybe they found him irritating. Makes you wonder, what was he like as a teacher? As the maestro of a workshop?

Leonardo kept withdrawing. He didn't want this conflict, or any conflict. I imagine him increasingly staying away from people, especially those two, working when he could alone in the cool of the night, and was probably doing a dissection by candle and mirror one evening when one of the Germans walked in and caught him at it—seeing a human leg on the table perhaps. Or a head Leonardo found and brought home, the brain in a bowl. Just the opportunity they needed to pay him back for all his complaining. What we do know is that they reported him to the pope and the pope called him in and put a total ban on any further desecrations.

As a consequence, Leonardo was banished from the hospital of Santo Spirito, his source for corpses, and was accused of sorcery. Apparently not even Giuliano was able to intercede on his behalf. Any dog on the street could take a bite at him now. It's like his early days in Florence when an anonymous accusation could get him thrown in a dungeon. He decided to get out of town for a while and traveled to Monte Mario to search for fossil seashells. In June he designed a stable for Lorenzo di Piero de Medici and had ideas for a new Palazzo Medici in Florence, and he re-creates his "mechanical lion" which he sent to Lyon as a gift for the coronation of Francis I on July 12. His notebooks otherwise show that he devotes himself to geometric games during this time, drawing compasses, figures dressed in theatrical costume, and, uniquely, an allegory of a wolf-dog at the helm of a boat with the compass oriented by a golden eagle. A veritable pile of symbols he was unable to make work.

He stayed busy, but he doesn't seem occupied. A lizard found in the garden is brought to him and he attacheed wings to it and used the thing to scare visitors who came by, claiming it was a freak of nature. A joke of sorts from a man with time on his hands. Michelangelo and Raphael are elsewhere, sculpting and painting like crazy.

In October of that year he went with the papal entourage to Florence where the Medici pope was greeted with flowers and music and great celebration. Leo X oversees a gathering of cardinals in the great Council Hall where Leonardo's half-finished *The Battle of Anghiari* was plainly obvious. And Leonardo was there, looking at his own history and probably shrugging his shoulders a lot when asked about it, talking with his hands, fingering the air, as hard to read as ever.

It had to be the theme of his life. He couldn't help talking about his unfinished work, but we have not a word. Did he sit with his back to it, or look at it the whole time?

The papal entourage continues on to Bologna, where Leonardo met the new French king, Francois I, twenty-one years old and recently victorious over the restored Sforza in Milan. Francois knew of Leonardo already as his father-in-law, Louis XII, valued his paintings and owned at least one, *Salvator Mundi*, and from just seeing *The Last Supper* in Milan, the city he had reconquered only months before. He also knew Leonardo from his mechanical lion which he'd seen in Lyon the previous July, which truly astonished the young king. Given later developments, it's reasonable to suppose that at this meeting in Bologna, Francois made Leonardo an offer of employment if he would come to France, and Leonardo either accepted on the spot, or considered it and later wrote to the king accepting. There is no surviving document that formalizes the king's offer or Leonardo's acceptance.

And yet he wanted to get away from Italy and had probably been thinking about it for some time. The last time he was in Rome he tried to leave for Constantinople. The lack of much enthusiasm from the current pope was surely a factor, as was the ongoing presence of Michelangelo and Raphael and the lack of commissions for him. Rome may well have seemed a dead-end to Leonardo, a premature grave, and it was the unresolved nature of his duties there that might've prompted him to move on. But I sense as well that impatient twitch coming over him with each passing day. This is an itchy guy. He doesn't stay where he's not wanted. He doesn't like being behold-

ing to someone who's ignoring him. He starts looking around, weighing his options.

By March 1516, he was back in Rome, messing with geometric problems of perspective. It looks like he was waiting for something. Then on the seventeenth of that month, Giuliano de Medici died of syphilis at age thirty-seven and Leonardo loses another sponsor and good friend. This is a period of uncertainty for Leonardo and he no doubt began casting about once again, considering again the offer of Francois I—and then abruptly made the decision to move to France.

There was no doubt some mail between Leonardo and Francois, and a final reckoning up of his affairs in Rome, and elsewhere. He was starting over again at age sixty-four. If you count his first move to Florence as a boy at age fifteen, this will be the eighth time Leonardo has decided to restart his life. Fortunately he doesn't have to write a letter listing all his job skills or worry about his reception. All he has to do is get there.

LATE THAT SUMMER he starts the journey north to begin his new job as royal engineer and painter to the King of France at his palace in Amboise, over 840 miles away. This will be a journey of three months whereby Leonardo transported something in excess of five hundred pounds of luggage, which included all of his notebooks and other books, as well as the *Mona Lisa* and *St. John* and other paintings he's still working on. Three months out in the open where everything valuable to him is subject to disaster, as is he himself.

I wonder if he stopped in and saw Machiavelli one last time as he passed through Florence. If so, Machiavelli had long since finished writing his infamous *The Prince*, and was at work on his eight-hundred page history of Rome, his *Discourses on Livy*—which is a critical counterbalance to *The Prince*—as well as all the poetry, and biographies, and the histories of Florence and Germany and France he managed to produce, in addition to his complete translation of

Lucretius's *The Nature of Things*. He'd written as well on the Italian language and military science, and several plays, both dramas and comedies. Machiavelli was a deeply humorous, profoundly intelligent man who cussed like a sailor and was talented in every direction. He also probably didn't sit right in his chair but was stiff and leaned to one side, his back ruined, lots of pillows, getting up to walk around every few minutes, twitchy and quick. And Leonardo was surely solicitous as he heard what awful events his friend had endured at the hands of his other friend, Giuliano, recently dead. Perhaps Machiavelli told Leonardo about his writings, explained his ideas to him, neither one of them living long enough to see any of the work published. They might've shared news of Cesare and Ludovico and Giuliano's recent death and discussed their plans for the future. But it doesn't seem they ever wrote to each other, and if Leonardo did stop by on his way to France, there's no record of it, as much as I wish it happened.

Cold weather is approaching as he turns northwest into the mountains. The temperatures then were colder than now and his trip could not have been easy. Three months on the road seems an extraordinary effort for a sixty-four-year-old man, especially riding horseback. Salai and Melzi are with him but Zoro has stayed behind in Rome where he will flourish, building his reputation as an alchemist and conjurer to new heights. It's just the three of them and the cart full of bags and boxes, lost perhaps in a larger train of travelers and guards. Leonardo's life work in a space probably four feet wide and five feet long, the average dimensions of a two-wheeled cart at the time.

Wrapped up like a Bedouin again, he's barely visible in all that cloth—a little bit of skin maybe and a lot of beard, swaying on the back of his horse for weeks at a time, two eyes watching that cart as it wobbles on imperfect wheels high above the river gorge below. Everybody hoping nothing comes loose for the next few hours until they're off that mountain for good. Nearly everything he values in the world is water soluble. A good soaking and all those notebooks turn to pulp.

Other than being anxious as hell, what else did he think about?

He's leaving his life in Italy behind and, given the effort needed, probably doesn't intend to return. He's leaving what family he has behind him. He's leaving all his friends and business connections and the various neighbors and all the sites of his childhood. He's waving goodbye with both hands.

And, it doesn't appear he spoke all that much French, or certainly wrote any at all, forward or backward. What did he anticipate ahead? What did he regret behind? What did he feel sitting in that saddle day after day? My guess is he entered a trance-like state on these long trips. A good smooth-riding horse will do that to you anyway, but if you're predisposed to trance states and look forward to invention, the back of a horse is a good place to find it.

1517	A sweating sickness epidemic breaks out in Tudor England.
1517	Martin Luther posts his 95 *Theses* and ignites the Protestant Reformation.
1517	Europeans enter the port at Guangzhou and begin to trade with Chinese merchants.
1517	Selim I conquers Egypt and declares himself Caliph.
1517	Luca Pacioli dies in Sansepolcro (b. 1445).
1518	The Dancing Plague occurs in Strasbourg, in which many people die from constant dancing.
1518	Tropical fire ants devastate crops on Hispaniola.
1519	Charles I of Spain becomes Emperor of the Holy Roman Empire.
1519	Hernán Cortés leads the Spanish conquest of Mexico.
1519	A smallpox epidemic kills one half of the indigenous populations in Central and South America.
1519	The first recorded fatal accident involving a gun in England.
1519	Ferdinand Magellan begins his voyage to circle the Earth.

PLAYING KICKBALL AT CLOUX

Ages 65–67

HE ARRIVED IN one piece, we hope, and wasn't covered in saddle sores or bruised from a fall off his horse. The young king, though, was as good as his word and installed Leonardo and Salaì and Melzi in a small chateau near the palace he had standing empty, and gave everyone salaries and even assigned them a cook, a woman named Maturina.

Other than demonstrating his mechanical lion once more at the palace, as expected, Leonardo became something of the court sage, much as he had been for Ludovico, only this time the king was twenty-three years old and all his pores were wide open to Leonardo's tricks and tales. It must've been fun, Leonardo playing him like a fiddle, entertaining them both.

A visit is recorded in October 1517 by the secretary of Cardinal Luigi of Aragon, who visited Amboise to see the king and stopped by to see Leonardo as well. His secretary, Antonio de Beatis, kept a travel log of the visit and it is one of the few first-hand accounts that survive of a stranger meeting Leonardo for the first time.

Like others, his impression was that Leonardo was older than he really was. He describes him as "an old man over seventy." Leonardo was sixty-five.

He showed His Lordship three pictures, one of a certain Florentine lady, done from life at the instigation of the late Mag-

nifico Giuliano de Medici, another of the young St John the
Baptist, and another of the Madonna and Child Placed on the
lap of St Anne: all quite perfect. However, we cannot expect
any more great work from him, since he is now somewhat par-
alyzed in his right hand. He has trained up a Milanese pupil
who works well. And while Master Leonardo can no longer
color with such sweetness as he used to, he is nonetheless able
to do drawings and to teach others. This gentleman has written
a great deal about anatomy, with many illustrations of the parts
of the body, such as the muscles, nerves, veins and the coilings
of intestines, and this makes it possible to understand the bod-
ies of both men and women in a way that has never been done
by anyone before. All this we saw with our own eyes, and he
told us he had already dissected more than thirty bodies, both
men and women, of all ages. He has also written, as he himself
put it, an infinity of volumes on the nature of waters, on various
machines, and on others, all in the vernacular, and if these were
to be brought to light they would be both useful and delightful.
Besides his expenses and lodgings, he receives from the King of
France a pension of 1,000 scudi a year, and his pupil gets three
hundred.

Beatis doesn't mention the backward writing, but then it's possible
he didn't examine it closely enough to recognize it as backward. It
also seems Beatis rewrote his travelogue some years later so what is
remembered and what is forgotten is in play. We get snatches too of
Leonardo's own words: "an infinity of volumes" and the promise of
usefulness "if they were published." A considerably large "if," which
apparently means published by someone else. Leonardo seems to be
making an offer here. Had he made the same offer to the king as well?
I suspect that was always the talk about the notebooks; it explained
in part why Melzi did so little to publish them after Leonardo's death.
He's trying to get someone else to do it. Melzi thought about the

notebooks in the same way Leonardo had taught him to think: as a project needing vast sorting and transcribing and editing and etchings by the hundreds and the imagination quickly runs away with all the complications possible in such an endeavor.

But as much as Leonardo had an editor's mind in other ways and revised and tweaked the world around him, he did not have the chops to edit and organize a book, his or anyone else's. Look at the task not from a professional editor's point of view, as we might today, but from a half-literate, self-taught, mirror-imaged individual's point of view like his, and it quickly becomes overwhelming. His brain just didn't work that way. Another of his failures. Many nights he must just sit in the dark and sigh, thinking what a wreck he's leaving behind.

And that was likely Leonardo's attitude to the notebooks most of his life. On one hand, they contained things both "useful and delightful," but on the other hand, it was all scattered throughout that big pile over there, and two lifetimes wouldn't be enough to sort it out.

But on the third hand, that's what originality looks like up close. It's scattered, not entirely coherent, full of holes and gaps and repetitions, even founded on false assumptions, but also containing great insights that penetrate into the nature of the world.

Consider the mind that wrote: "And any one standing on the moon, when it and the sun are both beneath us, would see this our earth and the element of water upon it just as we see the moon, and the earth would light it as it lights us."

I'm pretty sure that's what Neil Armstrong saw when he looked up from his golf swing.

The man had killer instincts.

The real question is not why Leonardo didn't get the notebooks sorted, but why Melzi didn't. Melzi had the time and, as far as we know, the opportunity to at least begin the task by hiring a scribe or two and perhaps an etcher to help him with the copper plates, and turn that upper room at the Melzi villa into a little factory for a few years—starting with an index of what he had, then the science

of painting book first, then the anatomy, and hopefully the book on flight as well, or water, not to mention the machine drawings. Melzi could publish one or two of them and hold back the anatomy until he was on his deathbed and beyond the reach of the church. But he didn't do any of that. Leonardo's vast fragmented enterprise, all of it but for some works of art, disappeared after Melzi's death. His kids started selling off the pages piecemeal out of a cabinet in the attic, letting anyone who wanted to rifle through them, scattering pages and whole notebooks to artist studios, as well as private libraries and storerooms and vaults all over Europe and England, some of which went up in flames during the many wars since. The net effect was as if they'd slipped into a hole for the next three hundred years and only half of them ever came back out.

WHAT LEONARDO IS doing at this point, it seems, is spending a lot of time with the king. He travels with his entourage to Romorantin, sixty-three miles away, probably a two-day journey. Perhaps they rode in a carriage together and told stories and Leonardo did magic tricks. He later draws up plans for a new, ideal palace, a bit like what he'd done in Milan thirty years before, and again in Imola for Cesare, only this time he included a garden and a large basin so the young king could stage sea battles with toy ships. Before the age of air conditioning, for those who had sufficient wealth, a comfortable garden made for a happy life. A large garden full of trickalation and surprise, like the king wanted, might contain whistling water spouts, labyrinths made of shrubs and paths, caged birds, sudden vistas and grottos, landscaping being already a developed art long before Leonardo took it up.

Leonardo is at Romorantin with Francois until mid-January when they returned to Amboise. Construction would begin on this new palace but will stop for an epidemic and other reasons, never to be completed. The curse of all Leonardo's architectural plans. He or-

ganized a festival for the wedding of the king's niece Magdalene de la Tour d'Auvergne to Lorenzo di Piero de Medici, grandson of the great Lorenzo. Among his very last drawings are more studies in geometry, perspective, and architecture.

But his burning fascination during those last couple of years seemed to have moved beyond the simple how-to of mechanical questions into the more complex realms of chaos and turbulence. He was fascinated by water right up to the end. He had been all his life, of course, but beyond containing and directing it, he had always wanted to know its insides, its anatomy, so to speak. What happened below the surface? What were the invisible muscles and sinews of a waterfall, or even a motionless pond? How did water move when disturbed and how did it come to rest? What was a ripple, and how did one ripple pass through another without disturbance? What was this nature of water, and most especially, the nature of turbulent water?

Nothing could have been more impossibly complex to the Renaissance mind than the interior hydromechanics of invisible turbulence. Anyone could see it was chaos itself—underneath a waterfall there's no sense to be made—and yet Leonardo thought he could see a pattern in there. He dropped tiny seeds into it, dangled long strands of hair, and with that marvelous vision, even impaired and dim by now, he thought he could see a pattern, and drew it.

He had a series of strokes along in here and grows dark, furious, half-lame in a chair, pushing his way forward into this new mystery, the mystery of bodily disintegration. What was it that was happening to him? And why? How? He continued asking questions for no reason other than to know.

I'd like to imagine (although there's not a shred of evidence) that before he got too lame and crippled up, Leonardo visited the fortress at Loches, only twenty miles away, where Ludovico Sforza had been imprisoned and died ten years before. Perhaps he saw Ludovico's first cell up in the tower and the childish drawings on the wall, the ignorant stars and meteors and family crest, and seen as well all the

black smudges where Ludovico rubbed against the cold stone, a vio-
lent life boxed extra small. And maybe Leonardo was likewise shown
that dark hole of a dungeon down those many steps below ground
where Ludovico finally died. You could still feel the lingering despair.
It must've been thick at one time. Ludovico had been ruled by his
nature, not his mind. The same was true of Cesare. They were not
men you could reason with. Leonardo must've felt fortunate to have
escaped with his life intact, not once or twice, but many times. Sur-
vival had been his greatest gift. Not something a peculiar person like
him could expect during times like these.

IN HIS PRIVATE room at Cloux up on the second floor where he
spends more and more time, there's a painting on a stand he's car-
ried with him and studied for years, and it provokes him still. It was
the hardest thing he'd ever tried to do, like capturing a vibration or
an echo. It was impossible to be sure if he had it entirely right even
yet. Genuinely an odd piece of work. His whole life he's experienced
that flash of momentary recognition, of truth glimpsed through an
accidental pairing of two things which spark a connection, an insight
perhaps. He lived for those flashes, those moments when the invisible
became visible, when suddenly he could see all the way through. A
wordless truth. A pictorial truth. How did that work? He still wanted
to know, and this painting was his best answer to the riddle. Most of
the time. But then on a bad day, you could never be sure. You had to
be alert and responsive in order to see. That was becoming harder
and harder for him. And yet the painting continued to draw his eye,
engage his mind. It *seemed* to work.

 A woman sitting on a balcony turning toward the viewer. Behind
her, an impossible depth and distance. In front of her, her own hands
crossed over her womb. He studied it as one would Egyptian hiero-
glyphs, testing his reaction over and again. The meaning was both
approximate and yet profound. And almost silly, which was his fear.

He'd made the scene impossible by forcing that background up under the balcony, making it appear the woman was sitting on the edge of an enormous cliff a quarter mile in the air, her back up against eternity. And yet he found it necessary for the effect. And the light was all wrong, coming from inside the room instead of outside in the sun. Not to mention the asymmetry of it all. Everything was out of balance, drawing the eye back and forth and all over. The mountains behind her not only impossible, but turbulent and vague, like out of a nightmare. And her face a collage of aspects, depending on if viewed from left to right or top to bottom or center to edge, it appeared to say different things at different times, and yet, like a dream it made sense. That dream sense had been the difficulty here, what had taken him so long to find, the juxtaposition of things that could only be one way, which should not work, but seemed to. It excited the imagination to make sense of it all.

He knew science could not explain this painting, logic was helpless in such a place, and yet the beauty of the enormous technique prevailed and persuaded. One glimpsed creation and regeneration and oblivion. A wordless truth where art moved beyond the philosophers and their books and perfect logic. This was more. It captured that ancient generative spirit that was everywhere and nowhere at once. His answer to those smart-ass know-it-alls back in Florence.

As artist he was always the scientist, and as scientist always the artist. Two views of *everything*. The man hummed like a lute string, even on his calmest of days. Every contradiction in the world seemed to find a home in his head. So much thinking!

LEONARDO'S WILL IS dated April 23, a week after his sixty-seventh birthday. Melzi was his executor and main heir, and he was left the paintings and notebooks and lab equipment. Salaì got cash and the land in Milan. Leonardo's half-brothers, the land in Vinci. The cook Maturina was given a nice fur-trimmed cloak and two duc-

ats. On May 2, 1519, Leonardo died. He'd waited to write his will until the last possible minute.

Later hagiographers, starting with Vasari, claimed Leonardo died in the arms of the French king who held him close to inhale his last breath. Maybe. Records seem to indicate Francois was elsewhere at the time, too far away to dash home and breathe deep. Leonardo probably died as he lived, surrounded by strangers, and fortunately one close friend. He studied his approaching death, I'm sure of that. If he was cogent, he was cogitating. *This is how we die* would be his next book, if only he was strong enough to dictate it. Or maybe he did, and that too is lost.

I think from his bed he studied his *Mona Lisa*, looking deep into that time tunnel all the way back to his very beginnings— noticing too he still hadn't gotten to her eyebrows. If only . . .

Almost his last words were, "Dimmi, dimmi se mai fu fatta cosa alcuna." "Tell me, tell me if anything ever got done."

THEY STORED HIS body for three months during the warm summer until a tomb could be constructed. Melzi waited for this final interment before heading back home over the mountains, carrying those same boxes with him that they'd carried before, minus a few paintings.

The chapel where Francois buried Leonardo was destroyed during the French revolution and the bones inside scattered. The tale is told of an old gardener, a man named Goujon who, in 1808, came upon the scene and saw a group of local boys playing a game of kickball with an especially large skull. He retrieved the skull and other bones he found scattered about, as well as broken pieces of marble with the letters EO . . . DUS VINC, and he buried the nearly completed skeleton in the "new chapel," where it remains today.

1520	Zoroastro (Tommaso Masini) dies in Rome (b. 1462).
1520	Raphael (Raffaello Sanzio da Urbino) dies in Rome (b. 1483).
1524	Salaì (Gian Giacomo Caprotti da Oreno) dies in Milan, shot by a crossbow in a duel (b. 1480).
1525	During the battle of Pavia, Francis I of France is captured.
1527	The Sack of Rome and the end of the Italian Renaissance.
1527	Niccolò Machiavelli dies in Florence (b. 1469).
1532	Francisco Pizarro leads the Spanish conquest of the Inca Empire.
1541	Michelangelo completes *The Last Judgment* in the Sistine Chapel.
1542	Lisa del Giocondo (*Mona Lisa*) dies in Florence (b. 1479).
1543	Vesalius publishes *De Humani Corporis Fabrica*, pioneering research into human anatomy.
1546	Michelangelo becomes chief architect of St. Peter's Basilica.
1559	Italian Wars conclude.
1564	William Shakespeare is born (d. 1616).
1564	Michelangelo dies in Rome (b. 1475).
1568	Francesco Melzi dies in Vaprio d'Adda (b. 1491).
1568	The second edition of Vasari's *Lives of the Most Excellent Painters, Sculptors, and Architects* is published.
1574	Giorgio Vasari dies in Florence (b. 1511).
1580	Francis Drake returns from circling the world.
1590s	Leonardo's *Leda and the Swan* is destroyed at Fontainebleau by Madame de Maintenon for its immorality.
1628	William Harvey publishes his discovery of the circulatory system.
1687	Isaac Newton describes universal gravitation and the three physical laws of motion. All of these things he hides in a drawer.

AUTOPSY

SO WHAT HAPPENED? Since Leonardo finished so few commissions and was weirder than a three dollar bill; how did he end up one of the most famous geniuses in history? The facts are that after his death Leonardo was largely forgotten, then something amazing started to happen. This man who rarely completed anything was suddenly being completed by others. You could even say this book is an example of that.

As I've tried to make clear, it's all about the ambiguity. Being undecided, betwixt and between, is the essence of Leonardo. It was out of that ambiguity that he made his greatest art. He swam in it his whole life, and for the most part that ambiguity stymied him. The gigantic irony is that the fame Leonardo failed to achieve found him anyway. In spades. And it was *because* of the ambiguity.

A well-regulated state does not produce Leonardos. Leonardo is what happens when a unique talent slips through the cracks—and is *not* destroyed, but continues to grow, even if strangely.

Still, the question is asked: Why are there no more Leonardos? Such a question usually imagines him as a modern superman who multitasks like a spider and thinks nine thoughts at once, which is obvious fantasy and wrong. What the modern man imagines when he looks backward into history is a version of himself, and what we fail to appreciate is how genuinely different we've become in the last

five hundred years. I think the truth is there are potential Leonardos everywhere in the world but they rarely survive or succeed in our regimented social order, and they don't do at all well on tests. A kid growing up wild in the country today, fifteen years old and unable to properly write or even sign his name, is what social welfare workers would call "a problem."

And what's complicated about all this is that the social worker would be right, usually. Rescuing isolated, handicapped kids is what a civilized society must do, and yet in this case what seems to have made the difference was Leonardo having to figure it out for himself. What accounts for Leonardo is an act of self-discovery, and the tenacity to make it, over and over.

Imagine Leonardo as a young boy growing up in Vinci those last few months and weeks *before* he discovered he could draw. Little "Lionardo," as he was before he found a way to make sense of the world. Learning to read was incredibly difficult, writing "correctly" even more so. Everything seemed wrong to him, backward somehow, and he couldn't figure out why. He felt so stupid. And then, somehow— perhaps it was his uncle Francesco—the idea was inserted into his confused little brain, *"Do it your own way, even if it is different. You are not stupid! Find how it works for you."*

And by some internal process he found his way, this left-handed, dyslexic, uneducated country kid who might well have had Asperger's—somehow, out of that unorganized swirl of sensation, Leonardo recognized a way to make sense of it for himself. And he did it by trusting his own instincts, finding his own connections.

And then there was Verrocchio who gave him his path.

That is the moment when Leonardo began to find a way to live. It's not knowable, of course, but it's there somewhere, it happened: *"I can do it, but only like this."* That was the box he lived in his whole life, seems to me.

Modern hagiographers like to imagine Leonardo as the total man, utterly complete in mind and body, whereas the evidence, objectively

considered, suggests someone who was terrifically lopsided and as defined by his shortcomings and disabilities as by his strengths. If anything, his shortcomings defined him more.

It seems to me we do ourselves a disservice when we over-praise a talent. It feels good to praise and idealize, but then we risk making art inaccessible to those who aspire. By turning Leonardo into a colossus, we objectify him just as much as if he was a centerfold in a magazine. Intellectual pornography of a kind. He gets more powerful every generation until finally we get writers who basically claim he invented the modern world and most of the stuff in it. But then, these always seem to be institutional men who over-praise Leonardo, specialists oftentimes stuck in offices perhaps. It's how the academy works.

It's all because Leonardo acts so on our imagination. Everything about him—his talent, his failures, his quirks and mysteries—all function as enticements to the imagination, and as provocations demanding closure. He points to mysteries in ourselves. While Leonardo could not have planned it, ambiguity and unfulfilled promise have served his legacy well. Into that ambiguity can be read whatever we want.

Leonardo, who was not "readable" to others at the time, is highly readable centuries later, not just because of distance and the perspective we have, but because he doesn't contradict us. He's a template upon which we project. Much like Shakespeare (or Kafka), the less is known, the more vivid he seems to become in the end. This is true of Leonardo's art as well. The mysterious *Lisa* is as strange today as she was in 1519.

When we look into the face of Leonardo, we see ourselves. When Leonardo held up a mirror and looked into the face of Leonardo, he saw something else entirely, and we weren't in the frame.

ACKNOWLEDGMENTS

I'D LIKE TO thank all the really great folks at Melville House, and especially Valerie Merians and Dennis Johnson for taking the project on. Likewise, my old friend and running buddy, Larry Baker, who helped Leonardo find a home. And most especially to acknowledge Scott Holt and his wonderful family. Thank you all.

ILLUSTRATION CREDITS

Portrait of a Bearded Man, possible self portrait by Leonardo da Vinci (red chalk on paper), Italian School / Biblioteca Reale, Turin, Italy / Bridgeman Images

The Lady with the Ermine (Cecilia Gallerani), 1496 (oil on walnut panel), Vinci, Leonardo da (1452-1519) / © Czartoryski Museum, Cracow, Poland / Bridgeman Images

Studies of war machines, 1485, by Leonardo da Vinci (1452-1519), sanguine on paper, Vinci, Leonardo da (1452-1519) / British Museum, London, UK / De Agostini Picture Library / Bridgeman Images

Fight between a Dragon and a Lion (brown ink with wash on paper), Vinci, Leonardo da (1452-1519) / Gabinetto dei Disegni e Stampe, Galleria Degli Uffizi, Florence, Italy / Bridgeman Images

Studies of the Proportions of the Face and Eye, 1489-90 (pen & ink over metalpoint on paper), Vinci, Leonardo da (1452-1519) / Biblioteca Nazionale, Turin, Italy / Bridgeman Images

Seven Studies of Grotesque Faces (red chalk on paper), Vinci, Leonardo da (1452-1519) (attr.to) / Galleria dell' Accademia, Venice, Italy / Bridgeman Images

A standing masquerader, c.1517-18 (chalk, pen & ink and wash on paper), Vinci, Leonardo da (1452-1519) / Royal Collection Trust © Her Majesty Queen Elizabeth II, 2016 / Bridgeman Images *Vitruvian Man*

Study of the Hanged Bernardo di Bandino Baroncelli, assassin of Giuliano de Medici, 1479 (pen & ink on paper), Vinci, Leonardo da (1452-1519) / Musee Bonnat, Bayonne, France / Bridgeman Images

NOTES

THIS BOOK IS not so much a work of scholarship as an act of synthesis, a narrative biography that is substantially based on the works of academic scholars and other researchers. Broadly speaking, where there is historical consensus I do not cite a particular source, otherwise every other sentence would have a citation. Any full biography will answer the questions a reader may have. Historically speaking, I dispute no facts generally agreed on, and offer no new facts; I question only the accepted interpretation and raise the possibility of another. The reader can be assured that no scholars or experts have been harmed during the making of this book.

Chapter 1: King Death

1 Timeline dates are approximate.
2 Slave story, Ross King, pp. 19–20. Slathern, p. 232.
3 Uncle Francesco, Serge Bramly, p. 45.
4 Rates of violence, Steven Pinker.
5 Machiavelli's History of Florence, 1532.
6 Professor Maryanne Wolf, Cognitive Neuroscientist, Tufts University. YouTube.

Chapter 2: Everything's Big at First

1 Leonardo paints a buckler for Ser Piero. Giorgio Vasari.
2 Leonardo's "morbid imagination": Bramly, p. 98.
3 "At this age he was primarily engaged with clothes, horses, and learning the lute": Kenneth Clark, p. 59.

Chapter 3: Hot to Trot

4 The artist as a new kind of man and Vasari as the apostle Paul, the bringer of good news, Turner, p. 55ff.

5 Jonathan Jones, the painting is not so much about the baby Jesus as it is about exquisite drapery. p. 13.

Chapter 4: Jailbird

1 Sodomy in Renaissance Florence. Charles Nicholl, p. 117ff.

2 "Say, any of the twenty-six men records show were punished in just the previous twelve months?": About one in five was found guilty out of 130 per year, or roughly about 26 men. Nicholl, p. 117.

3 Botticelli arrested earlier on a morals charge. Nicholl, p. 117.

4 Once, in his notebook, he wrote, "*The greater the sensibilities, the greater the harm*": Codex Trivulzianus, 23 b.

Chapter 5: Strange Fruit Hanging from the Balcony Rail

1 Verrocchio's name does not appear in any of his surviving notebooks. Nicholl, p. 87.

2 Paid in grain and wine and ended up having to paint a church clock. Bramly, p. 165.

3 I have been built and destroyed by the Medici. Nicholl, p. 167.

4 He's reputed to have illustrated a book on musical harmony, Practica Musicae. Bramly, p. 172.

5 Leo giving lessons on the lute. Nicholl, p. 159, the Anonimo Gaddiano.

Chapter 6: From the Edge to the Center

1 "Suspected of various crimes, the infamous and mysterious Zoroastro": Bramly, p. 113.

Chapter 7: The Musician from Florence

1 Letter to Sforza. Nicholl translation, p. 180.

Chapter 8: Ingenio

1 "Various monsters and a thousand strange worms": Ross King, Leonardo and the Last Supper.

2 Ludovico did "help" Leonardo paint backgrounds with pastels.

Chapter 9: Horsing Around

1 Nicholl, pp. 181–82.

2 "filling every corner with their stench and spreading pestilential death": Cat, 287r a, 65v b.

3 "He is a poor pupil who does not go beyond his teacher." Forster MS 3, fol. 66v.

4 "Geometry and modeling mathematical shapes." Martin Kemp interview with Marcus du Sautoy for the BBC series The Beauty of Diagrams, Episode One: Vitruvian Man.

5 Corte Vecchia built in 1360s. Ady.

6 *Small rooms concentrate the mind, large rooms distract it*": MS 2038, B.N., 16r.

Chapter 10: The Middle Is Off-Center

1 "First principles." Martin Kemp interview with Marcus du Sautoy for the BBC series The Beauty of Diagrams, Episode One: Vitruvian Man.

2 ff Toby Lester.

3 Michelangelo's bronze equestrian statue in Bologna in 1507. Jones, p. 245.

Chapter 11: A Question Too Far

1 Nicholl, p. 289.

2 Raffaello da Montelupo, left handed cite. Ross King, p. 85.

3 "He who uses up his life without achieving fame": Lines from Dante's Inferno copied out by Leo-nardo, Windsor fol. 12349v.

4 Two years later "corn" listed to buy. King, p. 200.

5 Siege of Novara. King, p. 116, 117.

Chapter 12: Shadow Boxing the Self

1 "When fortune comes, seize her firmly by the forelock": Codex Atlanticus, 89v.

2 Leonardo had many reasons for believing his experiments would succeed. King, p. 106.

3 Bramly on Leonardo's temper tantrum, not getting paid as cause. p. 282.

Chapter 14: Academia Leonardi Vinci

1 the "sublime left hand" that drew the various abstract mathematical illustrations for his second book: Pacioli, De Divina Proportione, preface, 1498.

2 "Poor pupil" Forster MS 3, fol. 66v.

3 MS CA 327v/119v-a. And, MS CA 323r/117r-b.

4 Corio quote on destruction in Milan. Nicholl, P 321.

5 "Sell what you cannot take with you": Nicholl, p. 322.

Chapter 15: On the Road Again

1 His list of who's dead or robbed in Milan. MS L.

Chapter 16: Machiavelli Enters the Mix

1 Sforza's "nest of talent" included (besides Bramante and Pacioli and others) the painters Vincenzo Foppa, Ambrogio da Fossano, the Predis brothers, Bernardino Butinone and Bernardo Zenale; poet Gaspare Visconti, celebrated physician and author of *Algebra*, Biuliano da Marliano; as well as Ferrarese architect and friend of Leonardo's Giacoma Andrea.

2 Borgia wanted tech support, hence Leonardo was drawn in. Strathern, p. 61, 107.

3 Machiavelli's description of Borgia. Strathern, p. 2.

Chapter 17: Here Be Dragons

1 Vasari's opinion that Leonardo did not know his own talents. Nicholl, p. 192.

2 Cesare's letter to Leonardo. Strathern, p. 129.

3 Windmill, Strathern, p. 133.

4 Leonardo was already in Fassombrone working on the city walls: Strathern, p. 138.

5 "It's not the sword that kills, but the man using it": Strathern, p. 139.

6 Maps as therapy. Strathern, p. 222.

7 Machiavelli's letter concerning Lorqua, Strathern, p. 187.

8 Little Ice Age, Wikipedia.

9 Most historians think that Borgia was vulnerable. Strathern, p. 156.

10 Machiavelli quote on sacking of Sinigallia. Strathern, p. 197.

11 "After having smashed everything in the village the soldiers burned it to the ground": Strathern, p. 210.

12 Zoro vegetarian, Ammirato 1637, 2.242, as cited by Nicholl, p. 43.

13 "a tomb for other animals, an inn of the dead": Cat 76r a. Slathern, p. 353.

14 Letter of Italian traveler, Andrea Corsali, 1516. Nicholl, p. 43.

Chapter 18: *Florence Redux*

1 "the Italian engineer Giovan Battista Danti, who crashed onto a church roof in 1503": White, p. 302.

2 A Medici ship Amerigo was standing on. Strathern, p. 41.

3 "adds 'corn' to his shopping list": King, p. 200.

4 Johannes Burchard. Strathern, p. 254.

5 He withdraws money from savings almost immediately upon arriving in Florence.

Chapter 19: *Fighting the Battle*

1 "'Curly the Goldsmith' are in attendance": Nicholl, p. 378.

2 "ornamento decente": Jones, p. 80.

3 "his face turning red": The entire anecdote quoted appears in two separate parts of Magliabechiano's journal. I have given the second entry first as it makes more descriptive sense.

4 As Jones points out, Leonardo lived in a shame based society. p. 80.

Chapter 20: *Jumping Off the Cliff*

1 "The great bird will take its first flight": Jones, p. 194.

2 On quitting *Anghiari*. Jones 235, MS Madrid II, 2a.

3 "Leonardo's drawing as a trance-inducing ritual": Jones, p. 202.

4 Designs for fortress at Piombino, Codex Atlanticus, folio 48 recto-b

Chapter 21: *I'm outta here!*

1 *The Virgin of the Rocks* which originated in 1483.

2 Nnaked children weeping": Leonardo notebook, Ar 224r, 231V.

Chapter 22: You Again?

1 "Because I am not well educated I know certain arrogant people think they can justifiably disparage me as an unlettered man": CA 327v/119v-a.
2 The story is told by Vasari of Rustici's studio. Nicholl, p. 415.
3 Certain embellishments are possible in Borgia's story.
4 Old man autopsy, MS B, 10v.
5 "an over-abundance of nourishment": Nuland, p. 148.
6 MS 2038, 23r.

Chapter 23: Milan II

1 Canapa, Cannabis sativa. Reynolds, p. 339.
2 Machiavelli torture. Strathern, p. 399.
3 Machiavelli poem to Giuliano de Medici. Strathern, p. 399. Machiavelli, Opere, Mondadori edn (Milan 1949), Vol II, p. 747.
4 Self-portrait with multiple mirrors. Bramly, p. 19.
5 Leonardo as model for Vitruvian Man. Lester, p. 214.

Chapter 24: Rome

1 "Alas, this man will never do anything": Nicholl, p. 467.
2 Banished from the hospital of Santo Spirito. Nicholl, p. 481.
3 Maximilian I supports Ludovico's nephew in an attempt to retake Milan.

Chapter 25: Playing Kickball at Cloux

1 Beatis letter. Nicholl, p. 490.
2 Moon quote, MS F, folio 118v.
3 Melzi, or someone, did manage to put together several of Leonardo's notes on painting into a codex of sorts, but did not publish it. It ended up in the Vatican's library and eventually found publication in France in 1651.

BIBLIOGRAPHY

General Biographies

Nicholl, Charles. *Leonardo Da Vinci, Flights of the Mind* (New York: Penguin, 2004).

Bramly, Serge. *Leonardo the Artist and the Man* (New York: Penguin, 1994).

Specialized Biographies

Ady, Cecilia. *A History of Milan Under the Sforza* (London: Forgotten Books, 2012), Kindle edition.

Bambach, Carmen, et al., *Leonardo Da Vinci, Master Draftsman* (New York: Metropolitan Museum of Art, 2003).

Capra, Fritjof. *The Science of Leonardo* (New York: Anchor Books, 2007).

Jones, Jonathan. *The Lost Battles* (New York: Knopf, 2010).

King, Ross. *Leonardo and the Last Supper.* (New York: Walker and Co., 2012).
　　Michelangelo and the Pope's Ceiling (New York: Walker and Co., 2003).
　　Brunelleschi's Dome (New York: Penguin, 2000).
　　Machiavelli: Philosopher of Power (New York, Harper Perennial, 2007)

Nuland, Sherwin B. *Leonardo Da Vinci* (New York: Penguin Lives, 2000).

Strathern, Paul. *The Artist, The Philosopher, and the Warrior* (New York: Bantam, 2009).

White, Michael. *Leonardo The First Scientist* (New York: St. Martin's Press, 2000).

Critical Commentary

Clark, Kenneth. *Leonardo Da Vinci* (New York: Penguin Books, 1959).

Kemp, Martin. *Leonardo Da Vinci, The Marvellous Works of Nature and Man* (New York: Oxford University Press, 2006).

Klein, Stefan. *Leonardo's Legacy* (Cambridge: Da Capo Press, 2008).

Lester, Toby. *Genius, Obsession and How Leonardo Created the World in his Own Image* (New York: Free Press, 2012).

Sassoon, Donald. *Becoming Mona Lisa* (New York: Harcourt, 2001).

Steinberg, Leo. *Leonardo's Incessant Last Supper* (New York: Zone Books, 2001).

Turner, A. Richard. *Inventing Leonardo* (New York: Knopf, 1993).

Additional Readings

Ball, Phillip. *The Devil's Doctor, Paracelsus & The World of Renaissance Magic & Science* (New York: Farrar, Straus and Giroux, 2006).

Boccaccio, Giovanni. *Life of Dante. One World Classics*, translated by Phillip Wicksteed, 1904.

Boorstin, Daniel. *The Discoverers* (New York: Vintage, 1985). See also *The Image* (New York: Vintage, 1961).

Capponi, Niccolo. *The Day the Renaissance Was Saved* (New York: Melville House, 2015).

Castiglione, Baldesar. *The Book of the Courtier* (New York: Norton Critical Editions, 2002).

Cawthorne, Nigel. *Sex Lives of the Popes* (London: Prion Books, 1996).

Clegg, Brian. *The First Scientist, A Life of Roger Bacon* (New York: Carroll & Graf, 2003).

Freud, Sigmund. *A Psychosexual Study of an Infantile Reminiscence* (Gutenberg. org, 1916).

Gadol, Joan. *Leon Battista Alberti, Universal Man of the Early Renaissance* (Chicago: University of Chicago Press, 1969).

Gleick, James. *Isaac Newton* (New York: Pantheon Books, 2003).

Grafton, Anthony. *Leon Battista Alberti, Master Builder of the Italian Renaissance* (New York: Hill and Wang, 2000).

Greenblatt, Stephen. *The Swerve: How the World Became Modern* (New York: W. W. Norton, 2012).

Hillman, D.C.A. *The Chemical Muse* (New York: St. Martin's Press, 2008).

Kalsched, Donald. *The Inner World of Trauma* (New York: Routledge, 1996).

Lewis, R.W.B. *Dante, A Life* (New York: Penguin Books, 2001).

Lucretius, *The Nature of Things* (New York: Penguin Classics, 2007).

Machiavelli, Niccolò. *The Prince* (Mineola, N.Y.: Dover Publications, 1992).

McMahon, Darrin. *Divine Fury, A History of Genius* (New York: Basic Books, 2013).

Pacioli, Luca. *The Rules of Double-Entry Bookkeeping* (New York: IICPA Publications, 2010).

Pinker, Steven. *The Better Angels of Our Nature: Why Violence Has Declined* (New York: Viking Books, 2011).

Reynolds, Barbara. *Dante, the Poet, the Political Thinker, the Man* (New York: Shoemaker and Hoard, 2006).

Santayana, George. *Three Philosophical Poets, Lucretius, Dante, and Goethe* (Cambridge, Mass.: Harvard University Press, 1947).

Suh, H. Anna, ed., *Leonardo's Notebooks* (New York: Black Dog and Leventhal, 2005).

Thomas, Keith. *Religion and the Decline of Magic* (New York: Penguin, 1991).

Vasari, Giorgio. *Lives of the Most Excellent Painters, Sculptors, and Architects*, 2nd ed. (Gutenberg.org, 1550).

Wilson, A. N. *Dante in Love* (New York: Farrar, Straus and Giroux, 2011).

Wittkower, Margot and Rudolf. *Born Under Saturn* (New York: New York Review Book Classics, 1963).

INDEX

ABOUT THE AUTHOR

MIKE LANKFORD is a graduate of the Iowa Writers' Workshop and the author of *Life in Double Time: Confessions of an American Drummer*, a memoir about his years as a white drummer in a black R & B band. The book was selected by eight major newspapers, including *The Washington Post*, the *Chicago Tribune*, and the *Austin Chronicle* as the best music book of the year.